OLD ONTARIO HOUSES

Traditions in Local Architecture

TEXT BY TOM CRUICKSHANK

PHOTOGRAPHS BY JOHN DE VISSER

FIREFLY BOOKS

A FIREFLY BOOK

Published by Firefly Books Ltd. 2000

First Printing 2000

**Library of Congress Cataloging-in-Publication Data
is available.**

Canadian Cataloguing in Publication Data

Cruickshank, Tom, 1954–
 Old Ontario houses : traditions in local architecture

Includes index
ISBN 1-55209-499-5

1. Architecture, Domestic – Ontario – History.
2. Historic buildings – Ontario. I. Title.

NX7242.O5C78 2000 728.09713 C00-930877-6

Published in Canada in 2000 by
Firefly Books Ltd.
3680 Victoria Park Avenue
Willowdale, Ontario M2H 3K1

Published in the United States in 2000 by
Firefly Books (U.S.) Inc.
P.O. Box 1338, Ellicott Station
Buffalo, New York 14205

Produced by
Bookmakers Press Inc.
12 Pine Street
Kingston, Ontario K7K 1W1
(613) 549-4347
tcread@sympatico.ca

Design by
Ulrike Bender, Studio Eye

Printed and bound in Canada by
Friesens
Altona, Manitoba

Printed on acid-free paper

Front cover: Seymour House, Madoc
Back cover: Hubbs House, Bloomfield
Inside front flap: Mount Grove, near Picton

*The Publisher acknowledges the financial support of the
Government of Canada through the Book Publishing Industry
Development Program for its publishing activities.*

Acknowledgements

Hats off to the following individuals, families, organizations and institutions who shared their time, knowledge and expertise and even opened their doors for the camera: Paul and Pat Albright, Allan Macpherson House and Park, Annandale National Historic Site, Architectural Conservancy of Ontario, Art Gallery of Sudbury, Barnum House Museum Foundation, Clay and Carol Benson, Black Creek Pioneer Village, John Blumenson, British High Commission, Jeff Celentano, Cottonwood Mansion Preservation Society, Dundurn National Historic Site, Ermatinger Old Stone House, Tim Farquhar, Paul Fritz, Larry and Peggy Fry, Elizabeth Goetz, Ron Hansen, Bill Hurren, Jon Jouppien and Heather Phyfe, Darlene King, Bazil and Shirley Kuglin, Lennox and Addington County Museum and Archives, Marten Lewis, Lower Grand River Land Trust, Macaulay Heritage Park, John and Eleanor Magder, Lola Martel, Dan Medakovic, Rollo Myers, Barbara Patterson, Perth Museum (Matheson House), Louis and Phyllis Peters, Phil and Marilyn Robins, Brent and Betty Glen Rowe, Bob and Marg Rowell, Frank and Pauline Steele, Jane Stieff, Thunder Bay Museum, Beth Tousaw, Upper Canada Village, Jim Wills and Beth Potter, Township of Wilmot, Paul and Kay Wilson, Woodchester Villa.

And a toast to Peter John Stokes, restoration architect, and the late Jeanne Minhinnick, consultant in historic furnishings, mentors who fostered my interest in Ontario's architecture and cultural history.

Tom Cruickshank
Summer 2000

CONTENTS

Introduction

Next time you're browsing through the real estate section of *The Toronto Star*, count the number of times you come across the term "all brick" in the advertisements for new subdivision houses. Like "ravine lot" and "parklike setting," "all brick" has a certain cachet for home buyers, and as buzzwords go, it probably carries more weight in Ontario than in, say, Calgary or Montreal, where brick construction was never so firmly entrenched in local building traditions. Indeed, Ontario is synonymous with brick and always has been. If you need more proof, just take the bridge across the international boundary from Sault Ste. Marie to the Soo in Michigan, from Fort Erie to Buffalo or from Prescott to Ogdensburg, New York. One of the first things an astute visitor will notice is the extent to which the American towns are dominated by frame houses and wood siding. Back home in Ontario, however, it's a different story, whether the dwellings are old or new.

From day to day, we tend not to notice our predilection for brick houses, but we ought to acknowledge it for what it is: one of the most recognizable traits of Ontario's architectural legacy and something that distinguishes us from our neighbours. But it is not the only virtue specific to our vintage houses. Ontario even has its own homegrown signature style, once so common in our towns and countryside as to be ubiquitous but just as valid a hallmark as the saltbox in New England and the steep-roofed habitant homestead in Quebec. Our style has no official name but can easily be recognized by the symmetrical arrangement of doors and windows under a roof that stands only a storey and a half high. Over the front entrance is another identifying mark: a gable peak fitted with a Gothic-pointed window. Similar houses can be spotted from Massachusetts to Manitoba but never in the same numbers as in the corridor between Windsor and Cornwall and north into the Canadian Shield. Although the type has been around since the early days of settlement, only in recent years have we seemed to notice that this is something we can truly call our own. Perhaps the time has come to give it a proper name: the "Ontario farmhouse" style.

Although easier to heat and more economical to build than a house a full two storeys high, the Ontario farmhouse owes its popularity more to politics than to pragmatism. Beginning in 1807, it was taxed at a significantly lower rate. At the same time, despite the ornament often lavished upon it, the gable was a purely practical amenity: it made the attic space more usable, providing extra headroom and much-needed light. Thus a provincial icon was born that would survive long after the tax was revoked in 1853. In fact, it was well after Confederation, when building fashion and technology embraced a new bigger-is-better ethic, that the classic Ontario farmhouse finally lost ground. Today, thousands of the genre survive in the heartland, a sampling of which are pictured on the pages that follow. As you study them, look for variations on the theme, especially the manner in which the front gable grew progressively steeper as the 19th century wore on.

The storey-and-a-half farmhouse may be our signature tune, but old Ontario is rich in other architectural melodies, each a reflection of the times. Very few, however, are pure examples of their type, unsullied by outside influences. Rare was the builder who, embarking upon an Italianate-style house, for example, could resist

Top: The Ontario gable takes on fanciful dimensions on this Meadowvale (Mississauga) farmhouse.

Bottom: Not every architectural influence was homegrown. Greek-style porticoes were an idea imported from the United States.

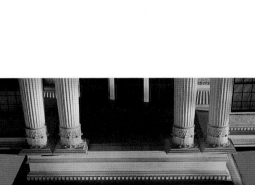

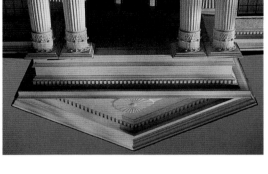

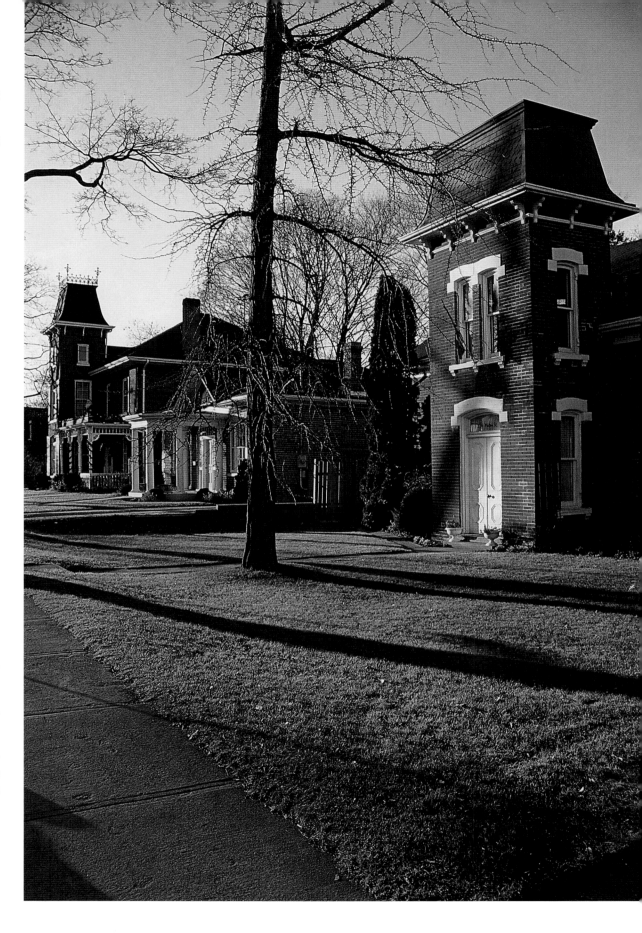

Right: Stroll into any Ontario town, and you will quickly see the extent to which brick dominates our older streetscapes. Here on Port Hope's main street, a demure Regency cottage is framed by two towered Victorians.

tossing in a few Gothic touches here and there. Indeed, most Ontario houses are unabashedly eclectic. They owe their symmetry to the Georgian tradition, while their verandahs were inherited from the Regency style. Roof brackets and slender windows are Italianate, and Gothicism shows in pointed church-style windows. Another feature that marks Ontario architecture is its tendency toward conservatism. Even in the 20th century, the concept of "home" was more often expressed in the tried-and-true than in the avant-garde. Likewise, it was considered quite vulgar to display one's wealth with anything pretentious or overtly extravagant. But when you think about it, perhaps this isn't surprising. After all, the very first settlers in the province, the United Empire Loyalists, were by nature a conservative breed, aghast at the revolutionary ideals of the new United States. It could be argued that Loyalist values set the tone for generations to come.

It is also no surprise to learn that Ontario houses, like the people themselves, were a blend of American and British influences, although builders were more likely to look to mother England for inspiration than south of the border. This would account for our preference for the British-born Regency and Gothic stylings, neither of which is as well represented in bordering states. And it also speaks volumes about why the Greek Revival, which swept the United States in the 1820s and 1830s, seldom took full flight in Ontario. It seems that its connections to democratic ideals and republican principles were just too much for monarchist Upper Canada. Indeed, suspicious eyebrows were often raised at any builder whose house displayed undue Yankee influence.

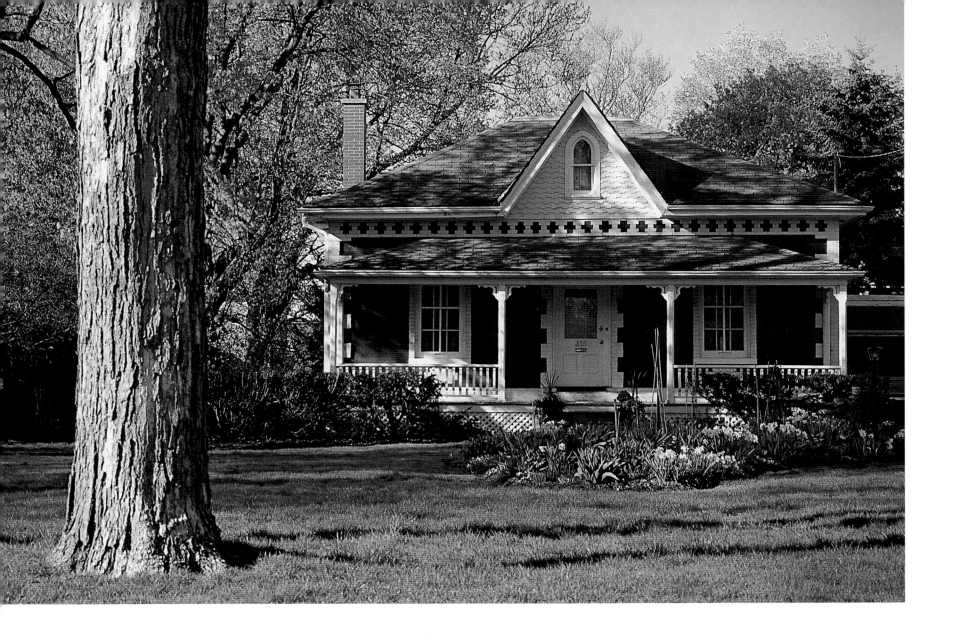

8 *Above:* The prim, symmetrical lines and, of
course, the gable peak over the front door
mark this Stratford house as characteristic of
the Ontario building tradition. It is a variation
on a theme seen time and time again in the
province's architectural legacy.

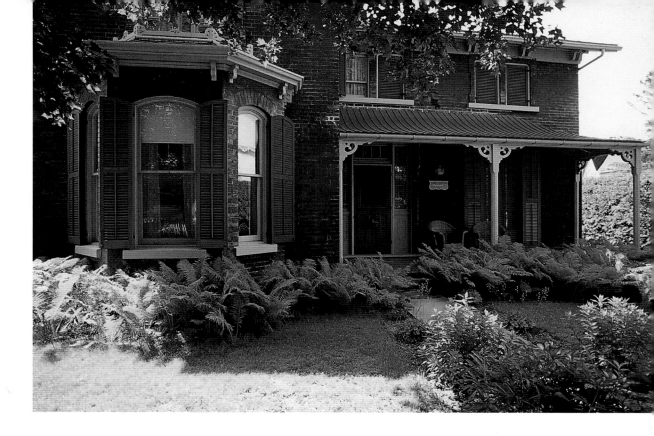

It is sad to note that many of our older houses were lost in the battle with 20th-century progress. Some were lost to neglect, but many more—in city and country alike—were bulldozed to pave the way for development, especially in the Toronto-centred conurbation between Oshawa and Niagara Falls. Fortunately, public opinion is no longer indifferent to the fate of our architectural heritage, and there is a whole new generation of enthusiasts for whom restoring an old Ontario dwelling is the stuff of dreams. This book offers plenty of inspiration, as it divides the province along informal geographical lines and presents capsule portraits of some of our very best vintage houses. Presented here are quaint farmhouses and fashionable urban addresses from almost every corner of the province, textbook examples of architectural finesse as well as homespun vernacular style, rare houses of the late 18th century, plenty from the 19th and several that demonstrate the new directions of the early 20th. Some are museums, but most are privately owned and maintained. Some are ordinary, some are exceptional, but all are possessed of a certain timeless charm. And more than a few are brick.

A Note on Nomenclature

If you've been following the news lately, you already know that the municipalities of Ontario have been reorganized. The process actually started in the early 1970s, when regional government was introduced to replace the county system. The latest round of reorganization has been much more thorough: New megacities have been created, and many a town and township have been amalgamated, not always willingly. Along with the changes, some familiar places have literally been wiped off the map, but the old names linger in common parlance, and for the purposes of this book, they remain very much alive. In a work that highlights history, it seems only natural to refer to Norfolk County, the City of Trenton and Darlington Township, even though none of them officially exist as municipal entities anymore. Somehow, the new names— the Region of Haldimand-Norfolk, the City of Quinte West and the Municipality of Clarington—don't yet trip as lightly off the tongue.

Now can anyone explain how the County of Prince Edward became something called the City of Prince Edward County?

Top: An 1866 house in Newmarket shows that even though the Victorian era ushered in a brand new aesthetic, Ontario's preference for brick never wavered. We had plenty of clay to work with, after all.

Bottom: The Ontario gable shows remarkable stylistic diversity. Here at Burritt's Rapids on the Rideau Canal, it is exceptionally wide.

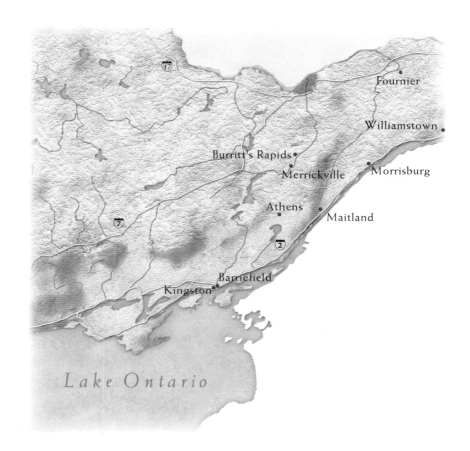

Fournier

Williamstown

Burritt's Rapids

Merrickville

Morrisburg

Athens

Maitland

Barriefield

Kingston

Lake Ontario

UPPER ST. LAWRENCE

After the American Revolution, when the boundary between the United States and what was to become Canada was finally established, the British were justifiably nervous about sharing the St. Lawrence River with the upstart republic. With the Yankees so close by, the British holdings, which were then only a wilderness, were highly vulnerable for the length of the crucial trade route between Montreal and the Great Lakes. The solution was to settle the valley and settle it fast. Indeed, the townships along the upper St. Lawrence were among the very first in the province to be surveyed and cleared for agriculture. By the late 1780s, the riverfront was dotted with new farmsteads, most of them granted to United Empire Loyalists as a reward for remaining faithful to the Crown throughout the hostilities.

The settlement strategy proved prudent, for only 30 years later, the upper St. Lawrence was attacked by the Americans during the War of 1812. Had it not been for its critical position, however, the valley would probably not have been so extensively settled. Aside from the choice lots fronting the river, much of the land proved marginal, but it was cleared and occupied nevertheless. The region eventually found its agricultural niche in the dairy sector, although it never proved a match for the more fertile regions farther west. Urban growth eluded it, save for that experienced in Kingston, but this ultimately proved to be a blessing in disguise, for the valley today is still very much tied to the past. The lion's share of notable old houses is found along the river—the stretch from Brockville to Morrisburg is particularly rewarding, as it is a rare treat to find so many dwellings, often in stone, of such early vintage. Likewise, Kingston is without question the best-preserved city of its size in the province. In the back concessions farther to the east, the Loyalist-Georgian influences eventually give way to the French-Canadian, which spilled over from Quebec in the mid-19th century.

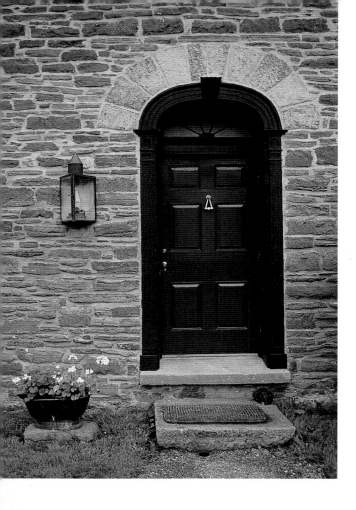

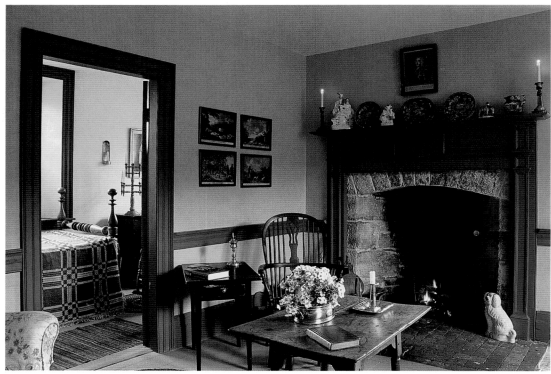

12

Above: Front door features a dummy transom.

Right: Although this is not a lavish house, its interior appointments are nevertheless charming in their simplicity.

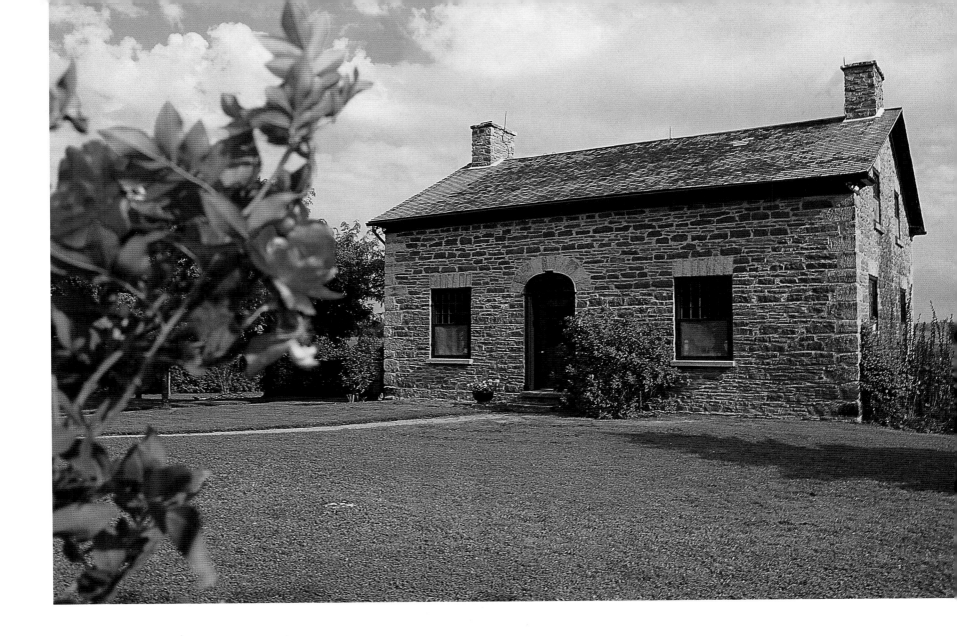

Moulton House

near Athens

There is charm in humility, and this little stone house in the heart of the Rideau corridor has it in spades. Not a large house nor a fancy one, its lack of pretension is, in fact, its strong suit, especially now that it has been treated to an authentic restoration.

The house does its best to keep up with the Joneses or, more accurately, the Flanagans. It stands in an Irish-settled neighbourhood in which housebuilding was governed more by function than fashion. The pragmatic Irish farmer, less inclined to stylistic indulgences than his English cousin, had little use for formality, and it shows in the off-centre placement of the front door, which opens not to a fancy centre hall but to a workaday cooking hearth. Likewise, the façade has only two windows, although there is ample room for more. And although the semicircular transom over the door might appear to be a gesture toward style, even

it falls short because it is merely a dummy.

Until purchased by the present owner in 1973, the farm had been in the same family since the•Crown relinquished title to the land in 1816. Generations of Moultons farmed here, the last of the line defiantly forsaking the comforts of indoor plumbing and running water. The house was built around 1829.

13

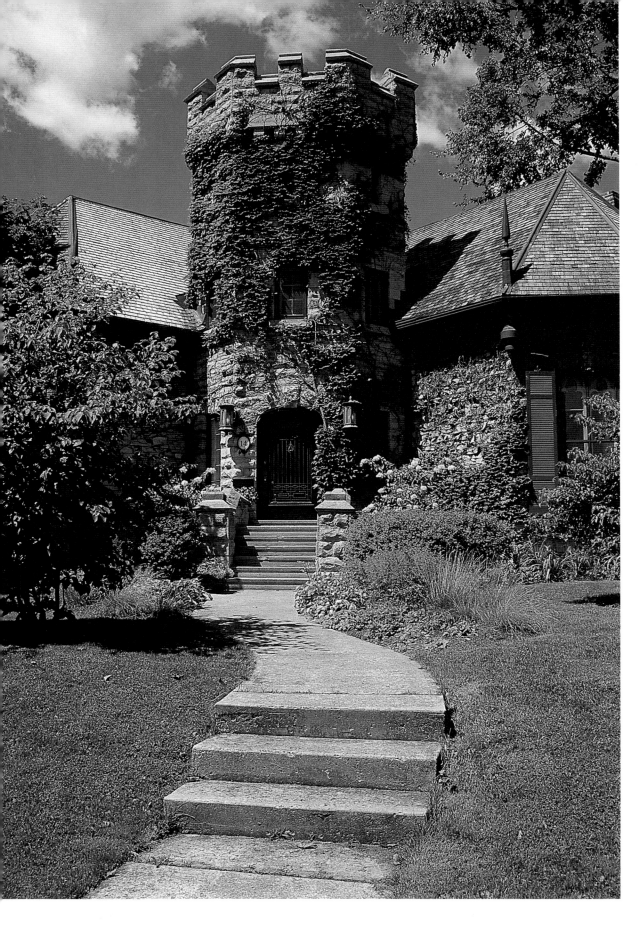

McIntosh Castle

Kingston

Of all the Ontario houses to take their inspiration from castles of the mediaeval era, McIntosh Castle, situated just across the park from the county courthouse in Kingston, is perhaps the most endearing. While others are so boastful that there's no mistaking they were built for men of exceptional means—just look at the famous Casa Loma in Toronto, whose ballroom has a 60-foot ceiling—McIntosh Castle has a humbler, more inviting scale. More a romantic hideaway than an indulgence of ego, this is a castle nonetheless, with its irregular plan, rustic rubblestone walls and, of course, the tower, complete with battlements on the roof.

Much of the credit goes to John Power, an English-trained architect who embarked on a solo career in Kingston in 1849. McIntosh Castle is said to have been his first commission. The client was Donald McIntosh, who made his fortune as the owner of a steamship. A victim of increased competition from the new railways, his business faltered, and McIntosh had to abandon his house-building project before he could complete it.

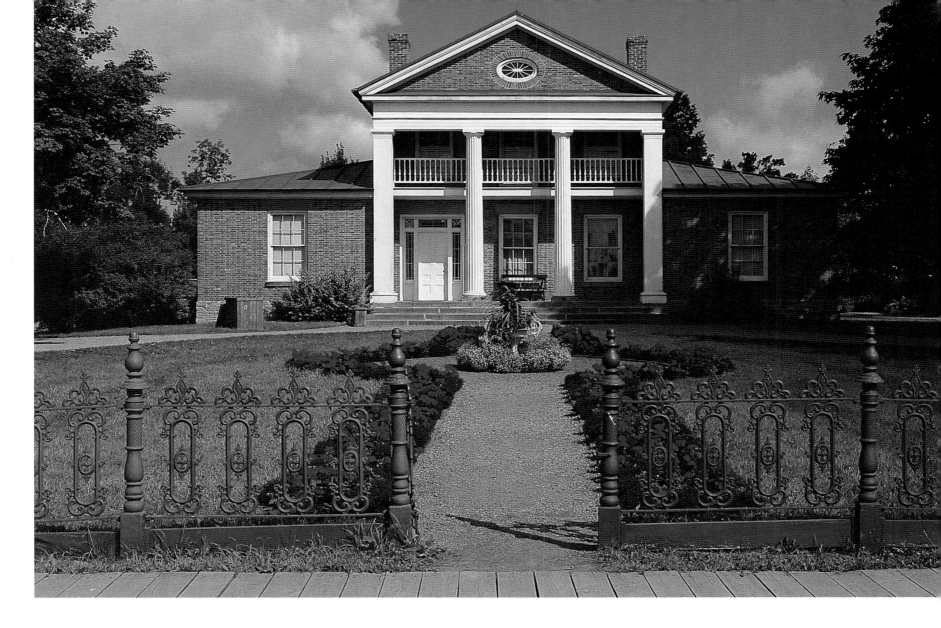

Crysler Hall

Upper Canada Village
near Morrisburg

The Greek Revival swept the United States in the 1820s and 1830s—picture Tara from *Gone with the Wind*, with its tall porticoed façade—but was never as popular north of the border. Perhaps that had something to do with British disdain for republican ideals, or perhaps the style's unabashed grandeur was a little outré for our conservative taste. Whatever the case, the Greek Revival in Ontario is much more understated, usually limited to interior trim rendered slightly bolder than in years before. Thus to find John Pliny Crysler's exemplary Greek on

the banks of the upper St. Lawrence River, as grandiose as anything in the American South, is a real treat.

Crysler Hall is Greek not only in its columns, which adopt the Doric order, but also in its basic form, borrowed from ancient temples: a central block, its gable end facing front, flanked by two smaller wings to the sides. This alone guaranteed that the 1846 mansion would forever rank among the landmarks of Ontario, but also to its credit is its connection to the Cryslers, whose family farm was the site of a decisive

battle in the War of 1812. In the 1950s, when plans were announced to create a museum village from houses that stood in the path of the new St. Lawrence Seaway, Crysler Hall was a natural choice. Dismantled brick by brick and re-erected on higher ground, it has been a highlight of Upper Canada Village ever since. Don't expect to see a restored parlour inside, however—the interior wasn't considered worthy enough and functions only as exhibit space.

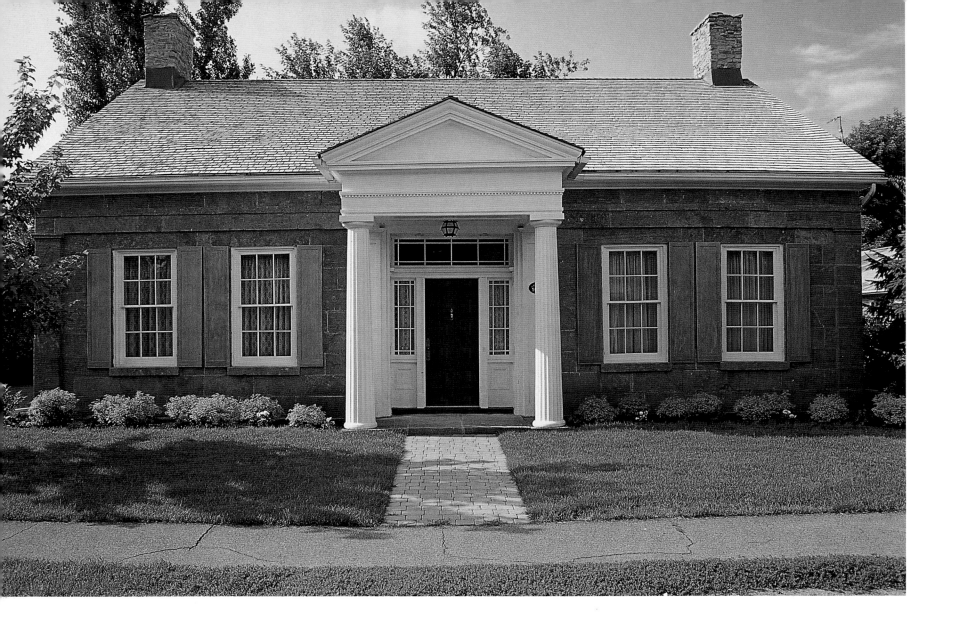

Stephen Merrick House

Merrickville

The village of Merrickville has many reminders of its founding family besides its name. Several houses—among the most stylish in town—are attributed to them, testimony to the Merricks' early success at the helm of an extensive complex of local mills.

This stone house, built about 1850, was the home of Stephen Merrick, a son of the founder. At a glance, it looks no different from scores of other storey-and-a-half dwellings, but look closely, and you'll see a house rich in Greek Revival detail. The portico alone is accurate enough to have been lifted straight from a Doric temple in ancient Athens, but its masonry is what makes it stand out from the crowd. The façade is rendered in precisely cut blocks of ashlar stone, a rare and expensive indulgence usually reserved for courthouses and other public buildings. Similarly, the stone pilasters at each corner and the entablature across the front mark this house as a cut above the ordinary. Indeed, few homes in Merrickville can rival it, save for some of the other Merrick houses.

16

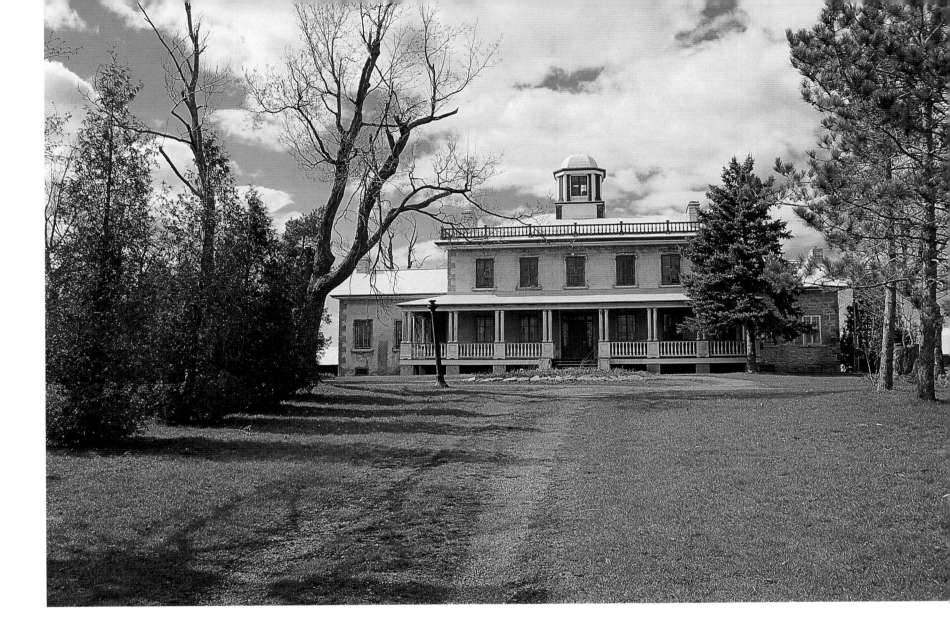

Fraserfield

near Williamstown

The old farmhouses of Glengarry County are marked by a certain Presbyterian modesty, as though local farmers had an unwritten pact not to upstage one another. The exception is Fraserfield, which stands head and shoulders above its neighbours as an architectural tour de force. From high upon a knoll, it announces its importance, not only with its sheer size but also with its rooftop cupola, the better to take in the view toward the Adirondack Mountains in upstate New York. "We had no idea that so grand a building was to be found in the wilds of Glengarry," commented an observer in *Canadian*

Pen and Ink Sketches in 1838. Those words still ring true today.

Built shortly after the War of 1812, the house was the brainchild of Colonel Alexander Fraser, a quartermaster during the war who went on to a distinguished political career. Down on its luck since the last of the Frasers sold out in 1879, the house was treated to a much-needed face-lift in the late 1980s. The verandah and roof balustrade were restored, and the stucco finish, which is scored to simulate smooth ashlar stone, was touched up.

17

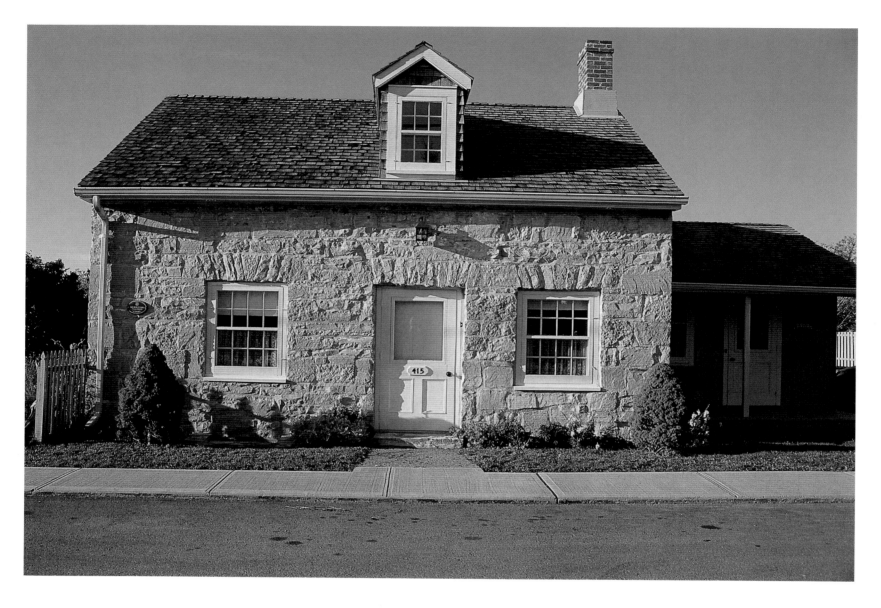

Hyland House

Barriefield

Always the poor cousin to Kingston across the Cataraqui River, Barriefield was traditionally home to dockworkers and military families who staffed nearby Fort Henry. It never attracted the merchant class, and by the 1970s, the village had slid into decay. But even in decline, Barriefield's humble streetscapes were not without a certain charm, and once history buffs took notice, its fortunes improved markedly. The village was the first district in Ontario to be officially designated for heritage conservation, and

many of its homes have been freshly restored.

Typical of Barriefield dwellings is the 1830s Hyland House, a tiny stone cottage. In dilapidated condition, it was purchased by a local preservation society to demonstrate that old houses can be rehabilitated to meet the needs of a modern family. A new board-and-batten wing was added to the side, while the old part was given a much-needed face-lift before the group decided it was ready for resale.

Log House

Barriefield

It's amazing how few log houses remain on their original foundations. Many, like this one, which made the trip from Allumette Island opposite Pembroke to a riverside location opposite Kingston, have been moved to new sites and adapted for contemporary living. Typically, they are aggrandized with features they never had when they were new, but the best of the breed haven't lost their genuine antique charm. Here, a new dormer window pops through the roof, and the façade sports an elegant doorcase. But of course, it's the log construction that steals the show. The logs are hewn to regular dimensions and joined with precisely cut dovetails.

For generations, houses like this were considered second-rate by architectural historians and lay people alike, abandoned and forgotten at the earliest convenience. Now we look at them in a new light. Their humble charm speaks volumes about the values of our ancestors.

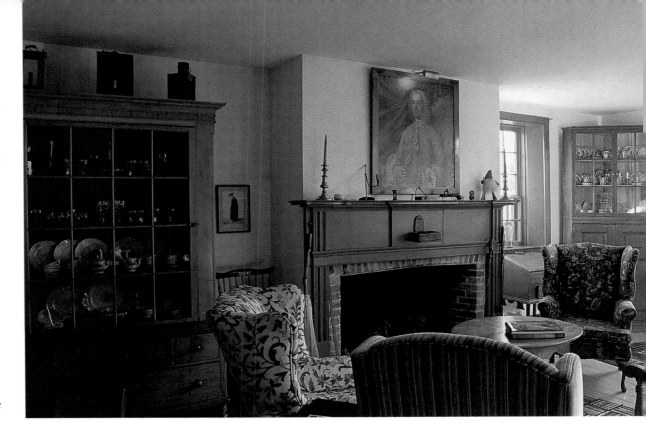

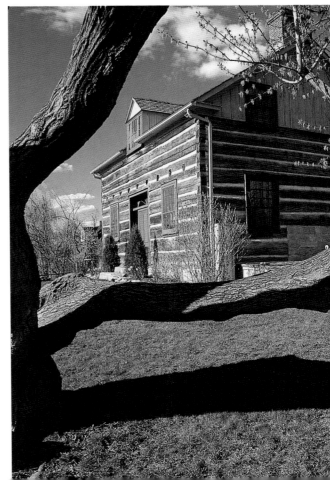

Above: Painted primitives and other country furnishings are well suited to the ambience of the log home, while the dining room basks in a surprising amount of natural light.

Merrick's Tavern

Merrickville

Just as Tillsonburg had its Tillsons and Streetsville its Streets, Merrickville owes its very existence to its founding family, the driving force in local business, politics and social affairs throughout the 19th century. The Merricks (also spelled Mirick) arrived in 1793 and harnessed the falls on the Rideau to power a crude sawmill. Their fortunes rose when the river was tamed by the construction of the Rideau Canal, and by the 1850s, the Merricks' empire included grist, woollen and carding mills, a distillery and a complement of other industrial buildings typical of a 19th-century mill town.

According to local lore, the family was also in the innkeeping trade. Aaron and Terence Merrick, sons of the founder, are thought to have built this humble stone building beside the canal as a tavern, although some historians surmise it was merely a "double house" shared jointly by the brothers and their families. Whatever the case, the house is an impressive, almost mediaeval figure beside the canal. What it lacks in sophistication—the walls are rubble, the façade is asymmetrical, the windows are tiny and the chimneys are bulky—it more than compensates for in humble charm. It was probably built around 1830.

Charles Place

Kingston

This delightful stone cottage in the heart of old Kingston has been known to stop traffic as old-house enthusiasts take in its graceful, snug proportions and striking detail, including a particularly good dormer window in the Gothic style. But what's especially remarkable about Charles Place is its umbrage, or recessed verandah, well known in Australian architectural traditions but quite rare in Canada.

The house takes its name from Charles Oliver, whose family owned the house for 60 years, starting in 1832. Some historians surmise that the dwelling is at least a decade older, and if it is as old as they say, it was a house ahead of its time, for such ground-hugging Regency proportions didn't have their heyday until the 1830s. The dormer was added by the Olivers sometime in the 1840s.

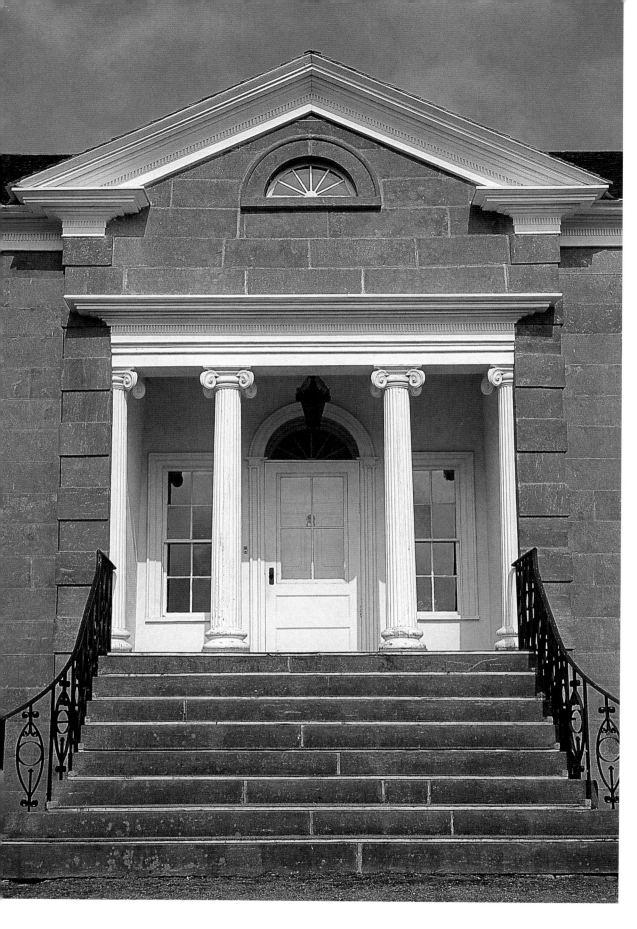

Maplehurst

Maitland

None other than the *Colonial Advocate*, William Lyon Mackenzie's famous York-based journal, paused to make mention of this house in its May 12, 1831, edition. "The residence of Mr. George Longley, an Englishman formerly member of the Assembly for Grenville, is well worthy of the traveller's attention in passing Maitland on the banks of the St. Lawrence. The house is an elegant and commodious stone structure with spacious offices." The description doesn't really do the house justice, for Maplehurst is more imposing than the newspaper suggests. It is a superb expression of Neoclassic and Regency manners, a formal design that has passed the test of time with flying colours.

Viewed from the road, Maplehurst presents a remarkably wide façade made all the more expansive with two smaller wings, one on each side. The front entrance is given special emphasis, recessed behind an umbrage and topped by a fanlighted gable. What can't be seen from the front is the extent of the kitchen tail to the rear, which rambles on at great length, incorporating kitchen, summer kitchen and servants' quarters.

Maplehurst is only one of the architectural surprises in Maitland, an underrated stone village just east of Brockville. It contains any number of buildings, many unspoiled, but the most curious of all is the remains of a windmill just across the street from Maplehurst. Longley used it to power his gristmill.

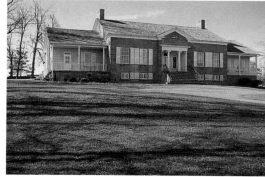

Green House

near Athens

The undisputed showstopper among its neighbours, the stone house built by John and Eleanor Green stands apart with its wealth of detail: a crisply defined cornice, a Gothic gable window and a doorcase fitted with side-lights and transom. It is a quintessential Ontario farmhouse made all the more memorable with a trellis- and lattice-trimmed verandah (a recon-struction based on photographic evidence) that wraps around three sides of the building with true Regency flair. Also of note is the stucco finish beneath the verandah, a curious anomaly occasionally found locally as well as in the Mennonite houses hundreds of miles away in Waterloo County.

The Greens were Irish immigrants who came to Canada at an early age. They bought the farm in 1838, but it was another 20 years or so before they graduated to this stone house. It was worth the wait.

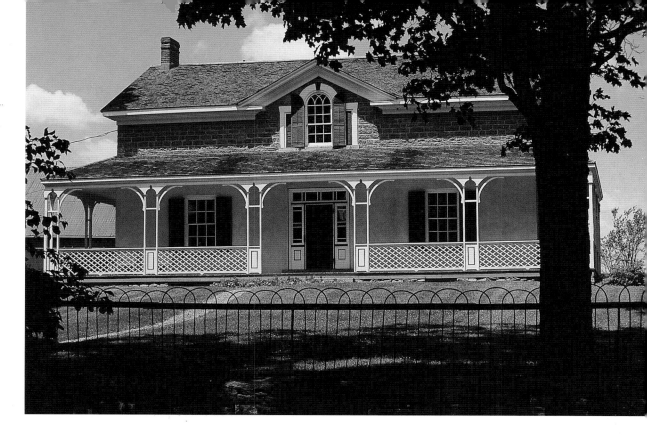

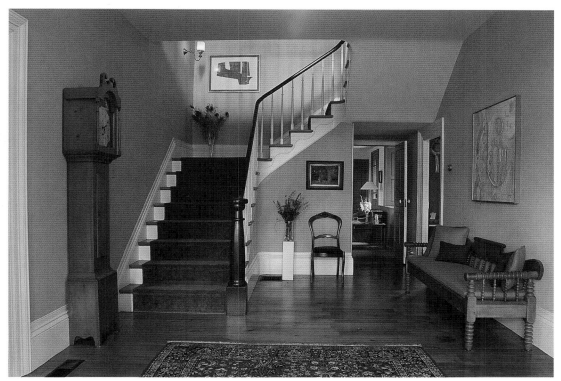

23

Above: The entry hall is wide enough to function as a room in its own right.

Left: The living area retains its rural character.

Cartwright House

Kingston

The Cartwright family ranked among the privileged elite in Kingston's early Loyalist days, and several downtown buildings can be traced to their business interests. But it is their house that is best remembered today. A picture-perfect essay in Georgian splendour, the 1833 dwelling has a stately, urbane look with its symmetrical façade and parapeted roof. Few homebuilders could afford such consummate stonework: The ashlar (regularly squared and smoothly rendered) façade is a rare treat, usually reserved for grand public buildings.

The house was home to the Reverend Robert David Cartwright, of the second generation of the family, and his wife Harriet Dobbs. Their son Richard, who grew up to serve as a cabinet minister in Sir Wilfrid Laurier's government, was born here.

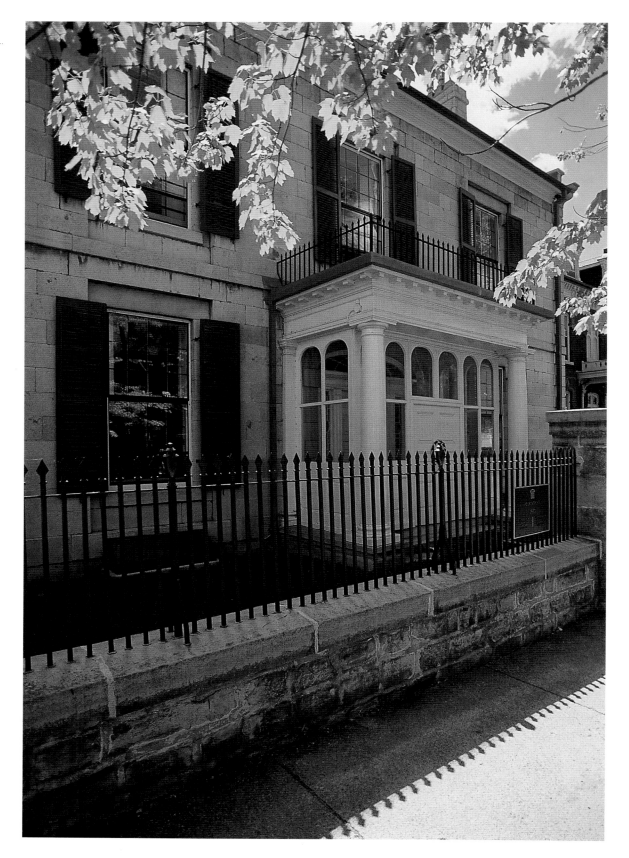

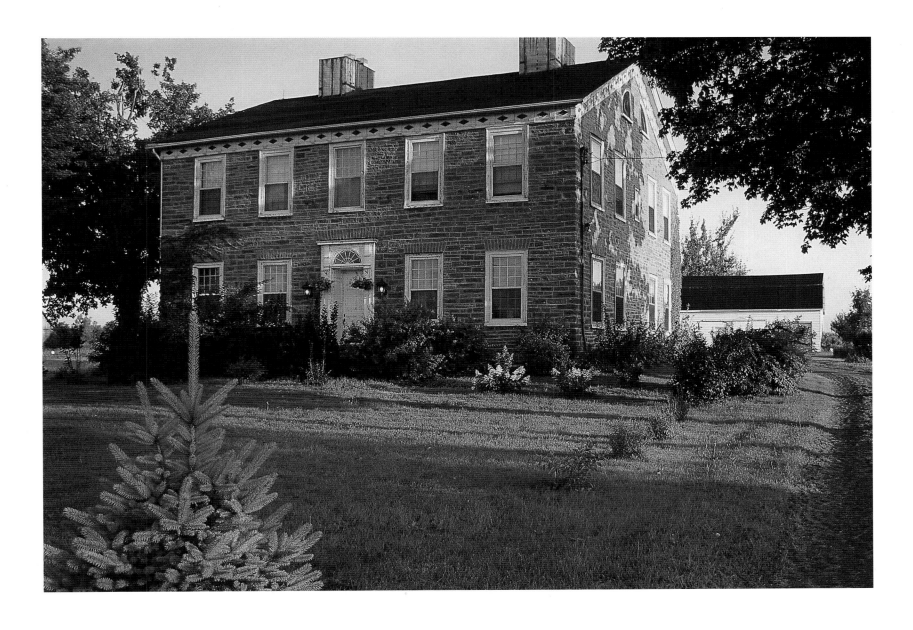

Poplar Hall

near Maitland

Of the scores of early houses along the river road between Brockville and Cornwall, Poplar Hall stands out as one of the best. Built about 1810 by William Wells, who was held hostage at home during the War of 1812, it marks a trend away from the profound simplicity of Georgian doctrine in favour of a less restrained approach to detail. Although it still adheres to the laws of Georgian symmetry, the trim—notably the cornice and fanlight transom—is more playful. The house was a harbinger of things to come as domestic architecture headed in new directions in the 1810s and 1820s.

Of special interest because the sides are almost as deep as the façade is wide, Poplar Hall was admirably renewed along historical lines in the 1960s (although the chimney stacks weren't restored to the letter). It remains a landmark in an area known for exceptional houses.

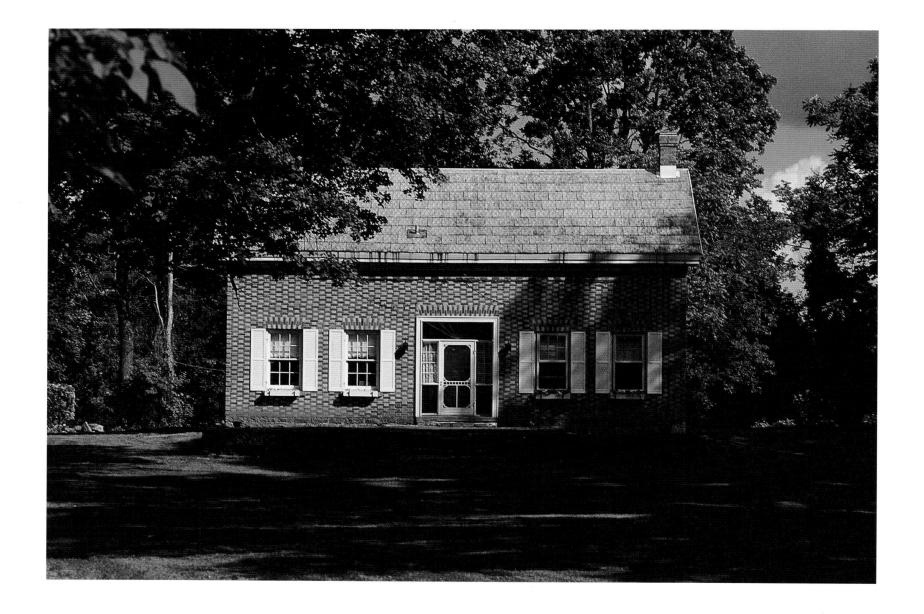

Checkerboard House

near Burritt's Rapids

Whether in the city or in the country, Ontario builders often experimented with colourful patterns in brick, enlivening an ordinary façade with a cornice or perhaps quoins in a contrasting hue (see Keough House, page 172). But the ultimate expression of this playful side of the mason's art is revealed in a handful of houses in and around Merrickville whose façades are dressed in a checkerboard pattern of buff and red brick.

To understand the pattern, you need to know the mechanics of Flemish bond, a traditional bricklaying technique that appears on the best Ontario residences of the early-to-mid-19th century. As the house was built, each row of bricks was laid in an alternating sequence of headers (the short end of the brick visible) and stretchers (the long end visible). The weave made an undeniably strong wall, but only the wealthy could afford it, as it consumed more bricks than did other techniques. Here, the checkerboard effect—buff-coloured headers and red stretchers—was a not-so-subtle reminder that these houses were definitely a cut above the ordinary.

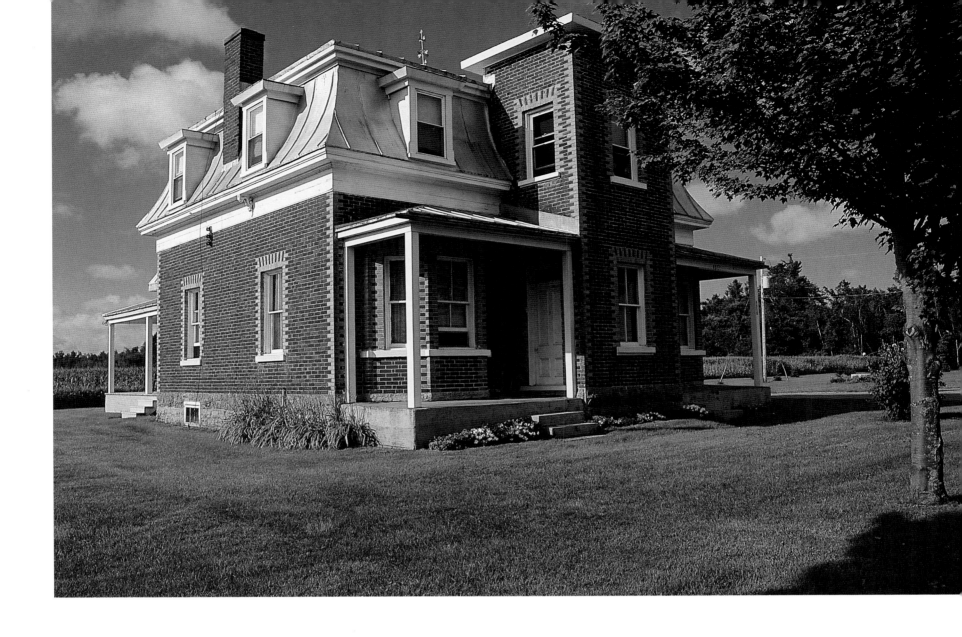

Maison Québécoise

near Fournier

Boundaries are arbitrary. Just because Canada's two solitudes meet at the Quebec-Ontario border, there is no reason to assume that the cultural traditions from one did not spill into the other. In the francophone townships east of Ottawa, a decidedly French-Canadian influence shows in the names on local mailboxes, not to mention in the names of whole towns such as St. Isidore and Ste-Anne-de-Prescott. Cassel-man, some 35 miles from the boundary, is dominated by an enormous Catholic church, as are so many towns in Quebec. What's surprising, perhaps, is that the influence isn't more profound, but there are virtually no habitant homes—the typical early Quebec farmhouse with the bell-cast roofline—in Ontario. However, the French character shows itself in other ways. This brick house, which looks as if it will celebrate its hundredth birthday in the early years of this century, has metal roofing and adopts the mansard-roof style, both typical of circa-1900 Quebec.

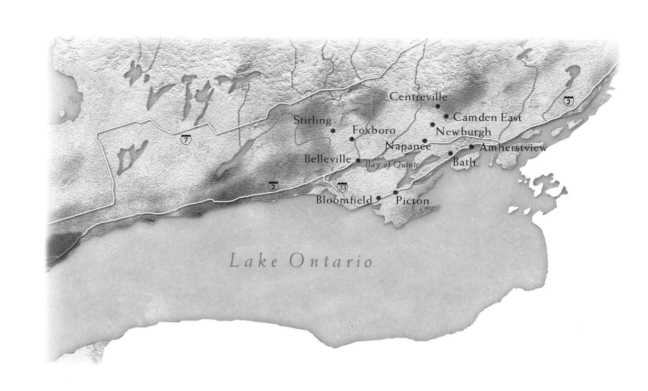

Centreville

Camden East

Stirling

Foxboro

Newburgh

Napanee

Amherstview

Belleville

Bay of Quinte

Bath

Bloomfield

Picton

Lake Ontario

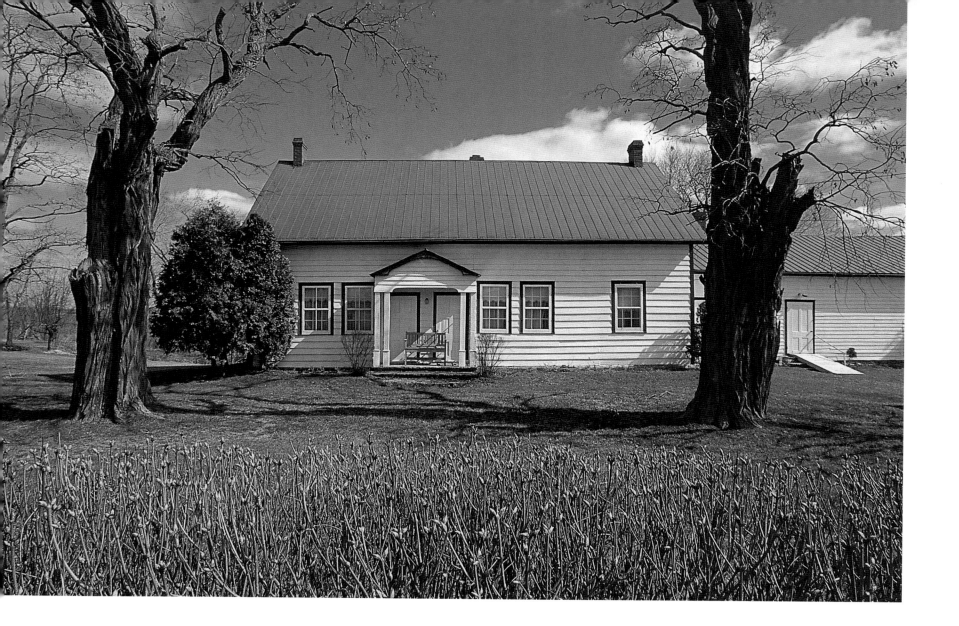

Mount Grove

near Picton

Green Point, a farming community on the southern edge of the Bay of Quinte, was settled primarily by Quakers, many of whom were unceremoniously exiled from their native Dutchess County, New York, for their pacifist stand during the American Revolution. It took years for them to put their lives back together, and until they could afford to build a meetinghouse of their own, Jacob Cronk let the congregation worship in the attic of his house, which was probably the most substantial frame building in the neighbourhood at the time. It dates to about 1805, perhaps earlier, and displays the precipitously steep roof characteristic of the very earliest Ontario houses. The Quakers have largely been assimilated into the mainstream, but their attic meeting room, divided into men's and women's sections, has remained untouched through all the years since.

Hubbs House

Bloomfield

Because it is virtually an island, Prince Edward County evolved as an entity distinct from the mainstream and even developed its own architectural accent. Several local houses are similar to this one—each with a graceful entrance bay flanked by twin verandahs—but you'd be hard-pressed to find anything similar elsewhere in Ontario. This handsome specimen was built about 1870 by Henry Hubbs and his wife Angeline Noxon, both of whom were descended from Quaker families going back to the very early days of settlement.

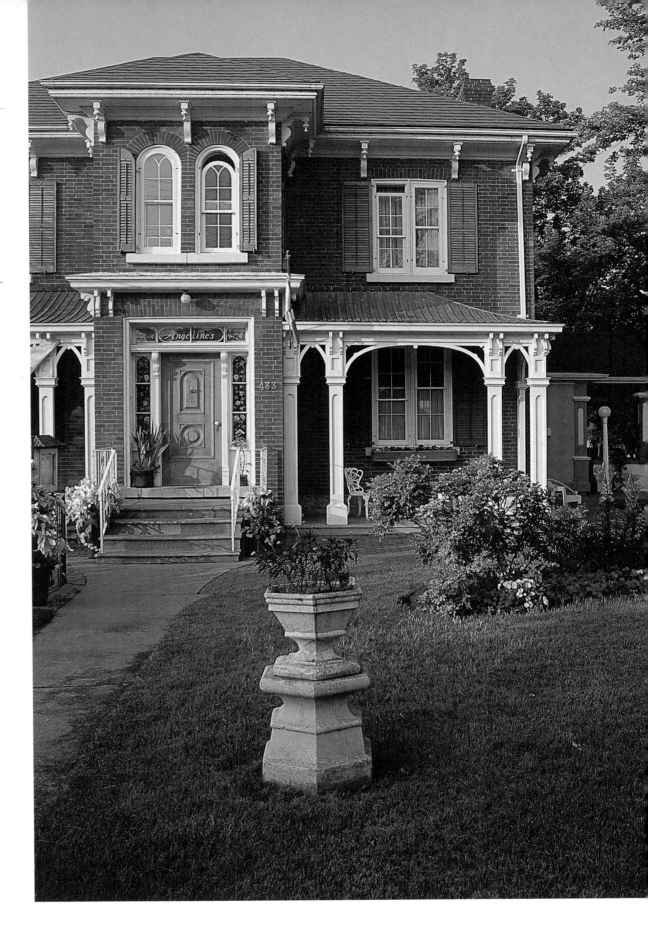

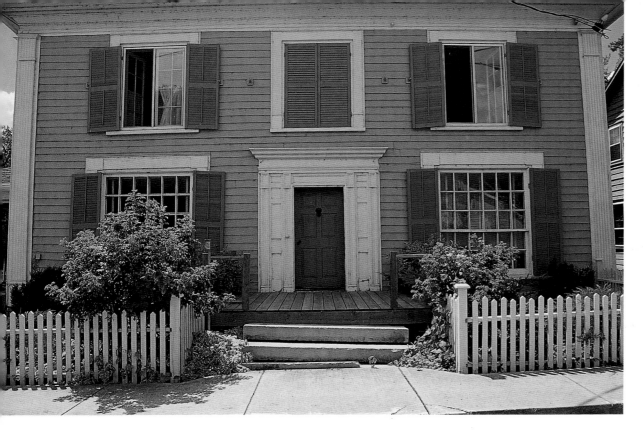

Lapum House

Centreville

Few houses better illustrate the progression of early-19th-century style than the James Lapum House, which stands restored in the hamlet of Centreville in the heart of Lennox and Addington County. Although the staid symmetry of the Georgian tradition is still very much alive, the trim takes a daring leap into the decidedly bolder Greek Revival style. The cornice, in particular, has striking proportions (compared with, say, the Macpherson House, page 37), while pilasters—mock pillars—define the corners of the façade in typical Greek fashion.

As storekeeper, postmaster and local member of parliament, Lapum had big plans for Centreville, but its fate was sealed when northbound railway construction bypassed the village. His house remains the most ambitious building in the community.

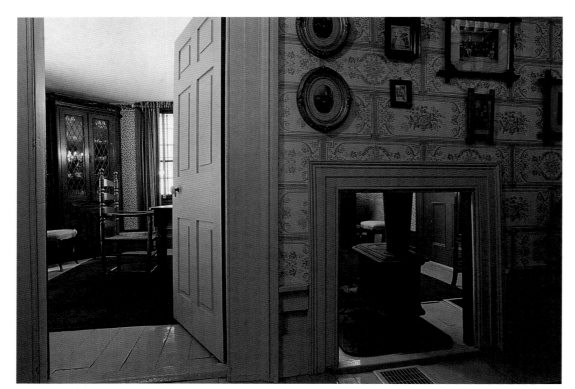

32

Above: A "heat hole" allows the dining-room stove to warm the hall as well.

Right: Faux graining aggrandizes the parlour trim.

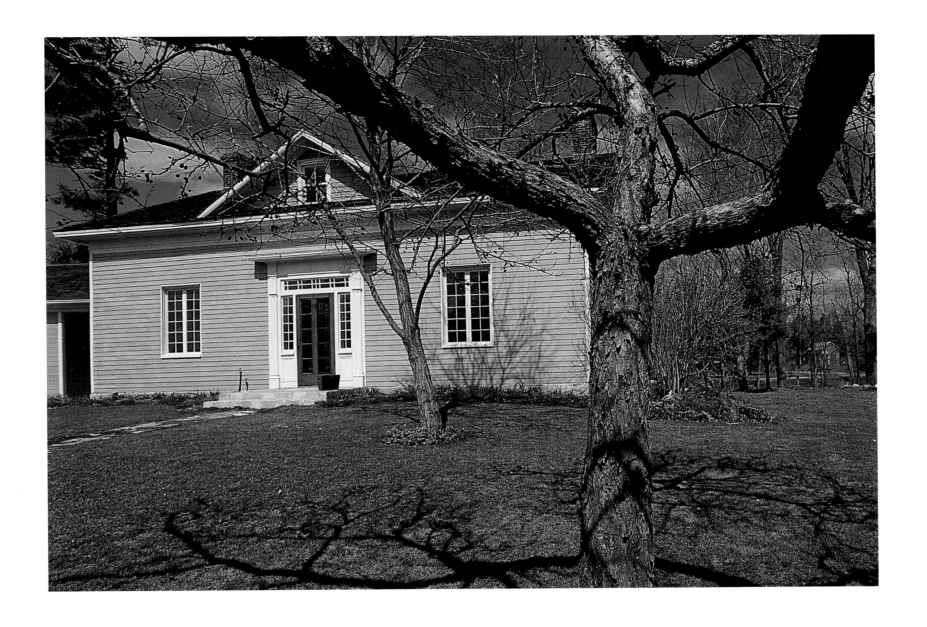

Clark House

Camden East

It's somehow poetic that Samuel Clark, proprietor of the local sawmill, would build a house of wood. After all, lumber was his lifeblood. (The same could be said of James Livingston, the paint baron, who spared no expense lavishing painted frescoes on his house—see page 152.) But this was no ordinary frame dwelling. Clark employed an unusual building technique called stacked plank, or sawmill plank, a solid-wall technique not unlike log construction. Here, the "logs" are actually sawn lumber spiked together at regular intervals and given extra strength with lapped corners. Undeniably solid, it was a rather inefficient use of wood, but of course, this was of little concern to the man who owned the village sawmill.

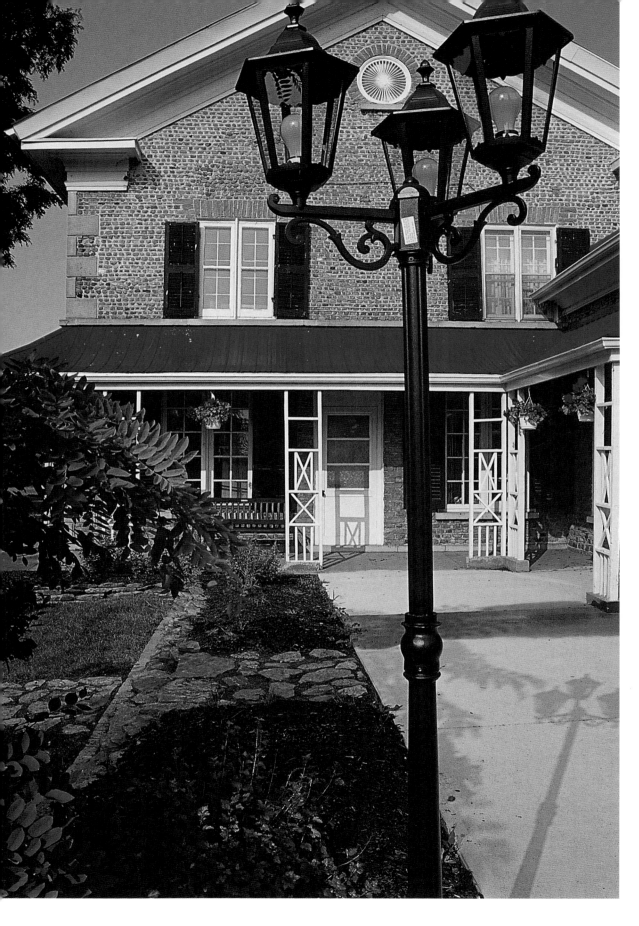

Roblin House

Belleville

The Roblins were a Loyalist family who could trace their roots to New Jersey, where they were well established in the milling trade prior to the American Revolution. They continued the tradition with great success when they arrived in the Quinte region. The family also had a genuine appreciation for architectural fashion; to the Roblins' credit are several outstanding local buildings, including an octagonal house, two superb Regency cottages and a five-storey gristmill that was dismantled in the early 1960s and re-erected as the showpiece of Black Creek Pioneer Village in Toronto.

In the same vein is this remarkable circa-1855 house whose red roof is just visible from Highway 401 at Belleville. Its coup de grâce is not so much the stylish appointments (although it cuts an impressive figure) as the innovative use of cobblestone as a building material. All the exterior walls are finished with a veneer of river-washed pebbles, each about the size of a potato, that lend the masonry a handsome and delicate texture. The same technique was employed in about a dozen other houses nearby, but the Roblin house stands out as the most sophisticated of its kind.

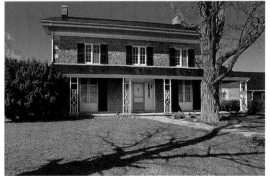

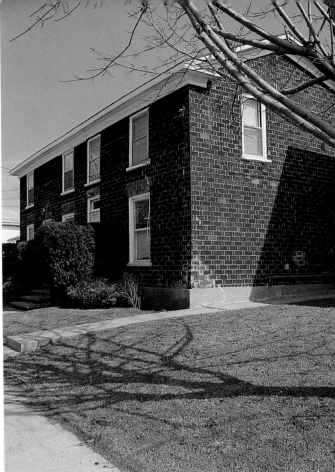

Welsh House

Picton

Take a close look at the masonry on this plain, no-nonsense house. At a glance, the bricks appear to be exceptionally large. In fact, they are of normal dimensions but laid on edge in a patchwork pattern architectural historians describe as "rowlock bond." The logic behind this technological innovation is a bit of a puzzle, although it has been suggested that it was employed simply as a way to save on the number of bricks needed for construction. That it should appear in Picton (about 10 local examples survive) and rarely anywhere else is another mystery. What is known is that the local rowlock houses were the work of the Welsh family—a father and three sons—who were in the mason's trade in Picton for decades. The house pictured here, the best preserved of the breed, was home to Robert Welsh, Jr., and his wife Grace. It was built around 1857.

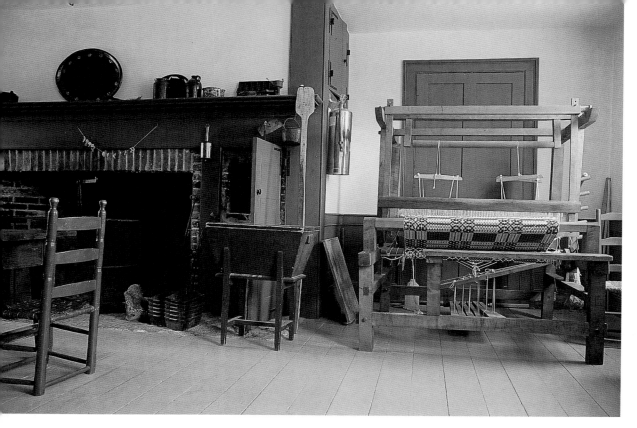

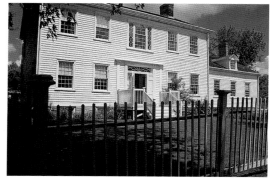

Clockwise from top left: The restored kitchen and loom; the riverfront façade; the "beehive" of the kitchen bake oven; period furnishings in the bedroom; and the elegantly appointed dining room.

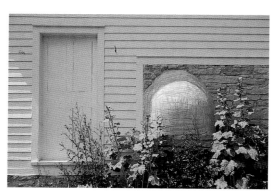

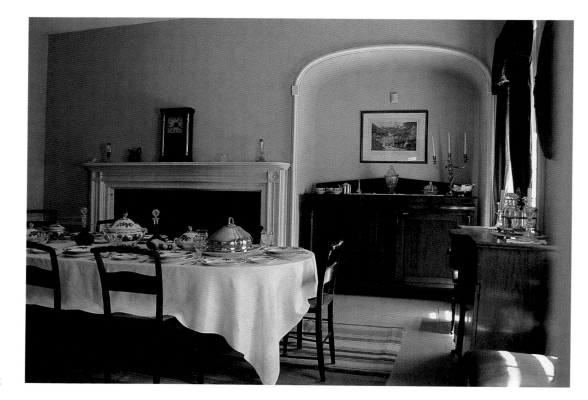

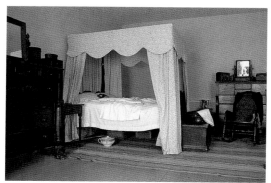

36

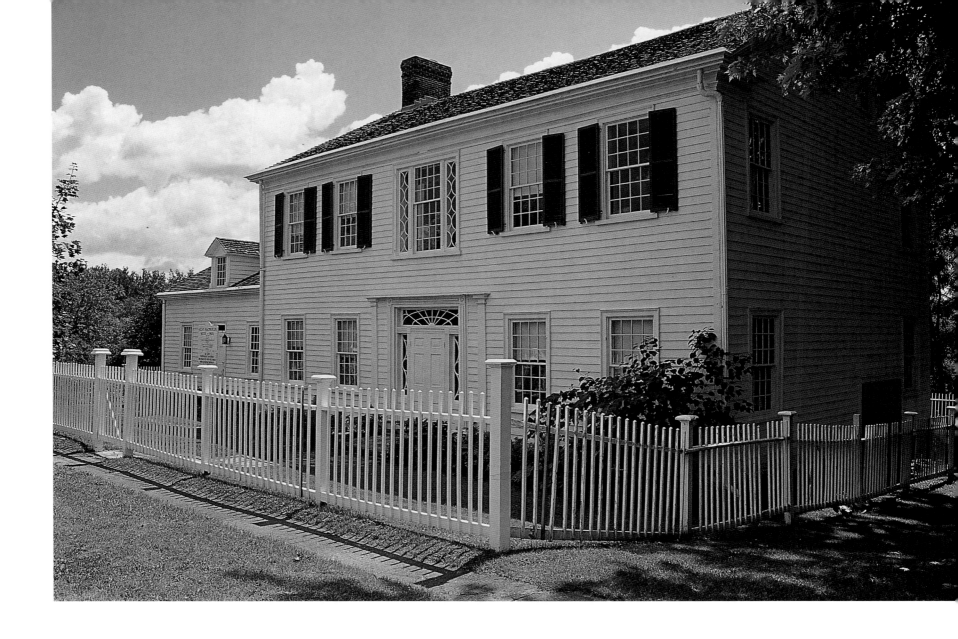

Macpherson House

Napanee

You wouldn't know it today, but the Allan Macpherson House was a basket case in 1962. Once the most stylish house in Napanee, it had slid into decline, the main section a tenement and the kitchen a barn. It looked like a lost cause except to members of the local historical society, who vowed to restore the house and open it as a museum. It took five years on a shoestring budget, but they succeeded.

Like so many others of its kind, the Macpherson House was built by the most successful man in the community. Allan Macpherson owned the local mill, a distillery and a store and was active in civic affairs. When he built the house in 1826, it was the only one on the north side of the Napanee River. It wasn't long before other upwardly mobile citizens followed suit, but none could rival the Loyalist Georgian perfec-

tion of the Macpherson House. It has two "façades"—one facing the lane to the rear and an identical front overlooking the river—and lavish interior appointments, including an upstairs ballroom. The twin doorcases—front and rear—are especially fine: The transoms are rectangular in shape but glazed to suggest an elliptical fanlight.

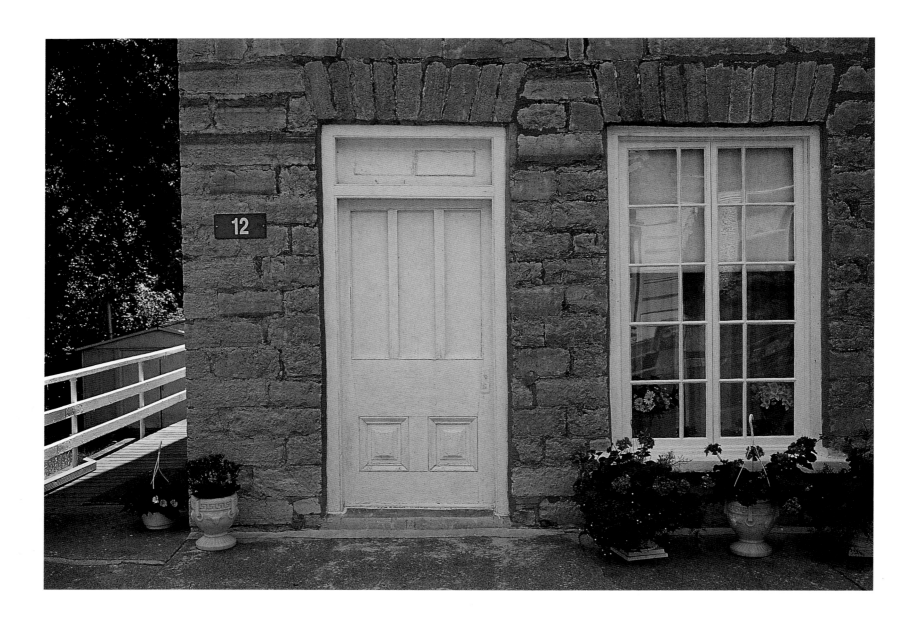

Eakins House

Newburgh

Newburgh, nestled into the steep valley of the Napanee River, was settled in the 1820s and was probably justified in thinking its future looked bright. For a time, it was a magnet for industry, largely on account of the abundant sites suited to harnessing waterpower. But the boom went bust when early railway development bypassed the village and a devastating fire in 1887 sealed its fate for good.

This little house on the bank of the river was built about 1855, during Newburgh's heyday. The separate entrance on the façade suggests that some of it was devoted to commercial use, and sure enough, early deeds reveal that the property was owned by a tailor for many years. The house aspires to grandeur with its well-proportioned doorcase, but the most notable feature is the eaves, not made of wood but laid in stone. A number of local structures have the same highly unconventional detail.

Bickle House

Stirling

There was no need for C.F. Bickle to tell his neighbours he was a man of means. His house said it all for him. An oversized tower a full three storeys high announced his status in the community better than any calling card. Take it away, however, and the house is not unlike many another late-Victorian dwelling.

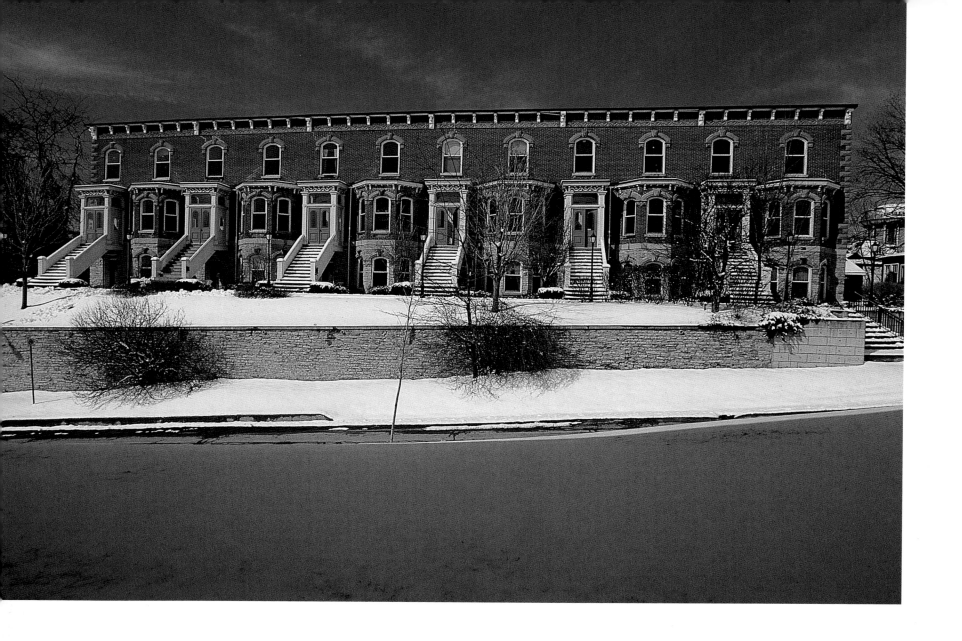

Bellevue Terrace

Belleville

Row housing seems a little at odds with the Canadian architectural legacy, considering ours is thought to be an uncrowded land of wide-open spaces. Nevertheless, terraces were often the rule in older towns, and not all were the "starter homes" we tend to consider them today. Some, in fact, were quite lavish, including Belle-vue Terrace, a six-unit row built in 1876 across the street from the local courthouse. Hand-somely appointed with bay windows and smart detail, they were the work of architect James A. Davis. Each unit was built on a raised basement that housed the kitchen and dining room; the main floor was reserved for receiving guests, while upstairs were ample bedrooms and a bath-room. In recent years, the terrace was subdi-vided into smaller apartments, but few clues on the exterior suggest any changes.

Vanderwater House

near Foxboro

It's only natural that a place settled by Americans would give away its Yankee heritage somehow, and in the Bay of Quinte region, the American accent shows in the placement of the woodshed and summer kitchen at the side of the house. To put such a utilitarian structure in plain view was a little overt for the genteel English, who were inclined to sequester these workaday functions to the rear in a tail. But such was the custom in upstate New York and New England, where many of the Quinte Loyalists originated, and it followed them here. Today, the "Yankee wood-shed" is a defining feature of the old architecture in Prince Edward, Lennox and Addington and Hastings counties, all settled by ex-Americans.

This house, sure enough, has an American pedigree. The Vanderwaters hailed from Dutchess County, just above New York City, from which dozens of prosperous families were displaced during the American Revolution. They first settled on Hay Bay, then moved north of Belleville to this farm in the 1820s. The family has remained here ever since. According to stories passed down through the generations, the woodshed is actually the oldest part of the house; a formal wing was added in Victorian times. The newer work is marked by a hand-some vestibule, another local trait (see the Hubbs House, page 31), and a graceful bow-roofed verandah that measures 120 feet and wraps around most of the building. Perched on a knoll and shaded by a grove of locusts and spruces, the house is greatly enhanced by its unspoiled setting.

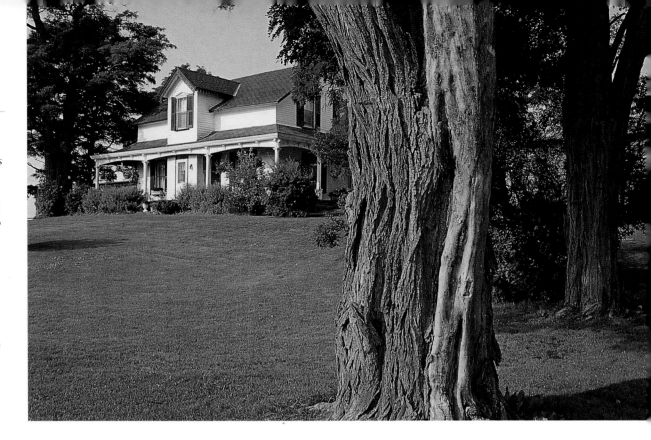

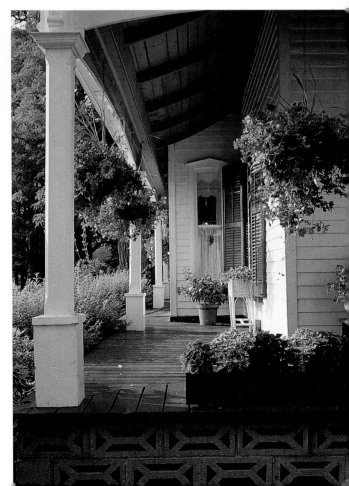

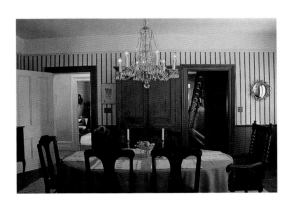

Left: All doors lead to the dining room.

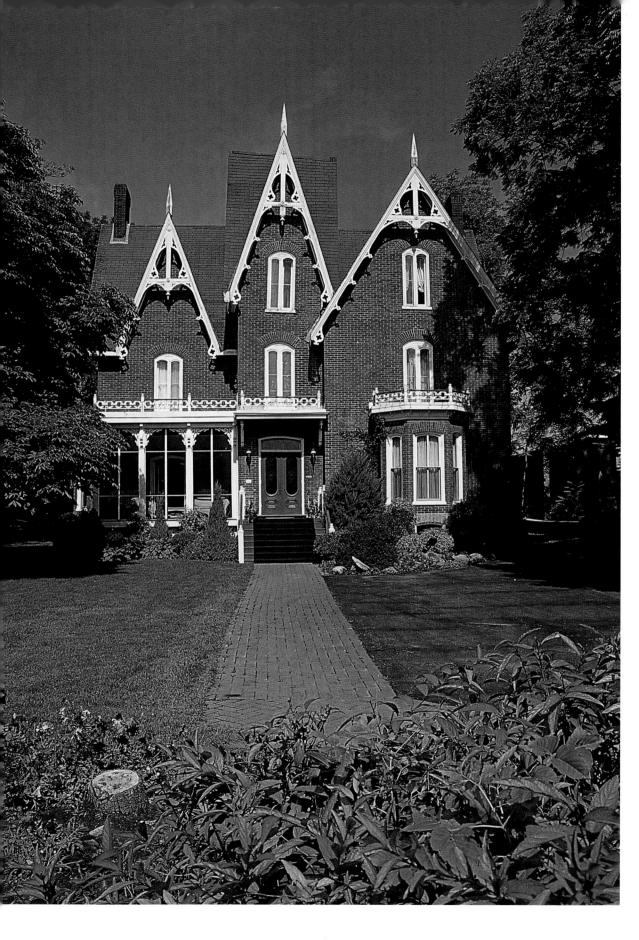

Merrill House

Picton

By the 1870s, the eastern stretch of Picton's main street had emerged as the most fashionable address in town. Amid the grandeur of so many doctors' and lawyers' residences, one house stands out as the most exuberant architectural display in the neighbourhood. The Merrill House, built in 1878, upstages all the others.

The house might be described as half Gothic and half Italianate. The precipitously steep gables—11 of them—are a mark of the former, but the basic shape owes more to the Italian tradition. Take a look at the Parker House in Woodstock (see page 94), and you'll see the prototype on which the Merrill House could easily have been based.

Benjamin Smith House

near Belleville

In an 1878 biography, Long Island-born Benjamin Smith was described as "perhaps as great a sufferer in the matter of confiscated property as any who bore the United Empire Loyalist name." But judging from his house, built about 1820, he wasn't destitute for long. Not only is his a substantial dwelling, but in its day, it was as stylish as any. The double-pilastered doorcase is particularly graceful. When the house was new, the verandah and sunroom weren't yet in the picture, nor were the miniature brackets under the eaves. These appeared during renovations in the 1860s.

The house was the showpiece of a little Smith dynasty in a milling community at the base of a cliff on the Prince Edward County side of the Bay of Quinte. The neighbourhood was officially called Smith's Mills but was better known as Gomorrah. It was just down the road from a larger village that had earned the nickname Sodom.

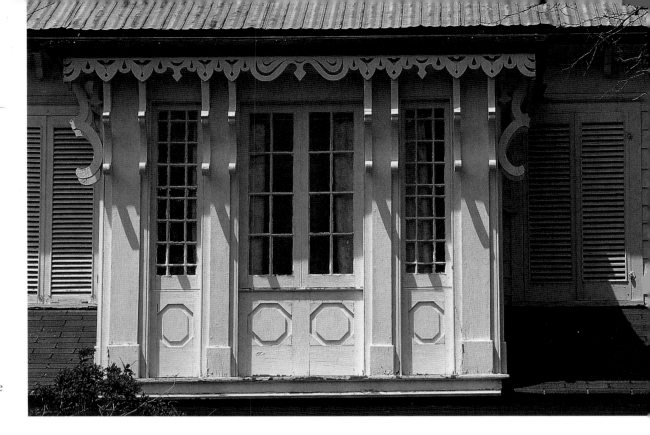

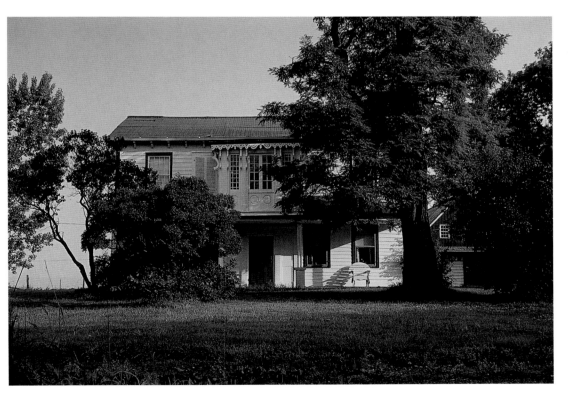

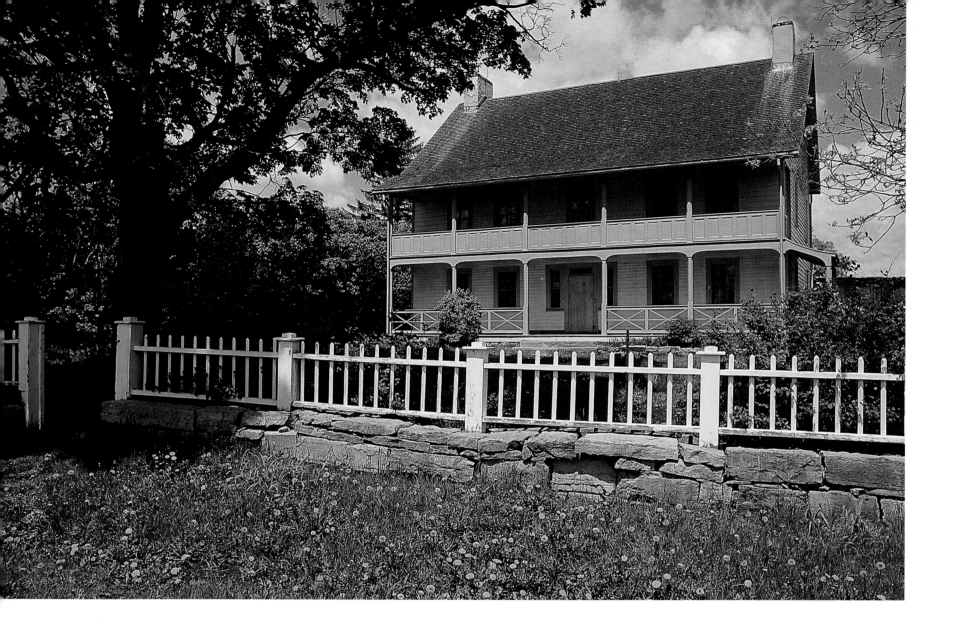

Fairfield House

Amherstview

To some eyes, the Fairfield House just west of Kingston looks positively Québécois in light of its precipitously steep roof and the way the flared eaves give way to the verandah. On a true habitant homestead, however, the transition from roof to verandah would have been a smooth curve, so it is more correct to say that the house is simply an example of a steep-roofed Georgian, a type peculiar to the very oldest dwellings in the province. After about 1810, architectural fashion favoured a much gentler pitch.

What is most remarkable about the house is its early date. Built in 1793 by a Vermont Loyalist named William Fairfield, it is one of only a handful of identifiable 18th-century houses in Ontario. That it is so well preserved after more than 200 years is astonishing.

44

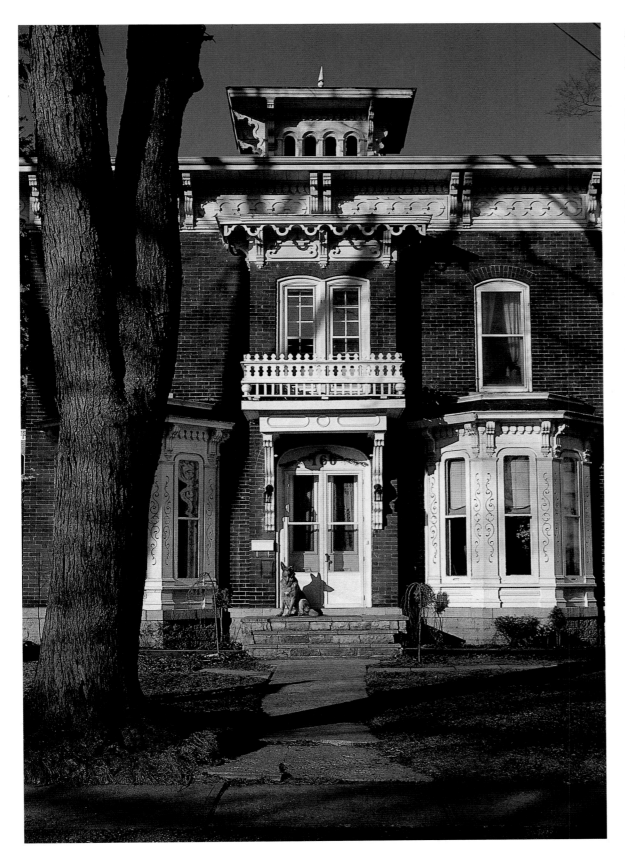

Alexander Smith House

Napanee

A more picturesque site would have been more poetic, but even though it stands on an ordinary town lot, the Alexander Smith House shines as a triumphant exercise in Italianate finery. It deviates from the prototype, for it lacks a tower and the façade is symmetrical (see Parker House, page 94). Nevertheless, its origins show in the slender windows and cube proportions, not to mention the bracketed cornice, a signature of the Italian style. From there, the house sets its own course with a splash of richly decorated detail of which the rooftop belvedere is the crowning glory. The layer-cake look makes it easy to lose sight of the fact that underneath all the fanfare lurks the ages-old centre-hall plan.

Researchers presume the builder was Alexander Smith, who bought the property in 1870. The house leaves no doubt about the owner's means and status.

Hayes' Tavern

near Picton

Restored to the letter with authenticity in mind, this handsome residence offers no clue that it stood derelict in the 1960s. Nor are there any reminders that it now stands a long way from its original site.

When new, circa 1838, the timber-frame house was actually a hotel, the finest ever built in Consecon, a milling village in the far western corner of Prince Edward County. Like many buildings of similar vintage (see Sovereign House, page 134), the basic shell recalls the Georgian Neoclassic tradition, but the trim has a decidedly Greek Revival flair, particularly the boldly executed cornice. In its day, the tavern was the social hub of the village, dependent largely on the business of local farmers coming to mill. But when the mill began to fail, Hayes' Tavern suffered the same fate as many a small-town inn. When local option voted against the sale of liquor, its fate was sealed.

The hotel stood abandoned and open to the elements for years but was rescued by a heritage enthusiast who dismantled it piece by piece, la-belled the parts and re-erected it on a new site at the opposite end of the county.

46

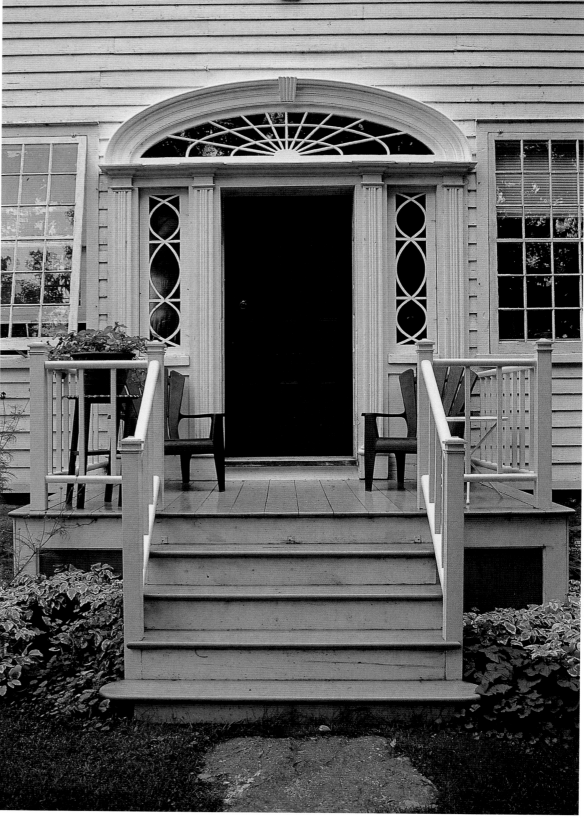

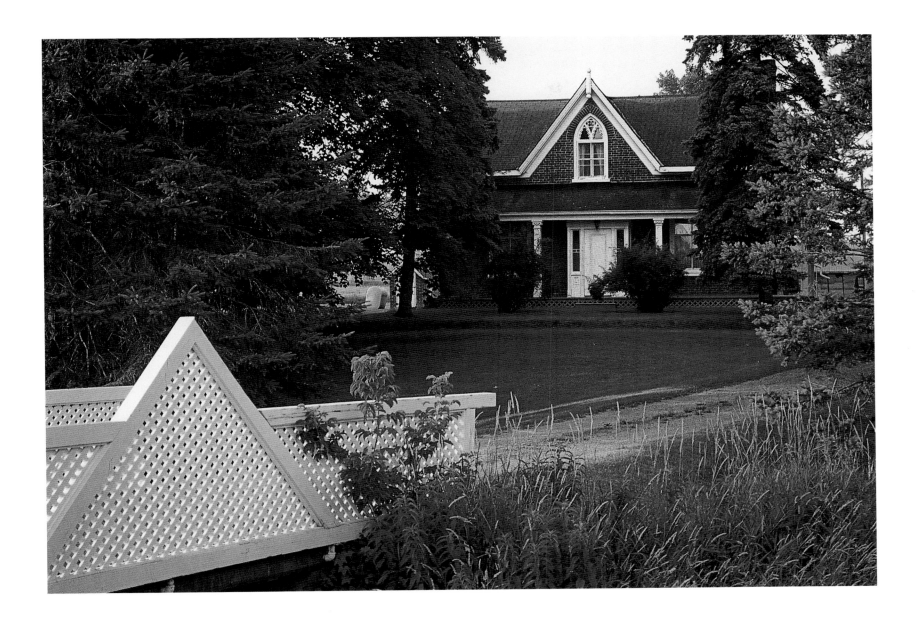

Lambie House

Bloomfield

There is something polite about this handsome brick dwelling that watches the world go by from behind the millpond creek in the heart of Bloomfield. Never ostentatious but not without ambition, it is blessed with pleasing proportions, and although the detail is abundant, it is restrained, save perhaps for the intricacy evident in the stylish gable window. Curiously, the front door is slightly off-centre.

Its early history is obscure, but the house could have been the work of Andrew Lambie, a carpenter who bought the property in 1858.

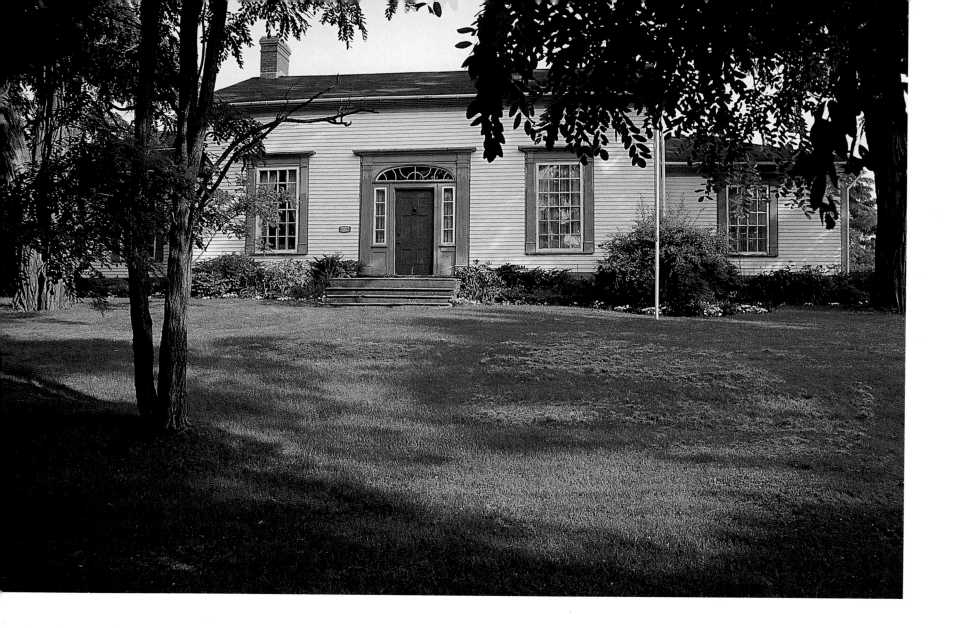

Davey House

Bath

48 When the Ontario architectural legacy first became a cause célèbre around centennial year, the Davey House was often cited as an example of the dire fate that awaited many of the province's best early houses. Slowly decaying into the ground, the circa-1820 dwelling appeared to be a lost cause. Fortunately, it was rescued and rehabilitated by historically minded owners. They recognized the significance of its basic form—the plain Georgian façade accented by two lesser wings—and the impeccable trim. The doorcase alone is superb.

Miller House

Newburgh

Wedged into the side of a hill so that the basement opens at grade, this circa-1853 stone house isn't as big as it looks, nor is it particularly fancy. But it has good "bones," pleasing proportions that more than compensate for a dearth of detail. Nevertheless, the casement windows and verandah add immeasurably to its character. The masonry bears the golden honey tint that characterizes many of the stone buildings in the Napanee River valley.

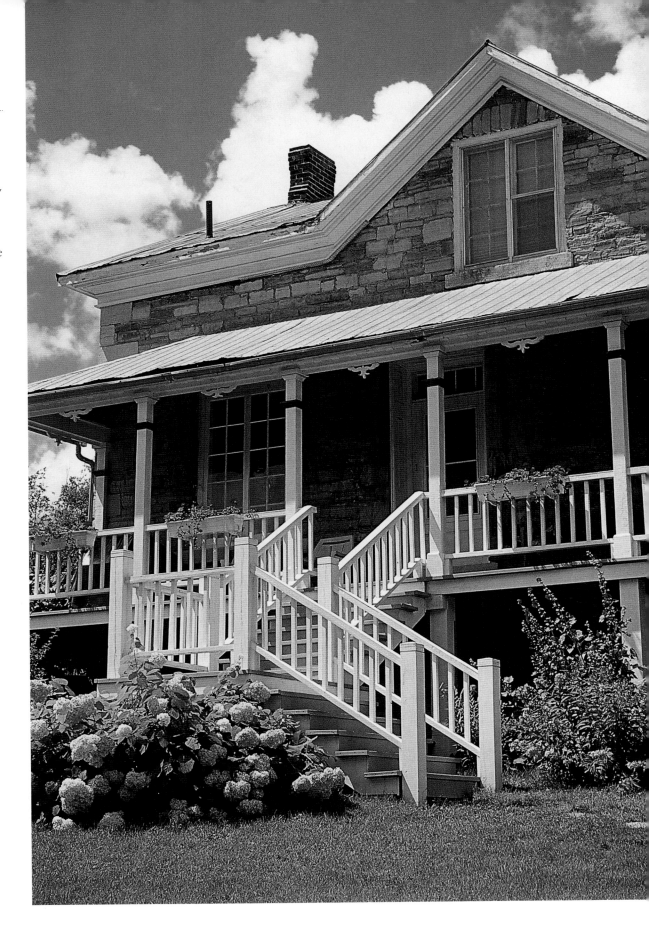

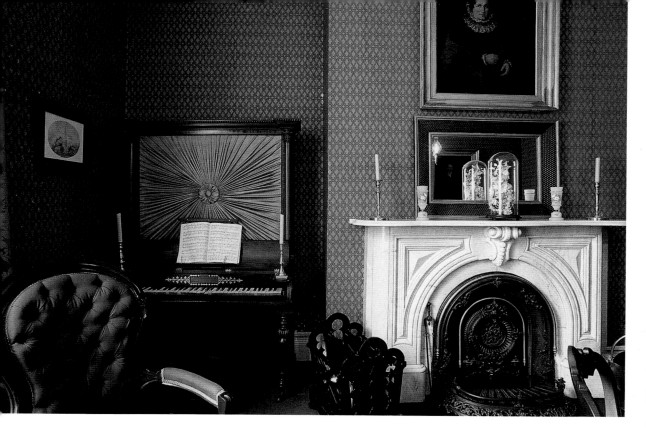

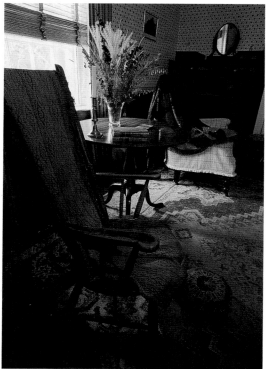

Top left and right: Furnishings date from Reverend Macaulay's second marriage in 1853.

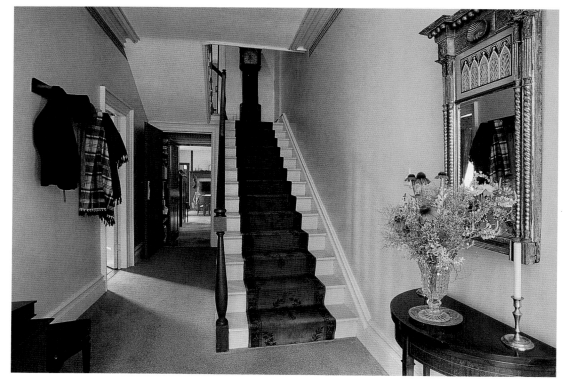

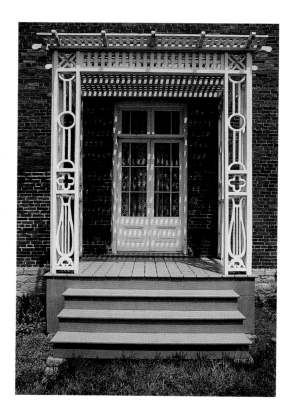

50

Bottom left and right: Stairway is typical of pre-Victorian era; a Regency-style trellis was part of Macaulay's 1850s renovations.

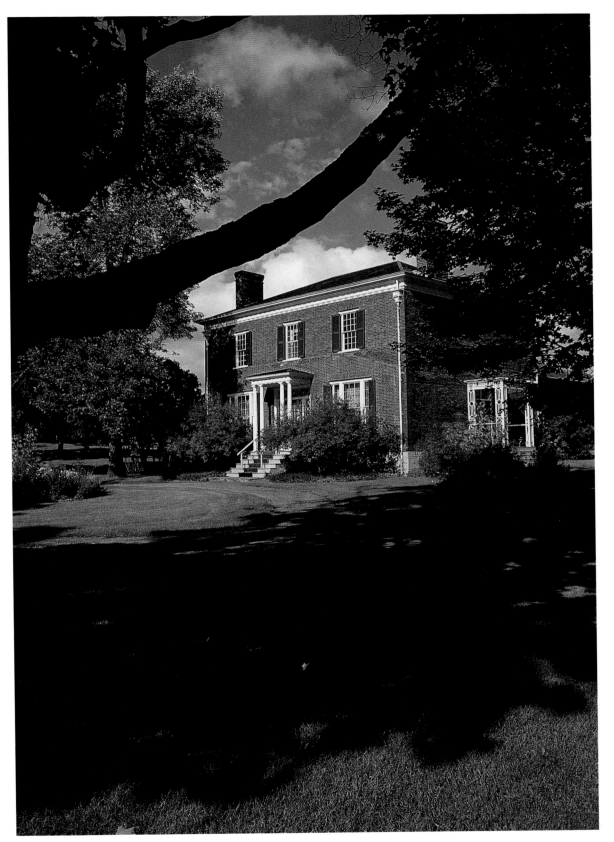

Macaulay House

Picton

As founder of the local Anglican congregation, the Reverend William Macaulay was Picton's spiritual leader in its early days. He was also a wharfinger, miller and landlord who, as son of a United Empire Loyalist, was granted much of the land on which the town would grow. Not only did he survey the streets, he also donated land for the county courthouse and two churches. Nevertheless, his fortune was not secure. Motivated more by paternalism than by profit, he sold some lots at fire-sale prices and forgot to collect the rents on others. Meanwhile, his dream project, the construction of the Anglican church, strained his finances severely.

Another endeavour that proved to be a financial burden was Macaulay's rectory, which he built next door to the church around 1830. At the time, there was arguably no finer house in the county, and today, it positively shines, with its Georgian proportions and intricate trim. The cornice mouldings alone stand out as a textbook example of the newer, lighter accents for which only the most stylish houses of the 1820s and 1830s would be known.

But good taste did little to enhance Macaulay's business affairs. Frustrated, his brother John threw up his hands and wrote, "He has some great project on hand which he will, of course, as usual, abandon when found impracticable." John was eventually granted power of attorney, leaving William free to "attend the duties of his sacred calling more sufficiently." At that, William succeeded admirably, presiding over Picton's religious and social affairs for the rest of his life. His church is now a museum, and the rectory has been restored to represent domestic life in the pre-Confederation era.

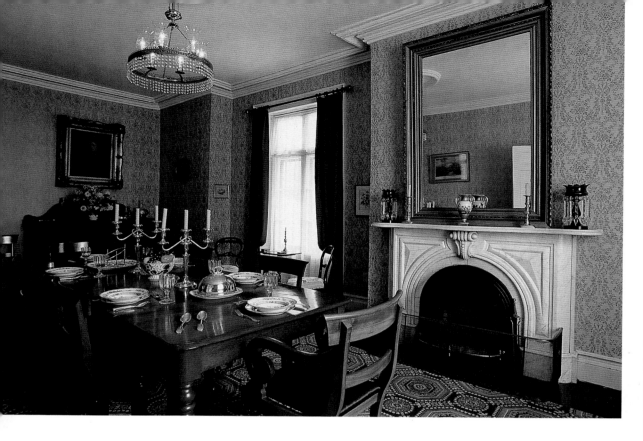

Clockwise from top left: High style in the dining room; the sitztub in the upstairs dressing room; and a linen press, canopy bed and fireplace in the bedroom.

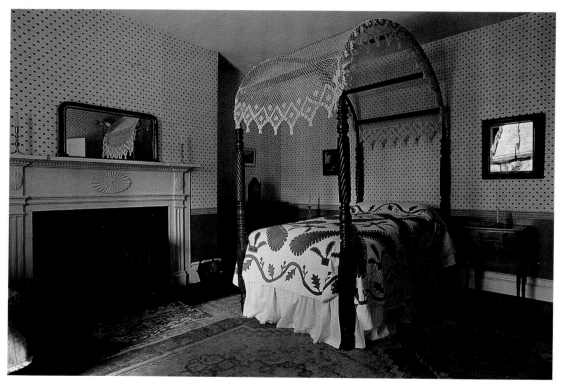

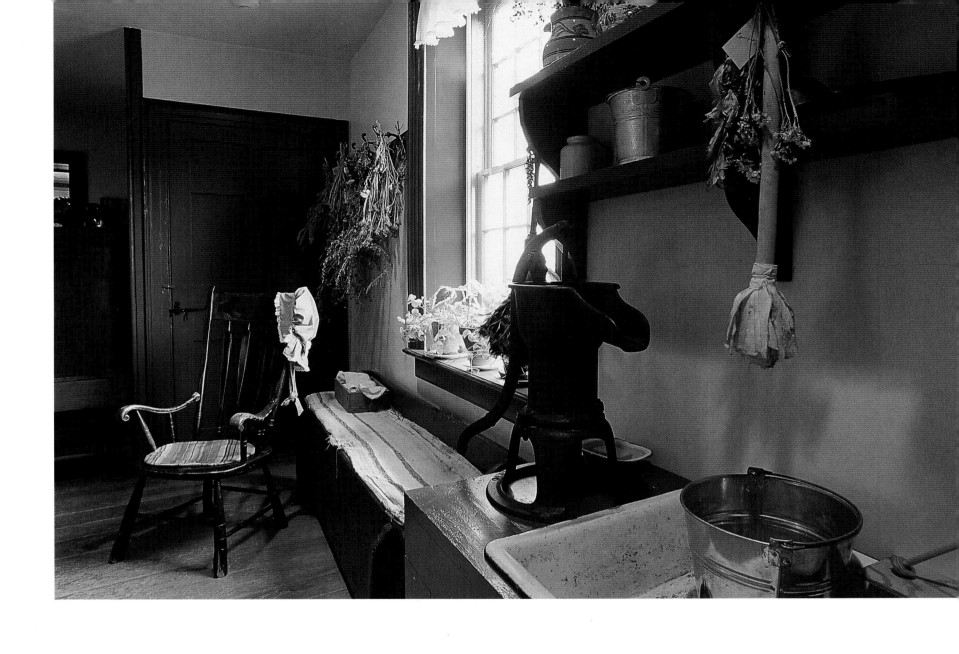

Above and right: The kitchen and summer kitchen are decidedly utilitarian rooms.

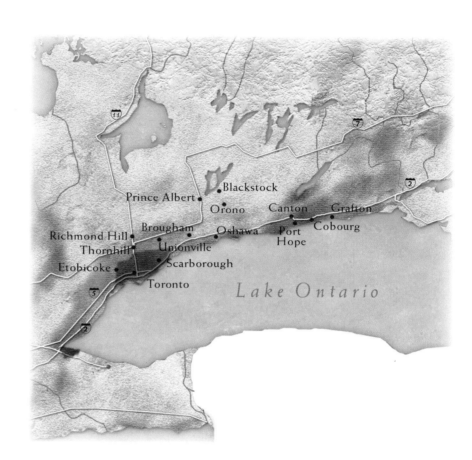

Blackstock

Prince Albert

Orono

Canton Grafton

Brougham Cobourg

Oshawa Port

Richmond Hill Hope

Unionville

Thornhill

Scarborough

Etobicoke

Toronto *Lake Ontario*

DANFORTH ROAD

The north shore of Lake Ontario is and always will be dominated by Toronto, but in the early days, when the city was known as York, there were other contenders in the race for economic supremacy in the region. Whitby, Port Hope and Cobourg were among the lakeside towns that tried, but none really had a hope of beating Toronto. After all, it had several advantages: It was the terminus of an ancient trade route from Georgian Bay, but most important, it was handpicked by Upper Canada's first lieutenant-governor, John Graves Simcoe, as the new capital.

More than any other person, Simcoe left his mark on the development of Ontario. He was shrewd in choosing Toronto, for he knew the capital would attract settlement on the Canadian side of the lake, filling the gap between the established townships at Niagara in the west and the Bay of Quinte in the east. His goal was to solidify the British claim to Upper Canada, but his influence was far more profound in the long run, for it was he who single-handedly determined the direction in which the province would develop.

Even Simcoe could never have imagined that Toronto would, in a short century and a half, balloon into a metropolis of international renown. But the city has paid a price for prosperity. Much of its architectural heritage has disappeared, and as its suburbs spread ever farther west, north and east, the towns in their path were swallowed whole. Here and there, a classic gem remains unscathed, and the city itself is home to some impressive early-20th-century houses, but the best architectural assets in the area are the old communities that still thrive despite the pressure to redevelop. Fortunately, there are places only an hour east of Toronto that seem to have more in common with the 19th century than the 21st. Drive along the Danforth Road (Highway 2), the military road initiated under Simcoe's direction, and see for yourself.

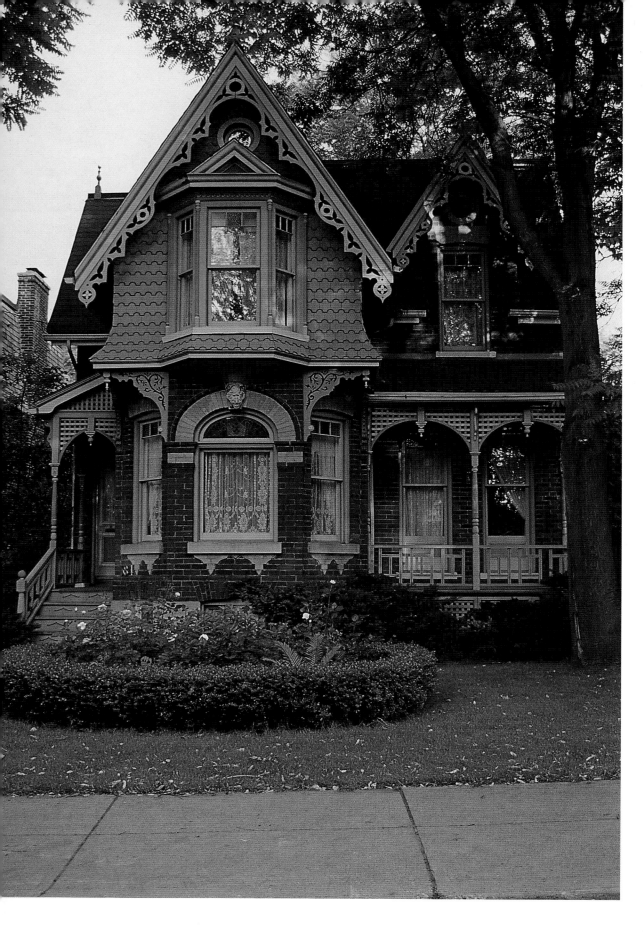

Hill House

Toronto

Architectural critics have been known to take a verbal hatchet to the houses of the Victorian era, but even the most jaded would concede that if the Hill House is an example, sometimes the vernacular builders of the late 1800s got it right. The house, in the heart of Cabbagetown, was not architect-designed, but it shows a lighter and more vivacious side of Victorian eclecticism. It might have failed were it not for the sheer exuberance and abundance of detail. The fun starts with the gingerbread that drips from the gables and carries into such fanciful touches as scalloped shingles, polychromatic masonry, an oriel window (in the upper-storey gable), extensive latticework and delicately turned verandah posts. The list goes on, but suffice it to say that this has to be one of the most playful architectural essays in the entire province. That it has been restored with fanatical attention to detail—the exterior trim boasts no fewer than 18 shades of paint—is the pièce de résistance.

The house is thought to have been built in two stages. Most of the decorative elaborations arrived when the house was extended forward in the 1880s. It was in the Hill family for generations.

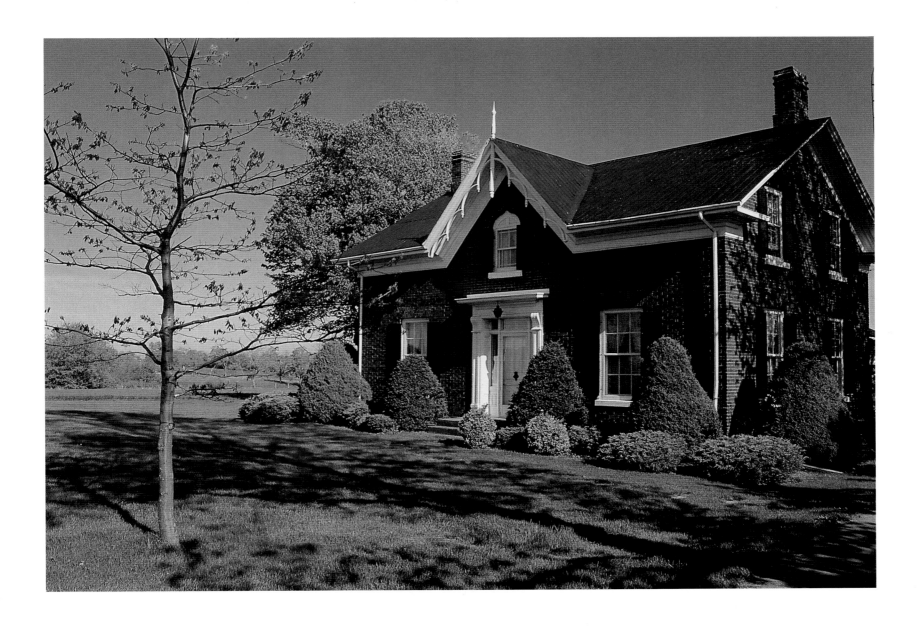

Burk House

near Oshawa

For a hundred years, this handsome farmhouse stood in a pastoral farm setting; today, the parlour looks out over the droning Highway 401, but despite the rush of speeding traffic, its handsome silhouette and fine detail persevere. The house, built about 1860 by Samuel Burk, has exemplary proportions accented by a smart cornice, gingerbread icing and a striking doorcase. The jewel in the crown is the front gable's ogee window, which comes to a more pronounced point than the conventional Gothic.

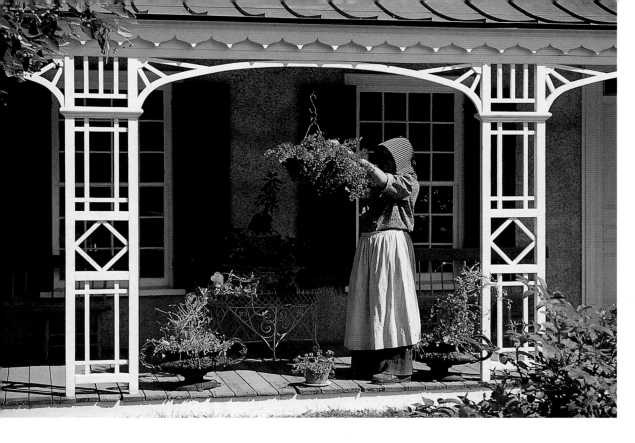

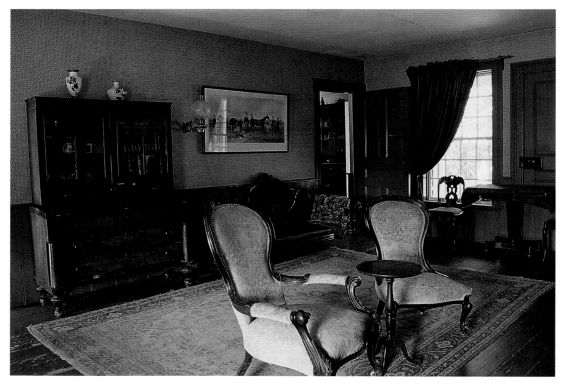

Above right: The surgery depicts a doctor's life around the time of Confederation.

Above: Parlour furnishings adopt a Victorian air.

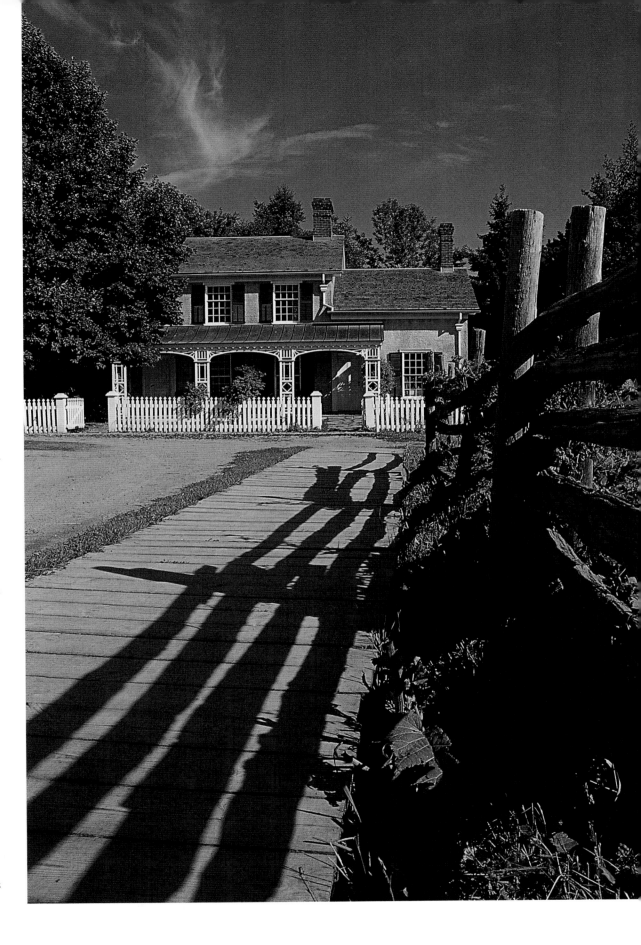

Doctor's House

Black Creek Pioneer Village
Toronto

In the late 1960s, the museum at Black Creek was looking to expand the scope of its collection of vintage buildings to include a house that could be restored to represent the life of a country doctor. Although no doctor had ever lived in it, no better house could have been chosen than the old 1830s James place in Chinguacousy Township. Neither too showy nor too pedestrian, the house strikes the right note for an interpretation of the role of the medical man in Confederation-era life. What's more, the façade has two doors—one opens to the living quarters and another to a separate room that's ideal for a doctor's dispensary.

The house would probably not have survived much longer had it been left on its original site. Shorn of its verandah and clad in Insulbrick asphalt siding, it would only have been a matter of time until it was bulldozed for the expanding suburb of Bramalea. The restoration was made all the more accurate when a James descendant came forward with an old tintype photograph showing the extent and stylings of the verandah. A little Regency, a little Greek Revival, this singular house is a real gem.

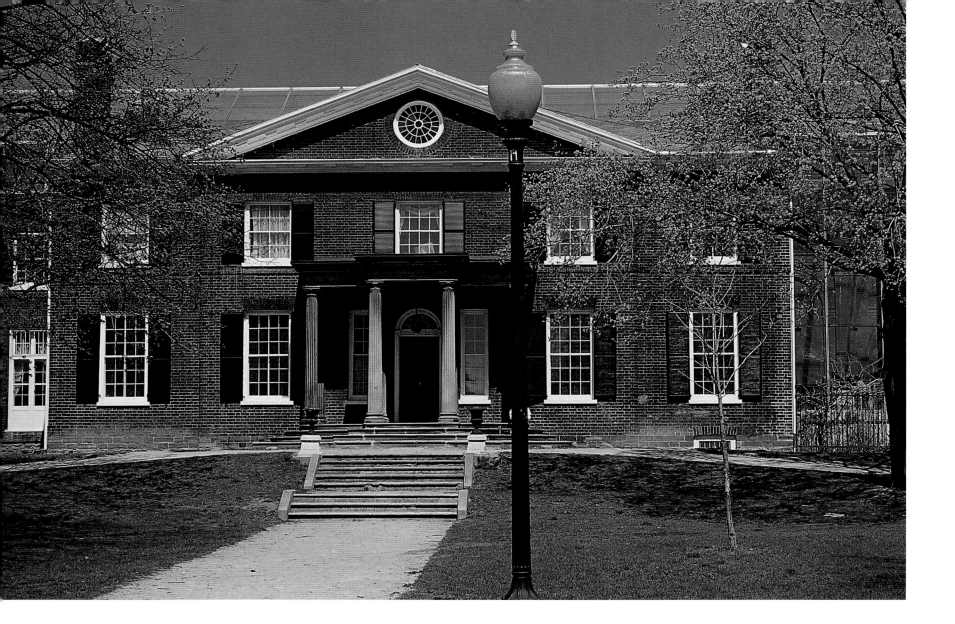

The Grange

Toronto

Creditors were banging on the door in 1846 when William Henry Boulton did some quick thinking to save his home, known as the Grange. One of Toronto's oldest and finest estates, it was built about 1818 by Boulton's father D'Arcy, a merchant who was firmly established in the Upper Canadian elite. As a prominent business-man and mayor of Toronto, the junior Boulton similarly honoured the family, but when his land-speculation deals turned sour, he hastily conveyed title to the Grange to his fiancée Harriette Dixon.

Harriette outlived her husband and married

again, the second time to Goldwin Smith, the celebrated journalist who advocated union with the United States. When she died, she left the Grange to the newly formed Art Gallery of Toronto. This marked the beginning of the Art Gallery of Ontario and the Ontario College of Art, both of which have since dwarfed the old house with modern institutional buildings. Nevertheless, the Grange still shines as a museum, restored to represent the privileged life of the Boultons in the 1830s.

The Grange is one of only a handful of Toronto landmarks past the 180-year mark, and

few other local houses were better candidates for restoration. It is also one of the most stylish, with understated Georgian lines enhanced by Neoclassic detail. For the sake of authenticity, some interior "improvements," including Gold-win Smith's square Victorian staircase, were removed in favour of replicas more in keeping with the originals. One look at the sweeping curve of the facsimile staircase speaks volumes about the elegance enjoyed by the upper classes in early Upper Canada.

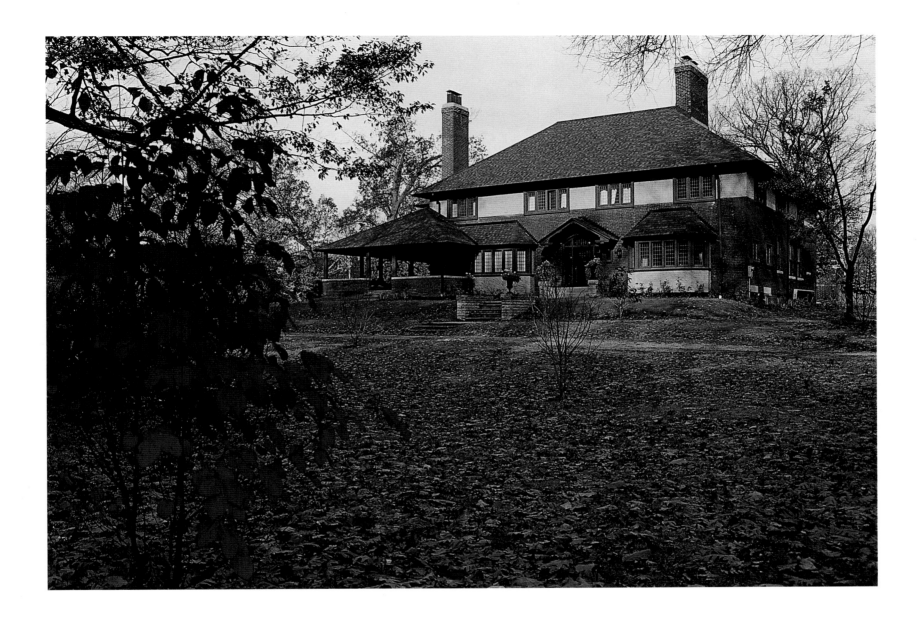

DuVernet House

Toronto

The early 20th century was a progressive era that put its faith in the future. All the decorative arts, from fashion to industrial design, followed suit, and so did commercial architecture, which literally rose to new technological heights with the advent of the modern skyscraper. Residential architecture, however, was another story. In 1906, when architect Eden Smith built this house in Wychwood Park, Toronto's toniest homebuilders were more apt to take their cues from the distant past—all the way back to mediaeval England, in fact. Progress was fine for office towers and factories, but at home, Torontonians preferred something more traditional.

Eden Smith designed scores of English-cottage-inspired residences, but with its imaginative use of gables and chimneys, the house he built for lawyer E.A. DuVernet is one of his best. There could have been no better site than Wychwood Park, a wooded central-Toronto enclave that began as an artists' colony. In the sylvan setting, you'd never know you're only a stone's throw from Bathurst and Davenport.

61

Mill House

Canton

As proprietor of the business upon which most of Ontario's villages were founded, the miller was often the most important and influential person in the community. He was also the wealthiest. If you're new to a village, you can often pick out the miller's house because it is the largest and the fanciest. Such is the case in Canton, just north of Port Hope, where the Mill House, as it is now called, has no rival. When it was new in the 1850s, its irregularly shaped façade was rather novel, and its wealth of lacy bargeboard trim, not to mention the informal appeal of the board-and-batten construction, helped it to shine as the handsomest house in town. And so it still is today.

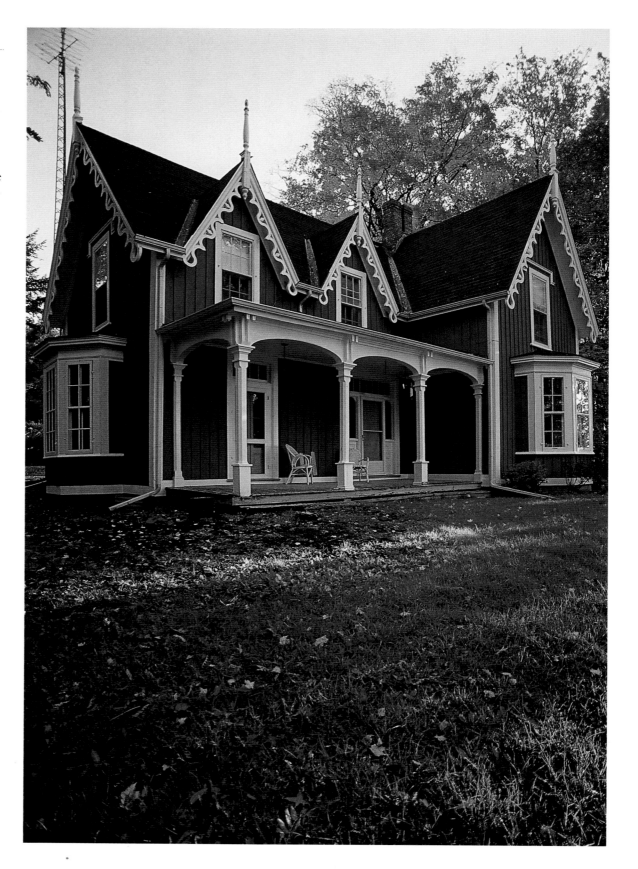

Danforth Road

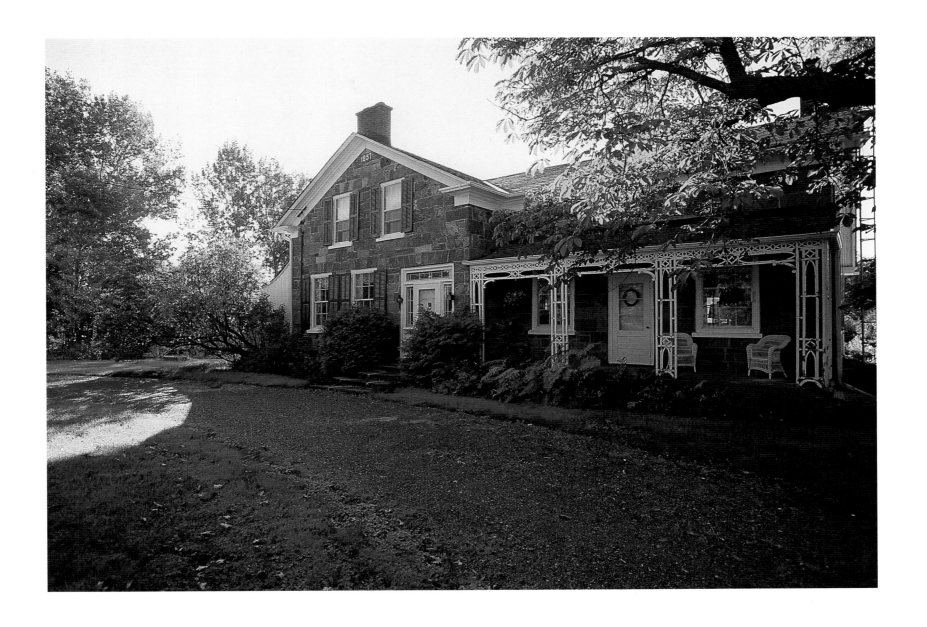

Sunnyside

near Oshawa

Sunnyside, built by Abram Varnum, is perhaps the best in a line of distinctive vintage farmhouses, several in stone, along the seventh concession of Darlington Township. It steals the show with its crisp, clean proportions and excellent state of preservation. Neither humble nor pretentious, the house displays good country manners without putting on airs. The alignment—gable to the road, front door in the corner—is unusual, but it is the details that really catch the eye: the coursed rubblestone, the generous windows, the trellis verandah and the 1857 date stone in the gable.

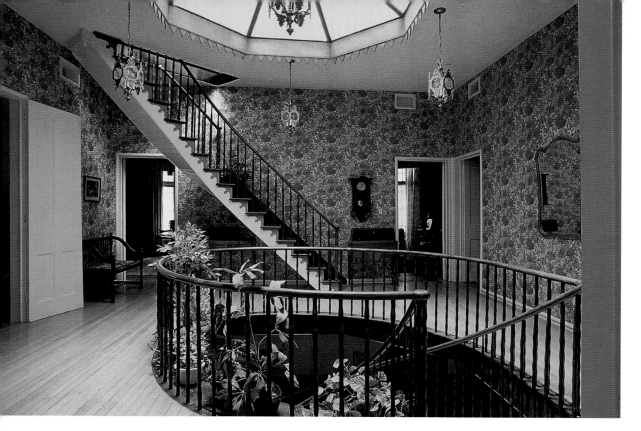

Barrett's Octagon

Port Hope

Phrenology, the study of human behaviour based on the shape and dimensions of the skull, would seem far removed from domestic architecture, but not to Orson Squire Fowler, a writer from upstate New York who applied phrenological principles to house design. In his 1849 book, *A Home for All*, he advised that the shape of a home was crucial to the well-being of its occupants and that only a circular or polygonal house could ensure personal happiness. Whether he was believed or not, Fowler inspired a whole generation of housebuilders, for before the fad had passed, Ontario boasted at least 45 octagonal houses, not to mention dozens of polygonal barns, schools and a jail or two. Good examples still stand in Hawkesbury, Bracebridge (see page 202) and Maple. Picton has two.

The best of the genre is probably the house built by Port Hope miller and business baron William Barrett, Jr., in 1856. Wedged into the side of a riverbank, it is large enough to avoid the cumbersome interiors that typically plague octagons, and its two-tiered verandah adds a decidedly graceful element. In its original guise, the roof was flat, which made the cupola all the more prominent.

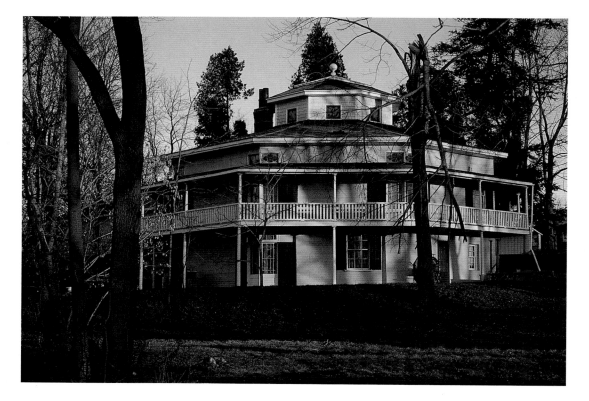

64

Top: Lit from the belvedere above, the hall is flooded with light. The eight-sided concept lends itself to an unusual arrangement of rooms.

Smith House

Port Hope

Much about this house invites comparison with the MacDougal House in Niagara-on-the-Lake (see page 123). Both are representative of an urban type of dwelling that owes much to the Georgian principles of balance and symmetry. They display their city manners not only in their side-hall plans, which make the most of narrow urban lots, but also in the tall parapet chimneys that guard against the spread of fire from neighbouring buildings.

The early history of this house is obscure, although the Smiths, Port Hope's leading tycoon family, are thought to have had a hand in building it. The exact date has never been uncovered, but the chinoiserie styling of the transom and sidelights suggests it was constructed in the 1840s. Long ago, the house was divided into apartments. Its exterior recently restored, it stands as proof that a house converted to multi-family use need not sacrifice its heritage.

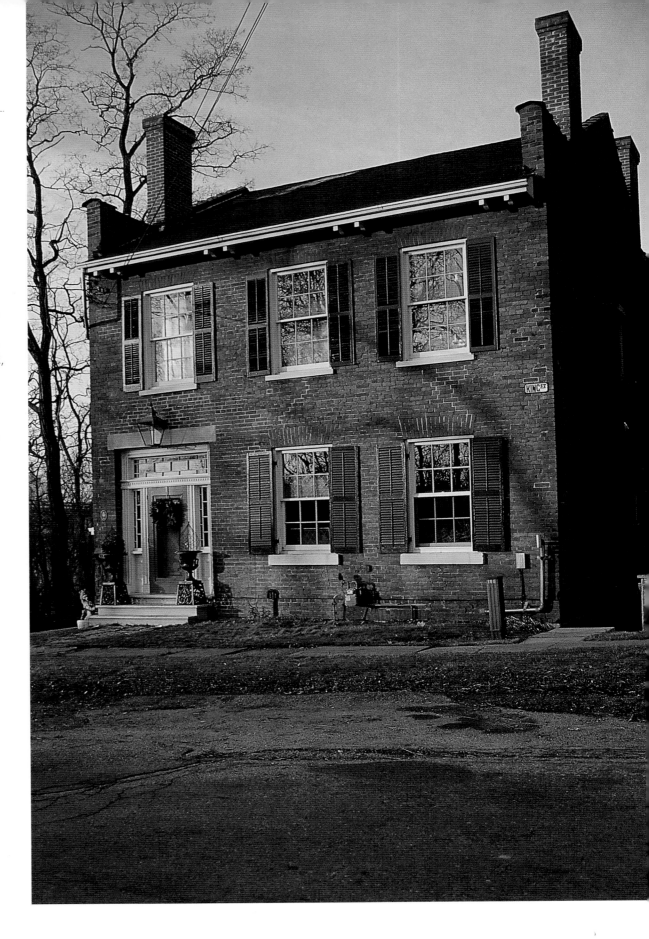

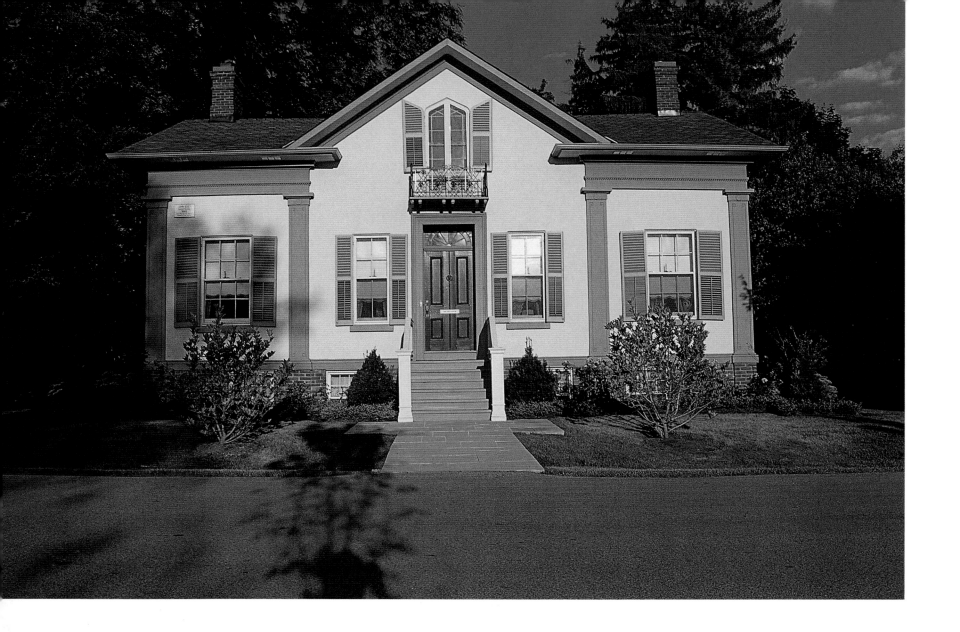

Edey House

Thornhill

John Edey left his mark on the old village of Thornhill as the carpenter responsible for several local landmarks, including St. Vladimir's Church. His own house, built in 1845, was obviously a labour of love, its diminutive proportions enhanced by pilasters and a handsomely defined cornice. The house would have been lost to the widening of Yonge Street had it not been moved out of the way in the early 1970s to a new site in a residential neighbourhood. It remains an exemplary essay in vernacular architectural composition.

Danforth Road

Doctor's House

Blackstock

This brick house obviously takes its cues from the villas of Tuscany (see Parker House, page 94), whose evocative stylings were the height of fashion in Confederation-era Ontario. Although it deviates slightly from the standard pattern in the placement of the watchtower and in the verandah's interruption of the upright proportions so characteristic of the genre, the house has an undeniably imposing presence. A Dr. Montgomery built this house in the mid-1870s, and a doctor's house it remained until 1966. The door at the long end of the verandah led to the medical office.

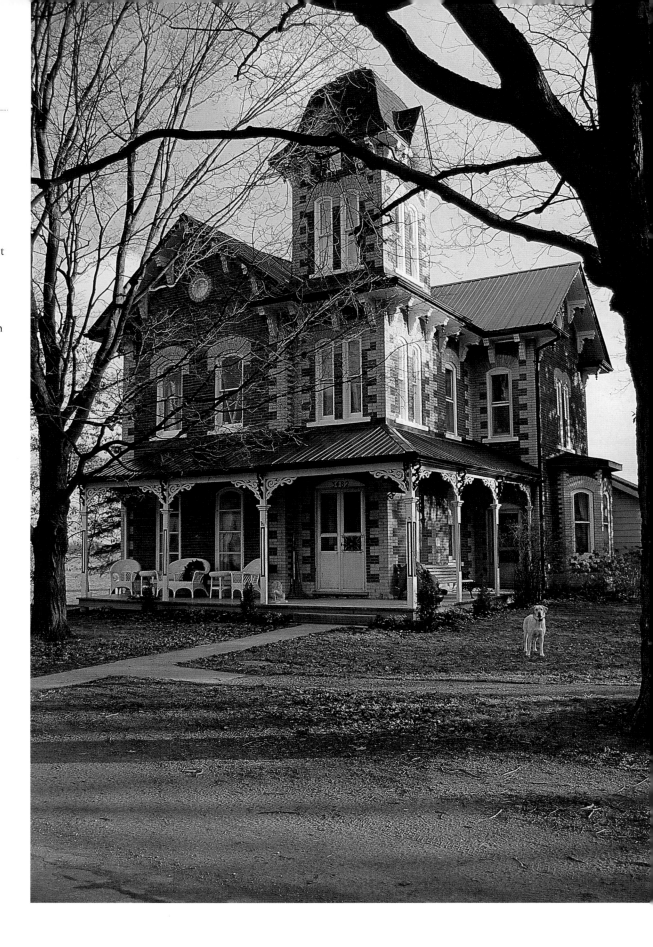

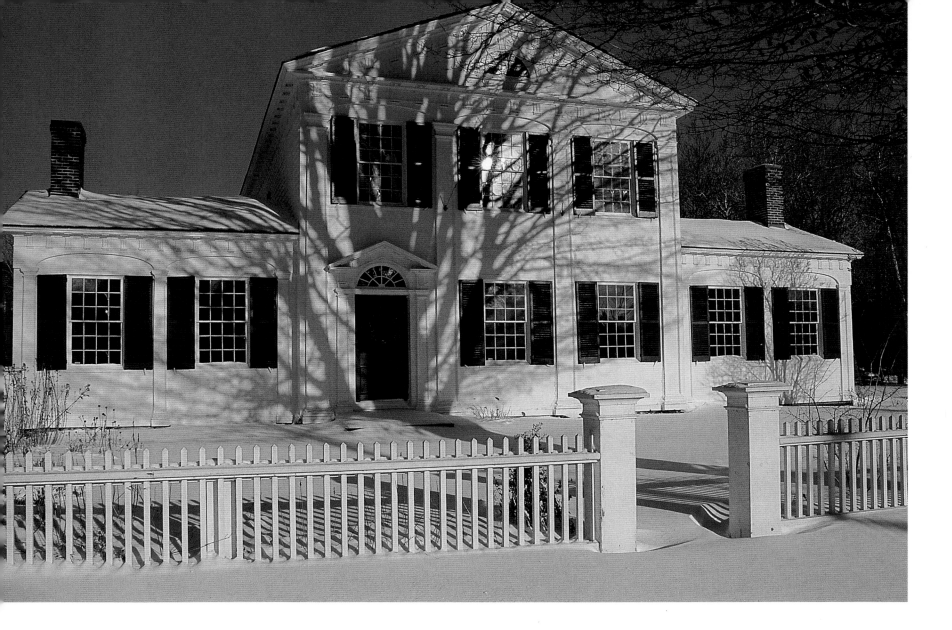

Barnum House

Grafton

"There is no house of similar size and material in the United States that is the superior of the Barnum House at Grafton." Eric Arthur, a professor of architecture and an early preservation activist, penned these words in 1938, and the accolades have been pouring in ever since. There is hardly a text on early Ontario architecture that fails to mention the Barnum House with its arresting architectural presence and superb craftsmanship.

Built about 1820, the house represents the pinnacle of good taste during the Loyalist era. Like Poplar Hall near Maitland (see page 25), it still has the good manners of the Georgian tradition, but where older houses were self-consciously plain, the Barnum House blazed a new trail with its wealth of ornamental details. Many of them—the triangular pediment across the façade, the arcaded pilasters, the cornice decoration—were borrowed from ancient Greek temples. Likewise, the basic plan—a grand two-storey centrepiece with lesser wings to the side—was also inspired by classical Greece. Today, homes of this type are sometimes called temple houses.

Architectural fashion would later take the Greek influence to new heights (see Crysler Hall, page 15), but when it was new, the Barnum House was on the leading edge of style. It's no surprise that it was built by a man of considerable wealth. Eliakim Barnum presided over 5,000 acres in and around Grafton and owned a local mill and distillery. Perhaps it's also no surprise to learn that he was an American, for similar temple houses were well known in upstate New York. They are rare in Ontario, although two other examples can be found nearby.

The façade is noted for its innovative use of flushboard. Unlike clapboard, flushboard has invisible seams between the siding planks, creat-

68

Below: The working kitchen; bedroom opening to smaller slip-rooms.

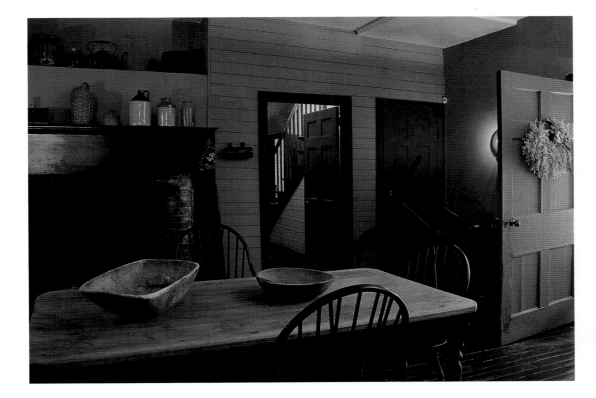

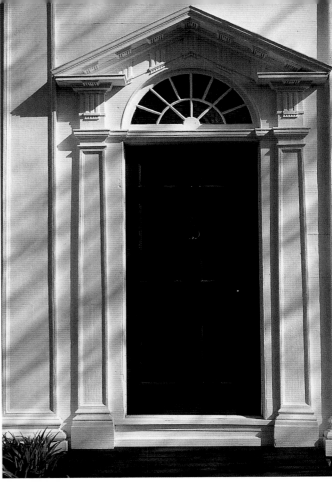

ing a smooth appearance that "in spite of exposure to the weather," wrote Professor Arthur, "shows few cracks between the boards." But when the Ontario Heritage Foundation took over the property in 1982, time had taken its toll on the rest of the building. The sill beams and stone foundation required $100,000 in restorative work. Later, a new wing was added to the rear, and today, the venerable old house functions as a museum and community centre.

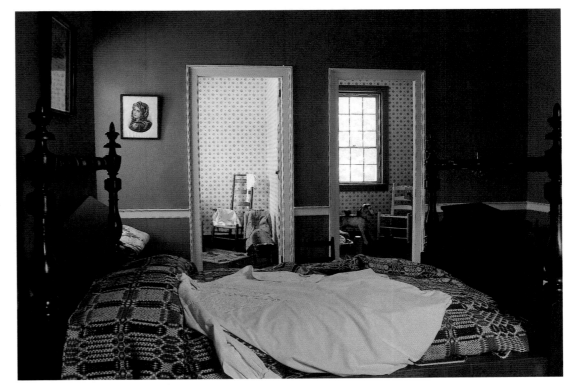

69

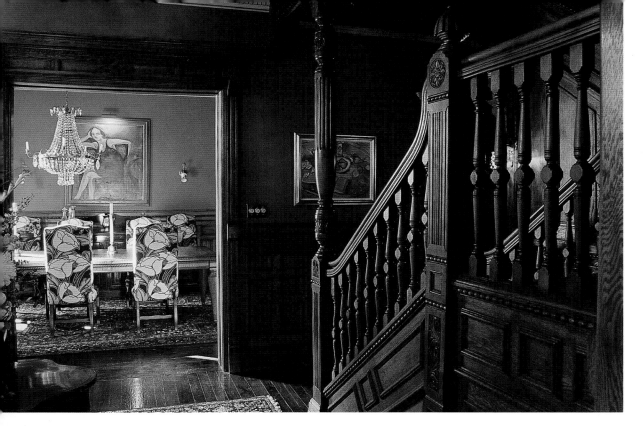

Brown House

Toronto

As the Victorian era drew to a close, Toronto was a city divided unofficially along class lines—except in Cabbagetown, a lively residential enclave just west of the Don River. Cabbagetown is a surprisingly diverse neighbourhood, with rows of plain workers' terraces set cheek by jowl against the more ambitious semi-detached dwellings of the middle class. And here and there in the architectural mishmash are houses like this one, every bit as ambitious as anything on Toronto's more aristocratic streets.

Don't underestimate this house, built in 1891. Although confined by a narrow street frontage, it extends back for what seems like a city block. Architecturally, it was a bit of a milestone in its day, its latent Queen Anne eclecticism giving way to a new order that would reach its zenith in the Edwardian era. The picture window (with stained-glass transom above) was a new innovation, as was the oversized pedimented attic gable; both became mainstays in Toronto architecture. Inside, the trim is equally stylish, with a dramatic use of oak panelling in the foyer and a fancy coffered ceiling in the parlour.

Although it had been open to subdivision as early as 1819, Cabbagetown was slow to develop. Its proximity to the Don Jail, not to mention the perceived health risks of living so close to the swampy river, did little to enhance its reputation. But when yet another new wave of immigrants descended on Toronto in the 1880s, the neighbourhood at last matured. The newcomers grew cabbages in their front yards, and thus Cabbagetown remained until it began a downhill slide that, by the 1960s, prompted several ill-fated urban-renewal projects. Fortunately, enough of the old domain survived to attract the eye of a new generation of whitepainters who admired its varied architecture and tree-lined streets. Leading the way was the rescue of the Brown House, which was renewed along historical lines as a private home in 1976. It set a good example for the neighbourhood restoration that followed.

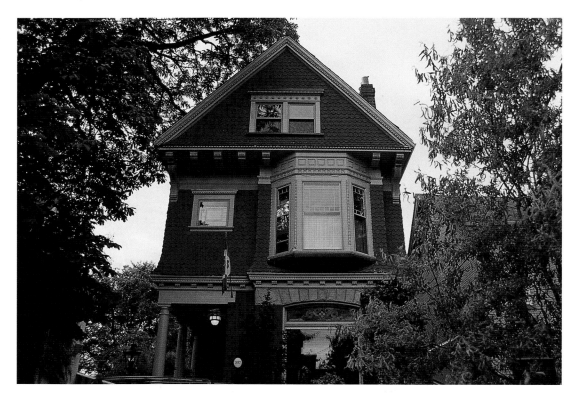

70

Top: Front entry hall

Model Home

Etobicoke

When developer Robert Home Smith planned
the Kingsway Park neighbourhood in the 1920s,
he billed it as a "little bit of England far from
England." It was a brilliant move, for the moth-
erland was synonymous with all things tradi-
tional, regal and secure, especially among the
affluent stockbrokers and businessmen he hoped
to attract to his new suburb. Kingsway Park's
streets ramble hither and yon, and Smith can be
commended for his insistence on maintaining as
much of the mature tree cover as possible. But
the real key to his success was the architecture,
which takes its inspiration from the mediaeval
buildings of merry olde England. As a model
home, the impressive 1929 dwelling shown
here—with its lofty roof, half-timber gables and
other mock-Tudor stylings—set the tone for the
rest of the development.

Smith's instincts were right on the money, for
Kingsway Park remains one of the most desir-
able neighbourhoods in Toronto.

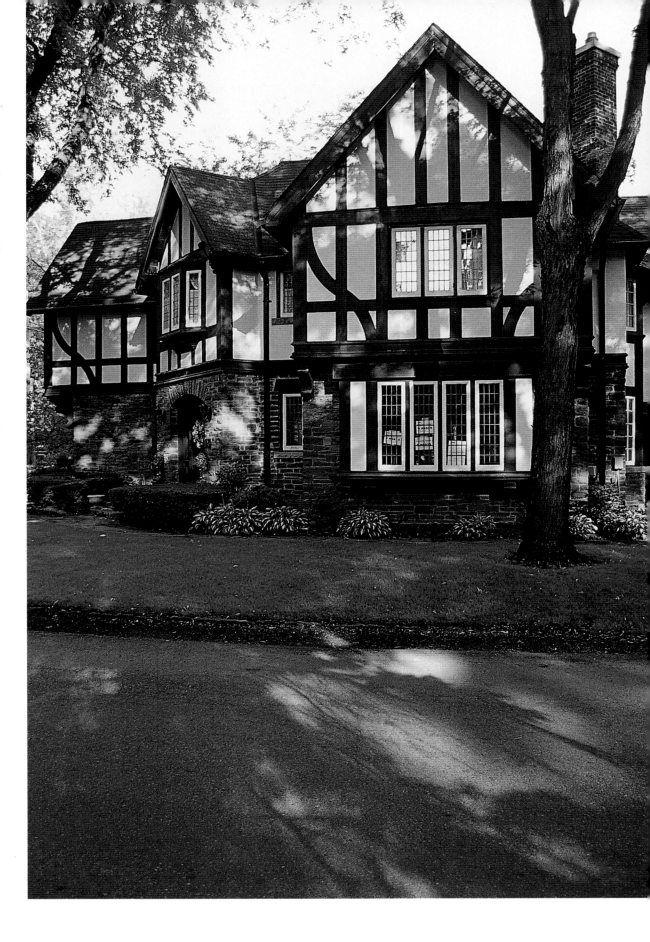

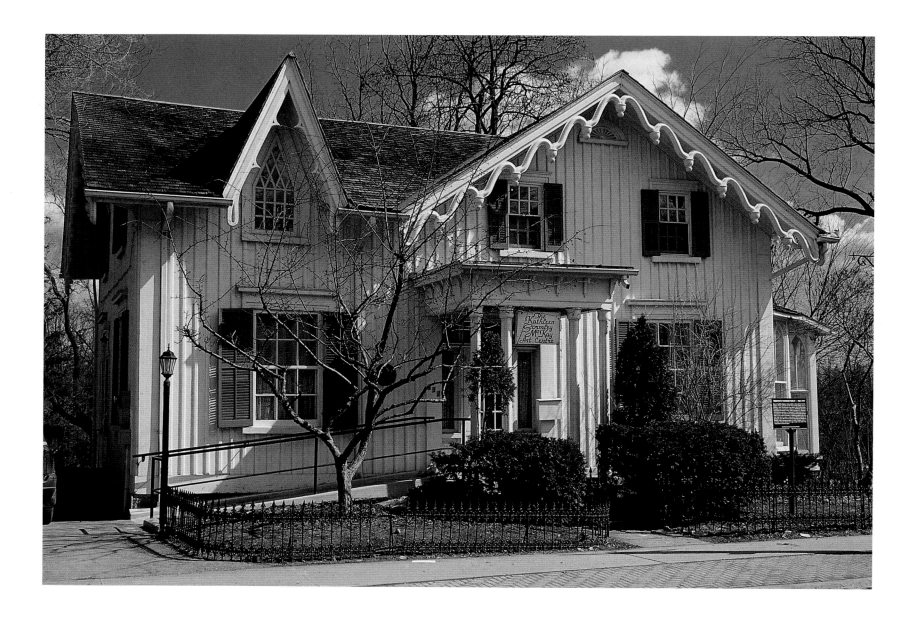

Eckhardt House

Unionville

For some reason, the environs of Markham and Unionville boast more than their share of board-and-batten houses. More picturesque than clapboard and cheaper to build, the style employed vertically aligned cladding with narrow battens to seal the gaps between the boards, lending a handsome texture to the architectural composition. It was touted by the 19th-century writer and champion of good taste Andrew Jackson Downing "because it has an expression of strength and truthfulness...properly signifying to the eye a wooden house."

Downing, whose 1848 book *The Architecture of Country Houses* made him the Martha Stewart of his day, was right on the money, especially considering the light, lyrical air that surrounds the circa-1850s Salem Eckhardt House on Unionville's main street. But board-and-batten siding is only one of its remarkable qualities. The real point of interest is its bargeboard trim, which hangs from the eaves like icing dripping from a cake. This is "gingerbread" at its finest, as worthy an example of the joiner's art as, say, an antique chest of drawers. Its sculptural three-dimensional quality sets it apart from the machine-made trim of later vintage.

The Eckhardts were a prolific family for generations in and around Unionville, but the most famous occupant of this house was Frederick Varley of the Group of Seven.

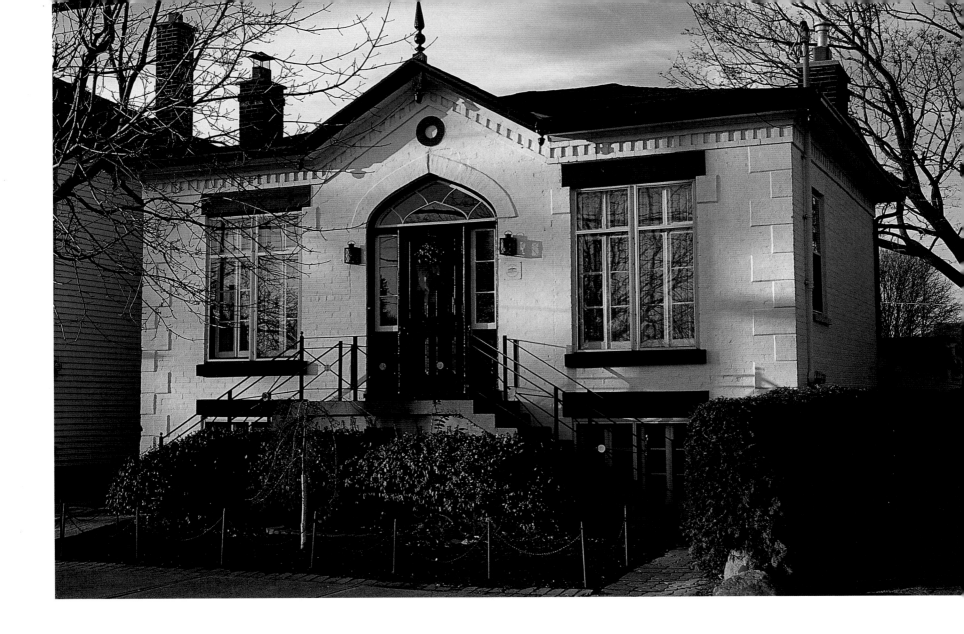

Trick House

Port Hope

Arguably the best-preserved town in the entire province, Port Hope is a shrine to the architectural fashions of the 19th century. Amid the gallery of heritage buildings, it is blessed with a curious predilection for Regency cottages, including this one at the top of the hill that leads downtown. One of the best of its kind, the house is perched on a raised basement and boasts generous windows and an extraordinary doorcase whose transom comes to a Tudor-pointed arch. The brickwork also merits com-

ment: Note the quoins that emphasize the corners and the textured pattern along the cornice, both marks of a skilled mason-builder.

The house was indeed home to a mason named Richard Trick, who was active in the building trade for many years. He is thought to have built the house soon after he bought the lot on which it stands in 1850. Two other houses in town have the same doorcase. Presumably, they were Trick's handiwork as well.

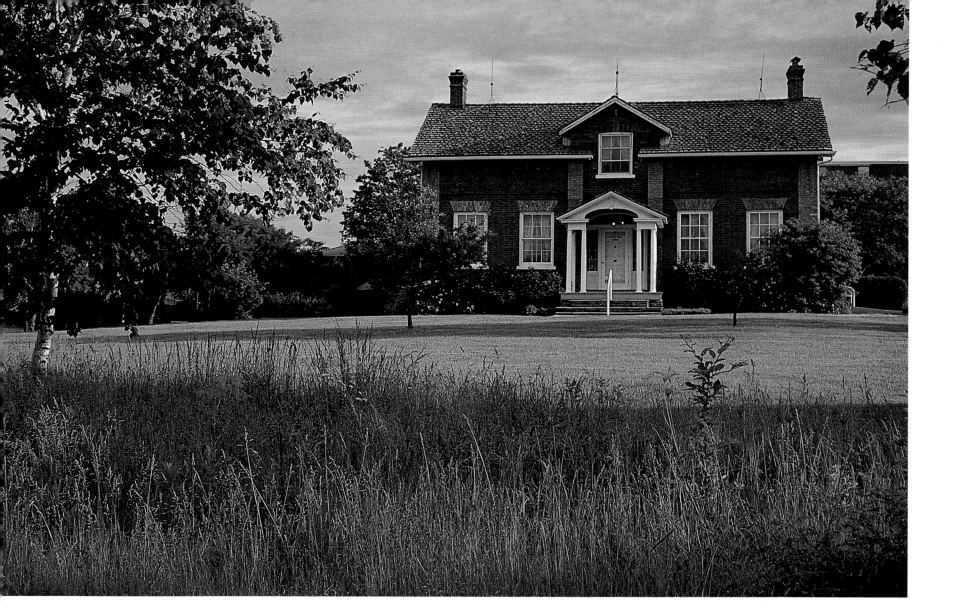

Applewood

Etobicoke

Considering how quickly Etobicoke grew, not to mention that it grew at a time when heritage was the last thing on the minds of municipal planners, it is surprising to see today even a handful of the farmhouses from the days when this suburb of Toronto was still an agricultural township. One of the best surprises is Applewood, a storey-and-a-half brick dwelling of about 1850, which was home to the Shaver family from the day it was built until the 1970s. Its prim lines and restrained detail (the dormer-cum-gable window over the front door was added in 1913, as was the portico, a replica of an early type) are of note, but its survival probably has more to do with historical connections. James Shaver Woodsworth, instrumental in founding what is now the New Democratic Party, was born here in 1874. In 1980, the house was raised from its foundation and carted a few hundred yards north from its original site on Burnhamthorpe Road. It now functions as a city-owned reception facility.

Danforth Road

Carswell House

Prince Albert

The village of Prince Albert once aspired to a more glorious destiny, but its fate was sealed in the 1860s, when a new railway passed it by in favour of nearby Port Perry. Its dreams dashed, it never proved an architectural match for its more prosperous neighbour, but among Prince Albert's unpretentious houses are a couple of gems, including this tiny cottage. It is thought to have been built in the mid-1850s, although there is much, including the pilastered doorcase, to suggest an earlier date.

The obvious inspiration is the Regency style, although the house is simple in the extreme, small in dimension and plainly finished. No room for architectural fanfare here. The house is arranged around a narrow centre hall with a kitchen extension to the rear. The ceilings are low, and the stairs to the attic are hidden. Nevertheless, it abounds in humble country charm.

The house was quite conservative for its day, which may have something to do with the fact that the builder, John Carswell, was well into his seventies when it was constructed. A silversmith by trade, Carswell didn't need anything larger; this was to be his retirement home.

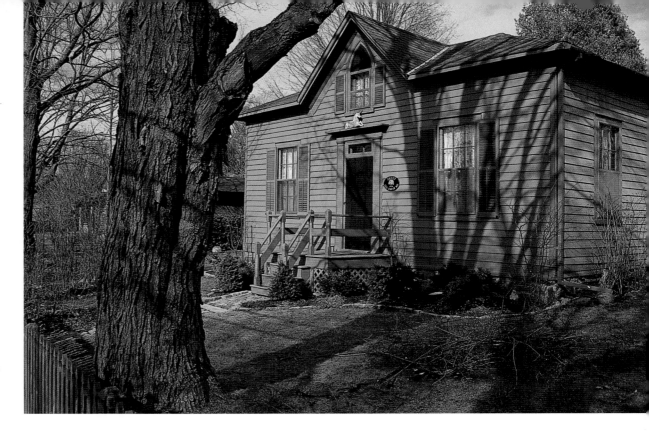

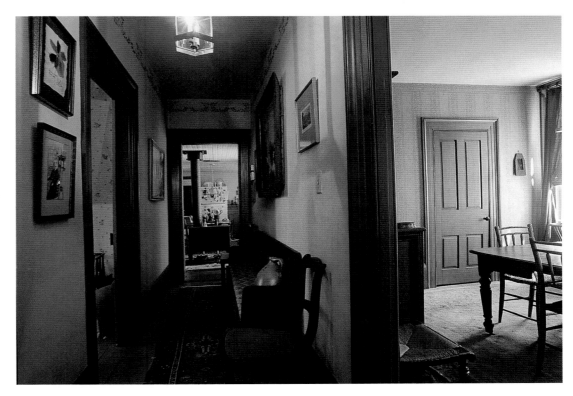

75

Above: The snug dimensions of the hall and dining room inform the house with an unassuming charm.

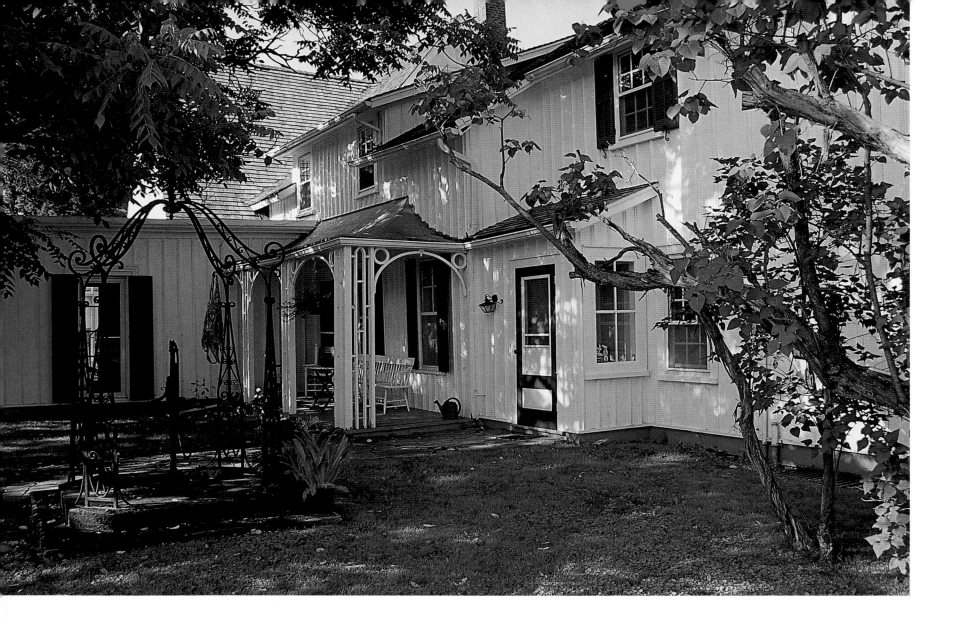

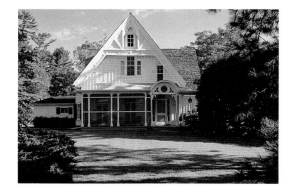

76

Danforth Road

Patterson House

near Richmond Hill

The Patterson House is nothing short of drop-dead gorgeous, a storybook fantasy come to life. With its lofty gables and wealth of fanciful detail, the board-and-batten landmark demonstrates that, in the right hands, the Gothic Revival could be playful and inviting.

The house speaks volumes about the social status of its builder, Peter Patterson, who farmed several hundred acres and, with his brothers, presided over a local farm-implements factory and the community that sprang up around it. The business was absorbed by Massey-Harris, and the village fell on hard times when it was bypassed by the railway. But the house, now approaching its 150th birthday, still watches over a sizable farm acreage. The only architectural alteration of note is the fretted bargeboard on the front gable, which was added around 1900.

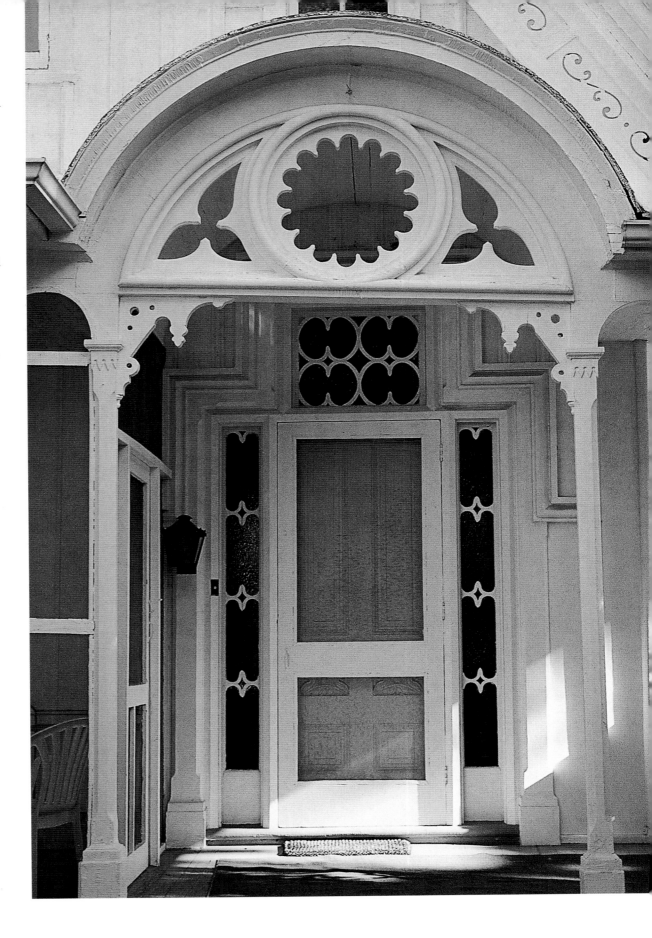

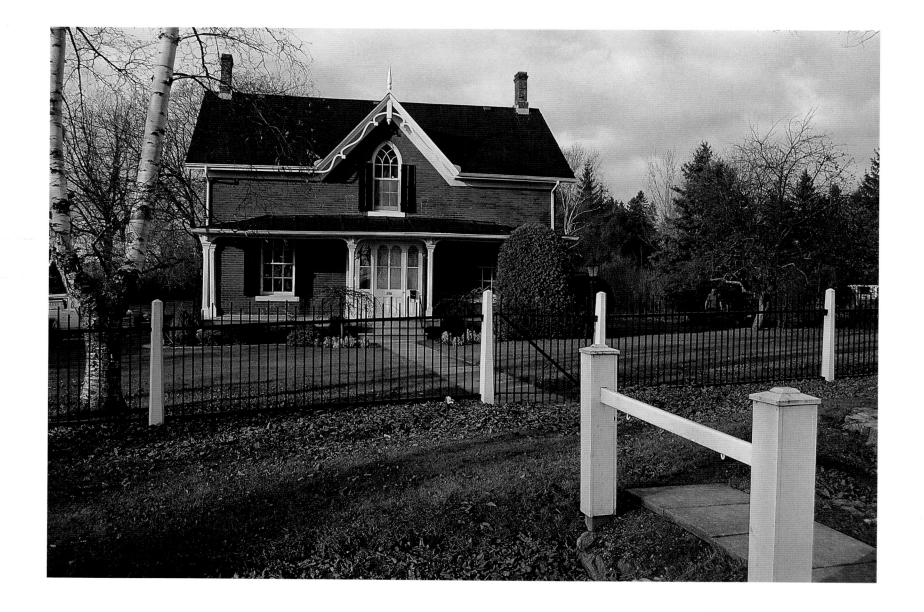

Brand House

Port Hope

The Brand family built this house on their farm at the west end of town about 1860. To call it typical suggests that it is ordinary, but it is nevertheless very much the quintessential Ontario homestead: brick, gabled, gingerbreaded, verandahed, symmetrically arranged with a Gothic window over the front door. It follows a pattern seen time and time again in Confederation-era Ontario, but its handsome proportions—the pitch of the roof, the size of the windows in relation to the walls—mark it as a cut above. Its excellent state of preservation and beautifully maintained setting help too.

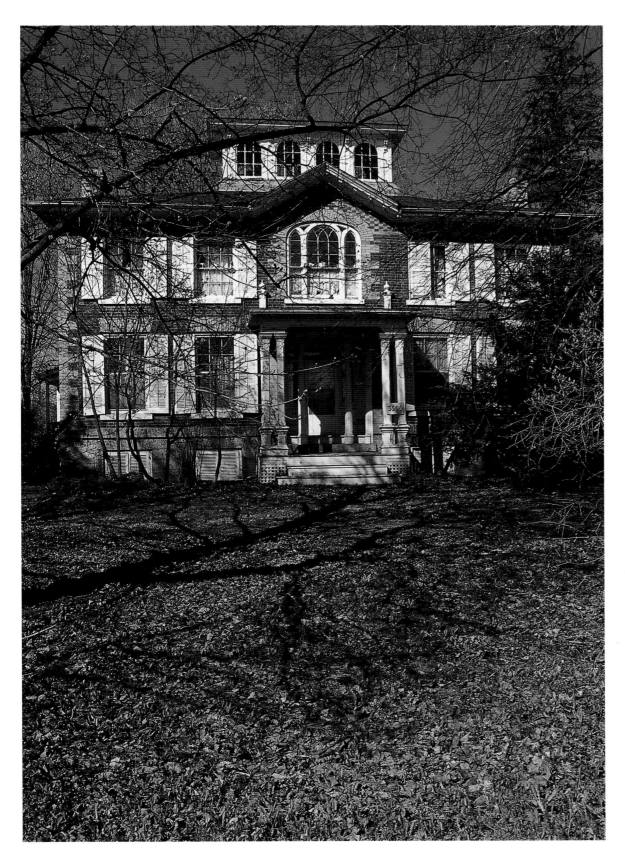

Bentley House

Brougham

In most old communities, the most prominent building in town is a church or public hall, but in Brougham, a crossroads hamlet that today seems perilously close to the inevitable northeastern expansion of Toronto, the honour goes to the William Bentley House. It stands proudly at the four corners, partially obscured by shrubbery, but its lofty rooftop belvedere never fails to attract the gaze of passersby. Architecturally, the house has even more to offer, with its generous windows and Georgian countenance. The impressive façade is enhanced by a gothicized Palladian window.

Bentley could easily have taken his cues from an 1865 edition of *The Canada Farmer*, which featured plans for a similarly styled "straightforward square house" (see Squire House, page 166), but he is actually thought to have built the house in the mid-1850s. His patent-medicine factory stood across the road.

Harris House

Toronto

Art Deco was a bold departure from accepted building convention in the 1930s. Its flat planes and fondness for severe geometric forms made Victorian and Edwardian architecture look positively stale and fussy. But what was innovative on a tony Miami hotel or a Manhattan skyscraper was perhaps a little too radical when applied to a home, and hence, very few true Deco houses exist in Ontario. There are some dramatic exceptions, however, built for architectural mavericks like Lawren Harris, who, as a founding member of the Group of Seven and heir to the Massey-Harris farm-machinery fortune, was on the leading edge of architectural fashion and could afford to become its patron. His house in the Forest Hill neighbourhood of Toronto, completed in 1931, is considered a milestone in Deco design and still stands out from its more conservative neighbours.

Toronto had never seen anything like it when Harris and his architect, a Russian émigrée named Alexandra Biriukova, devised the daring flat-roofed structure with its twin wings. Typical of the genre, it is finished in white stucco, and detail is stark and sparingly applied. The dominant component is a two-storey arched window with finely incised geometric motifs. In its own way, the house is as boldly abstract as any of the paintings for which Harris became famous.

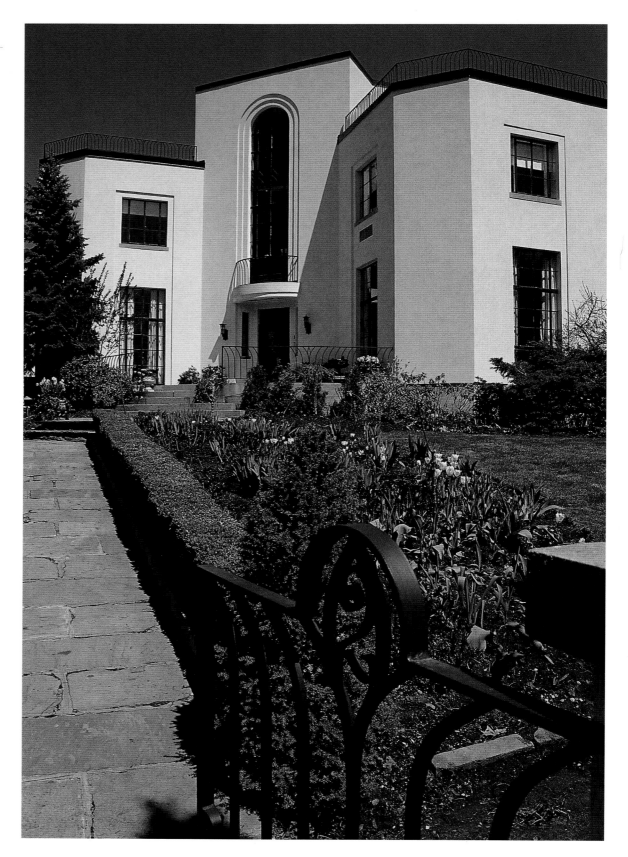

Danforth Road

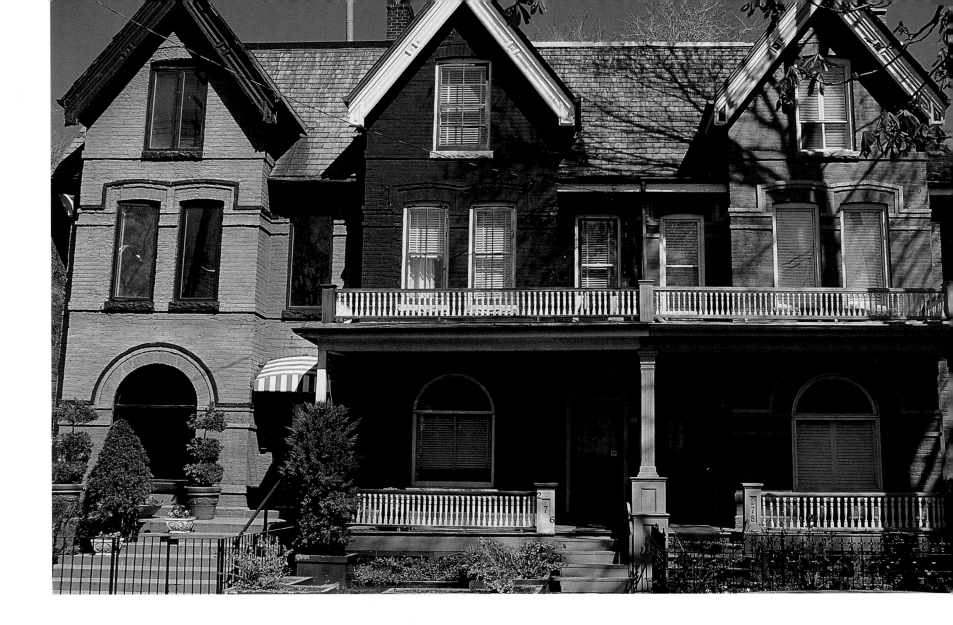

Terrace Houses

Toronto

With real estate always at a premium, 19th-century Toronto was, for the middle and working classes, a city of row houses. As the city's fortunes boomed, block after block of terraces were built by speculators, but it is nevertheless surprising how fashionable a house on a 25-foot frontage could be. By the last quarter of the 19th century, a certain pattern had emerged, one that was repeated so often that Toronto can claim it as an architectural icon all its own: narrow terrace houses with spiky gable-roofed bay windows. Their rhythm marks many a residen-tial street in the older sections of the city. Neither of Toronto's main rivals—Buffalo and Montreal—produced anything quite like them.

This row near the University of Toronto is a later example, with broad Romanesque arches reminiscent of the Old City Hall of 1899. Older terraces tend to have narrower round-headed windows and gables graced with Gothic gingerbread. Few stand today without substantial alterations, but even so, Toronto's "Bay & Gables" remain as important to the city's character as the brownstones are to New York's.

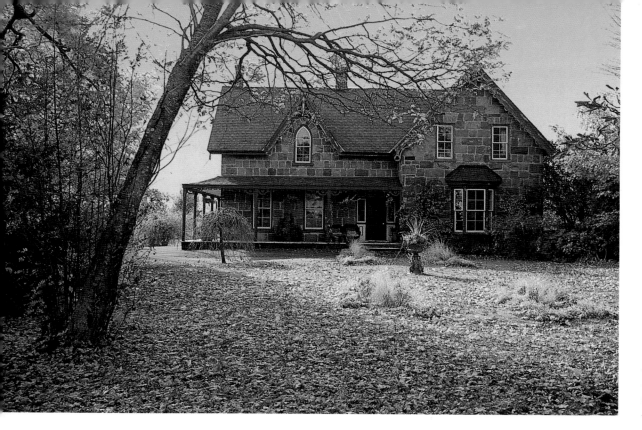

Floradale

near Orono

John Galbraith was well known in local farming circles for his interest in importing and breeding Clydesdales. Around 1865, he and his wife Flora built a new house that, like their horses, was a cut above the ordinary. Although never ostentatious, it struts its stuff with a three-sided verandah and gingerbread gables. Interior appointments—plaster medallions, moulded cornices and a fancy fireplace mantel—are surprisingly ambitious for a farmhouse. Likewise, it is larger than most of its neighbours. It adopts a variation on the traditional centre-hall plan with a pronounced jog in the façade.

Structurally, Floradale weathered the years well for 120 years, but it took an enthusiast's touch to renew its authentic vintage character. Outside, the priority was the restoration of the verandah, which had been removed. Most of the work, however, was reserved for the interior, which was renewed along historical lines. Wallpapers and furnishings take their cue from the architecture, neither too plain nor too Victorian.

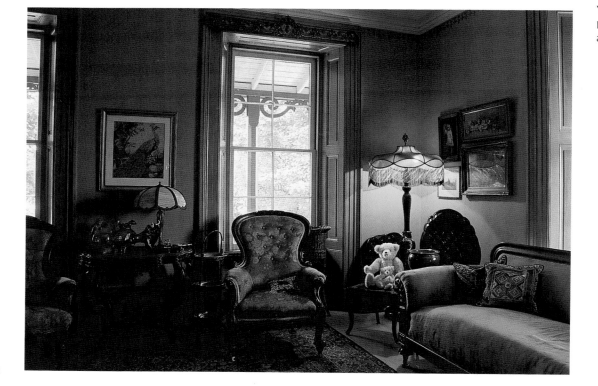

Above: Living room

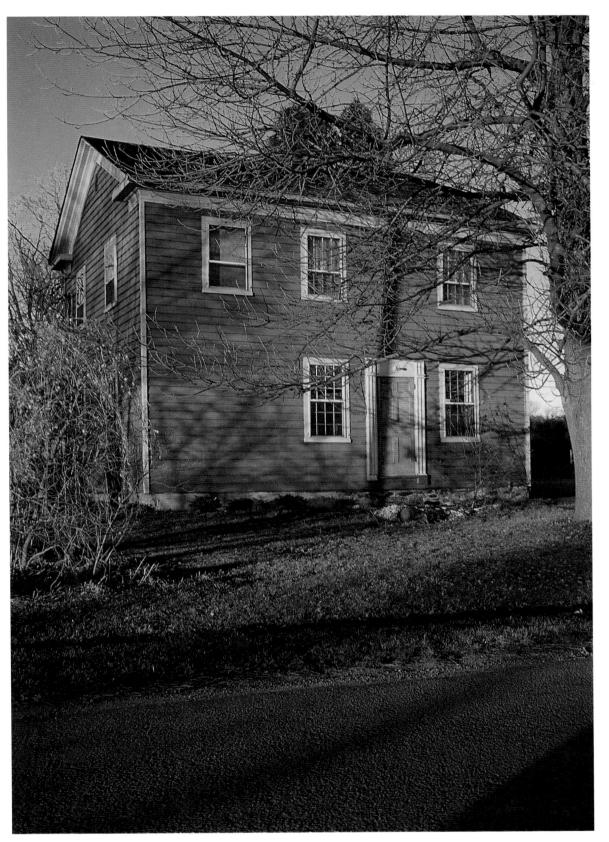

Burnham House

near Cobourg

Several branches of the Burnham family, which hailed from New Hampshire, were among the first settlers in the area that became the town of Cobourg. Their legacy includes this house, which may already have been standing when the family purchased the land on which it sits in 1813. There are several indications that this could be a very early house indeed, the most obvious of which are the 12-over-12 windows (12 panes in the upper sash, 12 in the lower) and the plain, unadorned lines. The house has a Georgian stance, but the placement of the windows is not entirely symmetrical, lending the building a certain vernacular appeal.

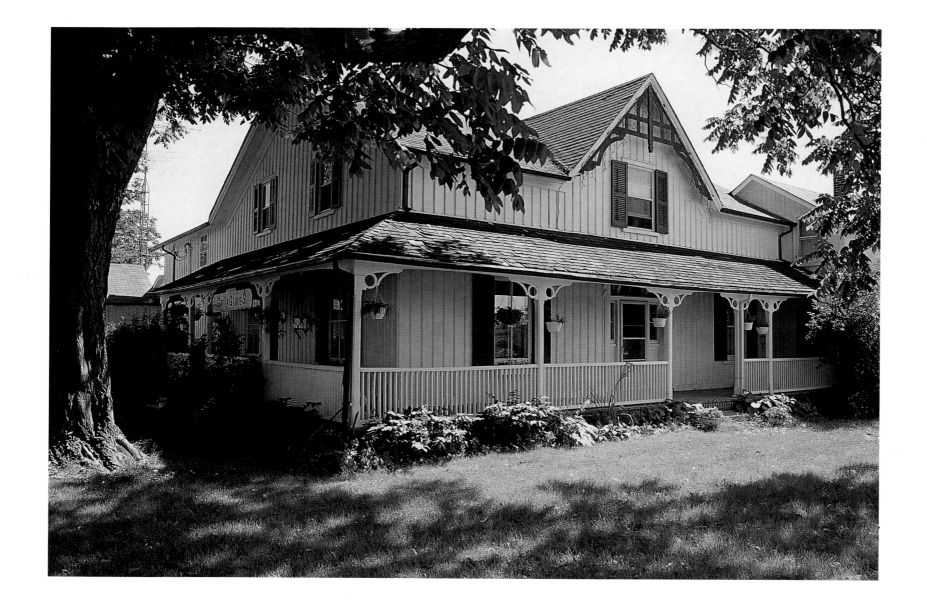

Reesor House

Scarborough

The Reesor House is a reminder of a third settlement of German-speaking immigrants. Their community along the Rouge River was never as large as the Mennonite enclaves in Niagara and Waterloo, but their legacy remains in a number of houses and churches in Markham and Scarborough. Of them, the Peter Reesor House, on the Scarborough (Toronto) side of the line that divides the two jurisdictions, is one of the most exemplary, as it bears many of the hallmarks of Mennonite-German architecture. It even has a *doddy haus*, an addition (at the extreme right of the photograph) built to house the family elders when they turned the farm over to a younger generation. The board-and-batten siding has a local accent: Many nearby houses were finished with the same V-grooved lumber.

84

Glendinning House

Scarborough

As the residential development of Scarborough pushed inevitably northward during the 1970s, most of the old farmhouses were bulldozed out of the way. The Glendinning House was an exception. In fact, its clean proportions and inviting verandah were shrewdly used as a showpiece in marketing the "Historic Glendinning" subdivision that now surrounds it, lending a certain cachet to what was otherwise just another housing development. The old house was built around 1870 by Thomas Glendinning.

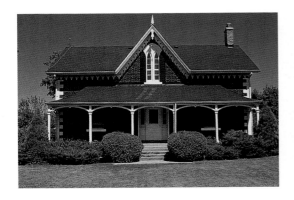

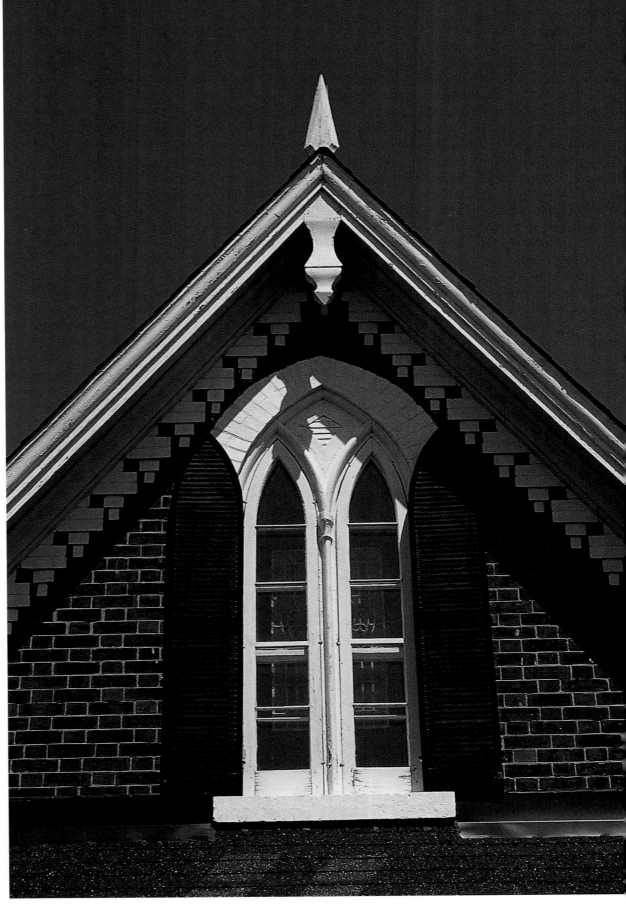

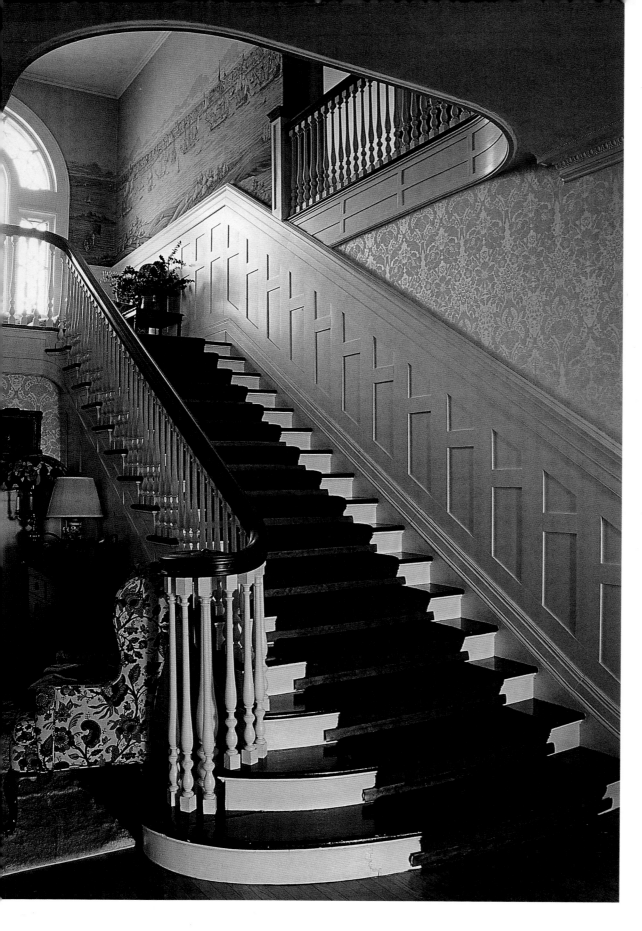

Left: Central staircase

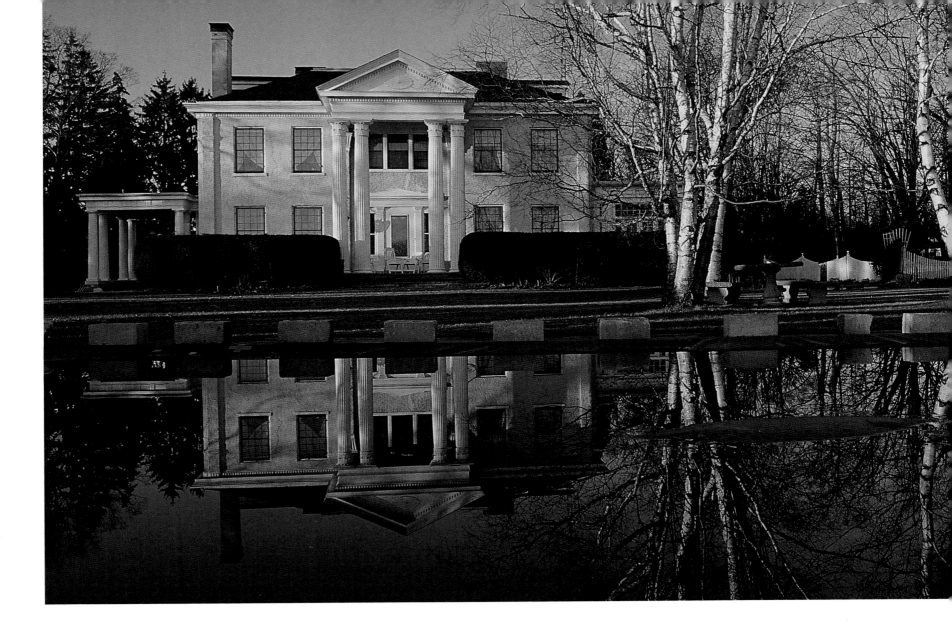

Ravensworth

Cobourg

Try as it might to beat rival towns into the back-country with a railway of its own, Cobourg was doomed from the start. Beginning in 1854, the venture was plagued with engineering problems, and when the causeway over Rice Lake foundered only a year or so after it was built, so did the railway. But out of the fiasco came something positive: American steel tycoons who had made the trip to survey their iron mines up north got to know Cobourg well, and it wasn't long before the picturesque town on the shore of Lake Ontario found new life as a resort for city-weary Pittsburghians. They called their adopted town "the Newport of the North," and their legacy remains today in the glamorous mansions they built as summer homes.

Ravensworth is typical of the breed: opulent, never shy and, with its grand and boastful countenance, oh so American. Designed by architects from Cincinnati for General Charles Lane Fitzhugh in 1897, it is actually only half the package: A companion house, identical in every detail, was built for Fitzhugh's son. It burned down in 1976.

If Ravensworth looks a little Georgian, or perhaps Greek, it's no coincidence. It was built at a time when architectural fashion, inspired by the American centennial in 1876, was taking a fond look back to the colonial era. Suddenly, Georgian symmetry, with its balanced proportions, was back in vogue and made all the more imposing with Greek columns and porticos. The genre has come to be known as Colonial Revival and was a hit well into the 20th century, even among Canadians.

The revival houses are usually more exaggerated than their older cousins and easily distinguishable, inside and out. Ravensworth is more restrained than some.

87

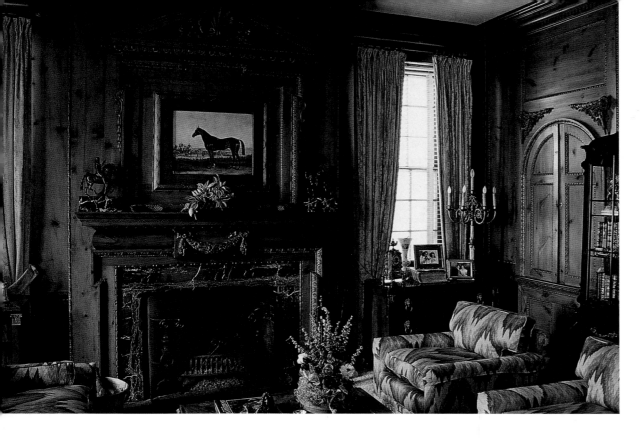

Clockwise from top left: Everything about Ravensworth takes its inspiraton from American houses of the Colonial period: the elaborately panelled walls; the staircase stylings; the millwork and mouldings; and the grand scale of the main-floor rooms.

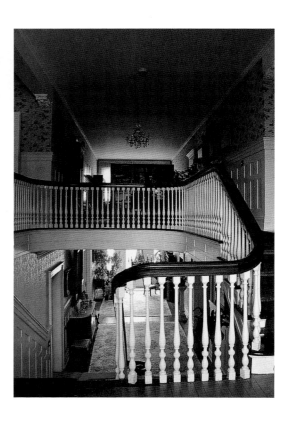

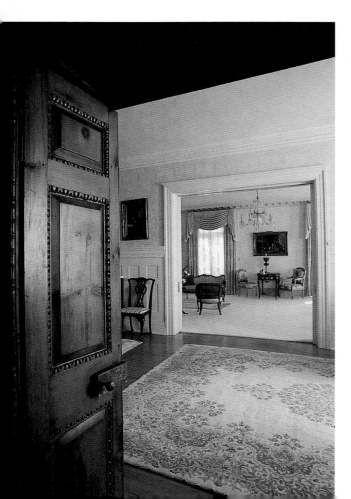

Danforth Road

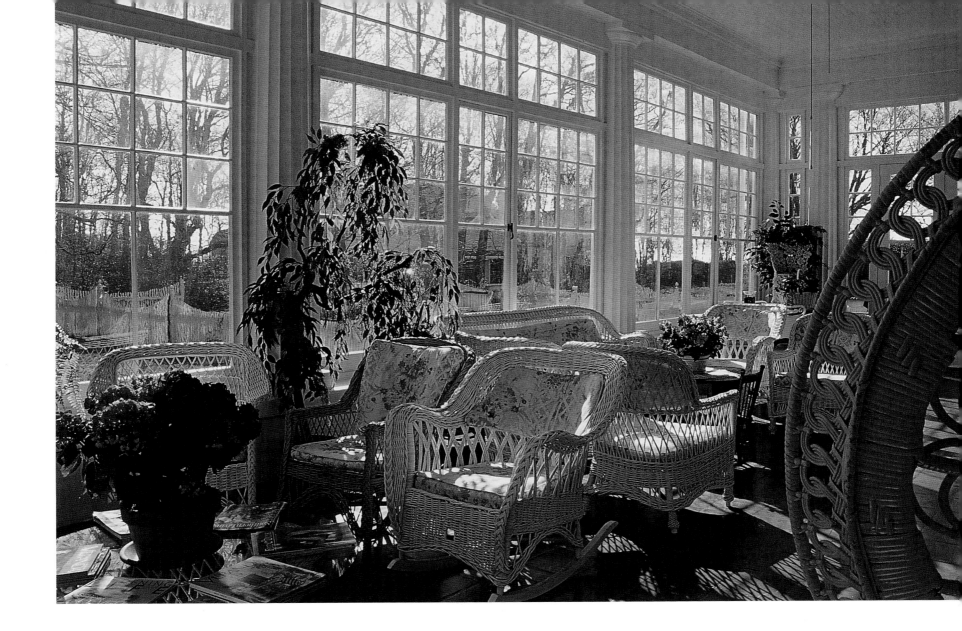

Above: The light-dappled sunroom

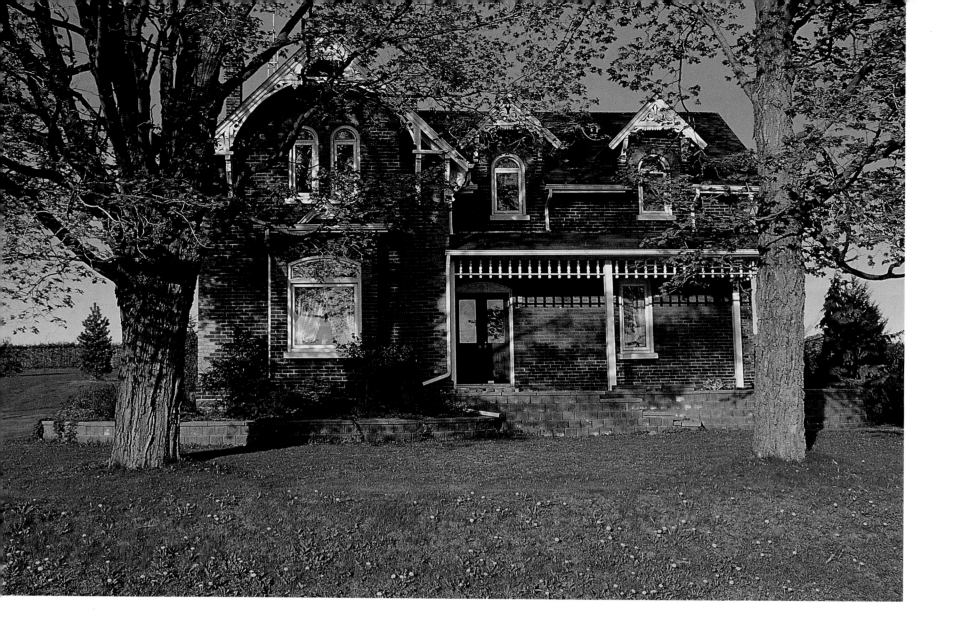

Tremeer House

near Oshawa

90 If you didn't know that the John Tremeer House was built in the 1890s, you could guess by at least two architectural features: the picture windows divided by an arched transom and the spoolwork trim on the verandah. Both were hallmarks of the 1890-to-1910 era, innovations that any builder could specify from off-the-shelf parts at the local lumberyard. The gingerbread, too, had evolved from the early days; by the 1890s, it was also mass-produced and less sculptural but nonetheless integral to creating a picturesque vernacular composition.

Dodds Log House

Port Hope

Back in 1976, no one realized that this humble farmhouse was log, but more than one heritage enthusiast was alarmed when word leaked out that its days were numbered. Beneath modern siding and other alterations, they recognized the silhouette of an early dwelling and negotiated to dismantle it piece by piece and re-erect it on a new site. That it turned out to be a log house was the icing on the cake.

The house is thought to have been built sometime in the late 1840s. Like most of its kind, it is undeniably simple, but it definitely ranks a cut above a settler's shanty with its pleasing proportions and regularly hewn timbers. The signature mark, of course, is the extended roofline, which forms a verandah across the façade.

Restored more as a personal history project than with contemporary living in mind, both the interior and the exterior were renewed with period authenticity. It has no modern intrusions—no running water and only the heat from the cooking hearth to keep it warm. Likewise, each room is furnished with primitives and country furniture: Nothing fancy here, for this house was never a showplace.

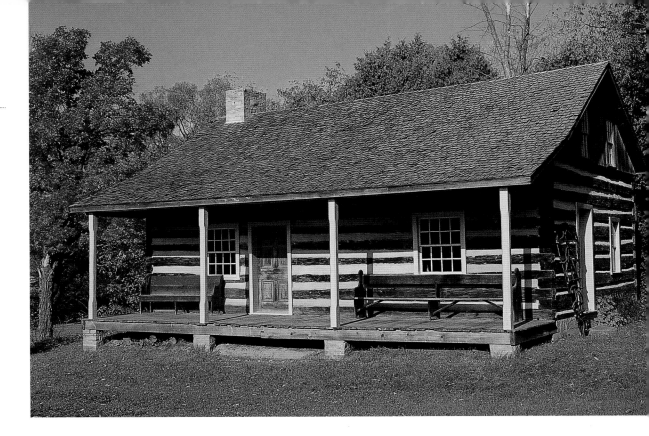

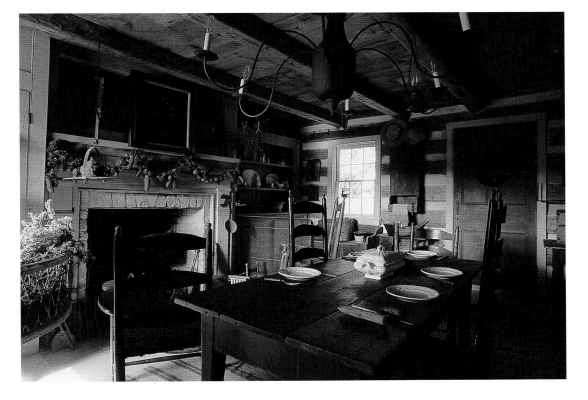

91

Above: Dining area

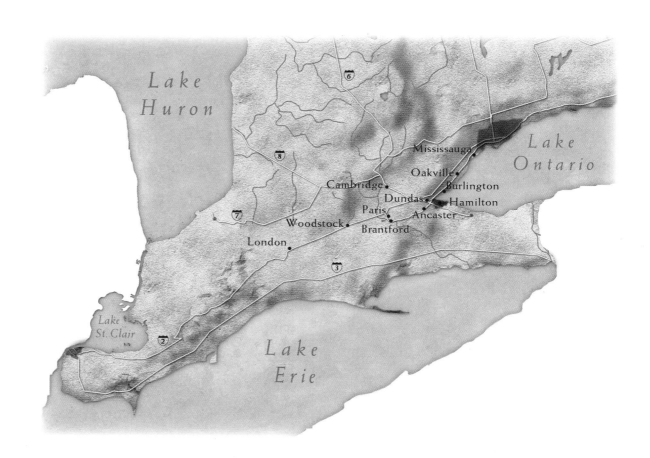

DUNDAS STREET

Crucial to Lieutenant-Governor John Graves Simcoe's blueprint for Upper Canada was his plan to cut several military roads through the bush. These would ensure that troops could be mobilized if the lower Great Lakes fell into enemy hands. To the north, he built Yonge Street; to the east, leading from Toronto to Kingston, he started the Danforth Road; and heading west toward London, a site he seriously considered for the capital, ran Dundas Street.

At first, the roads were no more than trails through the forest that began to grow over as soon as they were blazed, but they were nonetheless important in establishing the network of highways that is still with us today. Dundas Street, running straight as an arrow through Oakville, Ancaster, Paris, Woodstock and London, established the east-west link that would be paved and improved as highways 5 and 2 and set the pattern for Highway 401.

Like the other military roads, Dundas Street was also a catalyst for settlement. The wave of immigrants moved from east to west, starting at the Toronto end in the very early years of the 19th century. They were not a homogeneous crowd but a mix of Protestant and Catholic, English, Irish, Scottish and, occasionally, American. They prospered, and the houses they left behind were stylish and substantial. They read like a textbook on Ontario architectural history, with all the 19th- and early-20th-century styles represented, whether the medium is stone, stucco, frame or brick. Despite the encroaching suburbs at the Toronto end, Dundas Street and environs are still a feast for anyone who admires old buildings.

Parker House

Woodstock

At least one Italianate villa could be counted among the mansions in the more prosperous Ontario towns at the time of Confederation, and few are more faithful to the formula than the John Parker House, a landmark on Woodstock's most fashionable street. Designed with the airy country abodes of Tuscany in mind, the villa was the darling of architectural writers such as Andrew Jackson Downing and John Claudius Loudon. The irregular façade was a prerequisite, as were the elongated arched windows, the asymmetrical placement of the verandah and prolific use of brackets under the eaves. The signature mark, however, was the watchtower, and it commanded most of the architectural limelight. Builders of lesser means would sometimes forgo the tower, but without it, much of the romance was missing. Although inspired by the countryside, Italianate villas were an urban phenomenon. Similar dwellings stand in Port Hope, Toronto, Niagara-on-the-Lake and Kingston.

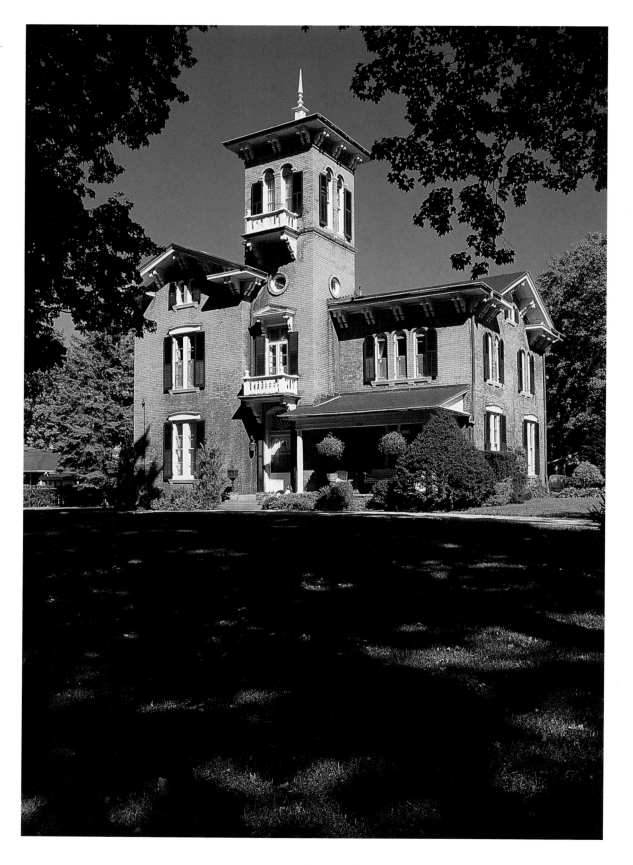

Dundas Street

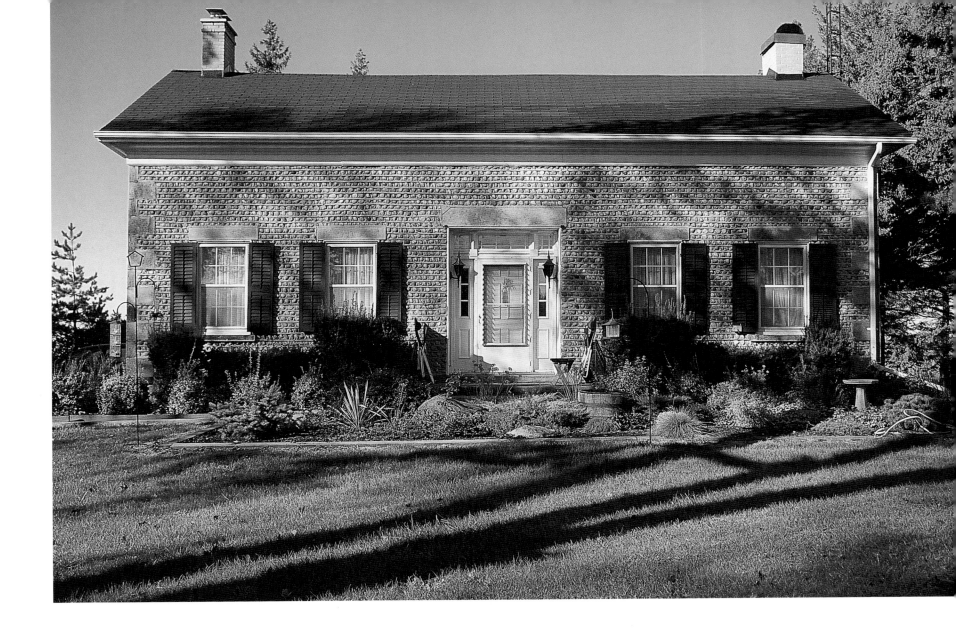

George Brown House

near Paris

The environs of Paris and Belleville are the only places in Ontario that can boast substantial collections of 19th-century cobblestone construction. Although separated by some 200 miles, each area has more than a dozen buildings—churches, shops and especially homes—whose stonework is enhanced by the pattern of small, river-washed pebbles arranged in precise rows. That they should occur in such disparate locales is explained by the social history of both regions. Paris and Belleville were settled by Americans who maintained strong family and business connections across Lake Ontario to Rochester, New York, which is acknowledged as the motherland of cobblestone in North America. There, the cobblestone buildings number in the hundreds.

The tradition came to Paris with a Rochester-bred mason named Levi Boughton, who trained others until the area was dotted with cobblestone veneers. Their prowess was at its peak when this farmhouse was built in the late 1850s for another American immigrant, George Brown. Its Georgian symmetry and Greek Revival detail are enough to mark it as a cut above the ordinary, but the undisputed star of the show is the precision of the herringbone masonry.

95

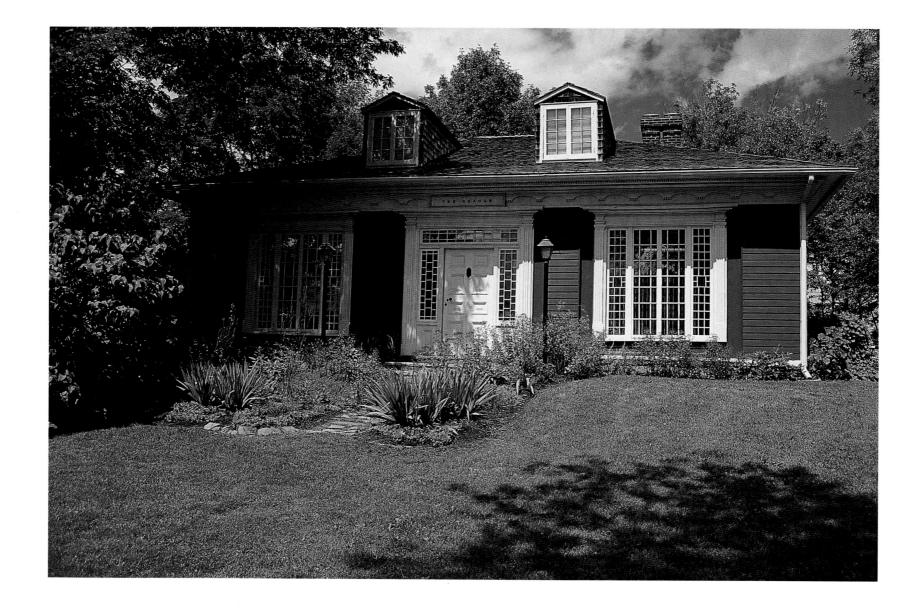

Robinson Cottage

Mississauga

Exquisite in its fine detail, this striking Regency cottage in Erindale was the brainchild of none other than Sir John Beverley Robinson, whose distinguished legal career saw him appointed attorney general for Upper Canada when he was only 22 years old. Born into the Family Compact, the elite upper crust whose names appear time and time again in Crown appointments in pre-Victorian Upper Canada, he became chief justice in 1830. It was about this time that he built this charming country house far from the stress of political life in York. The fantasy didn't last long, however. Strapped for cash from building not only this but a large Georgian estate in the city, he abruptly sold the property.

The most remarkable attributes of the Robinson Cottage are its abundant light and sublime detailing. The generous windows with their delicate pattern of tiny panes are its singular feature, and the door- and windowcase mouldings display a refinement usually reserved for only the best parlour fireplace mantels.

Kress Hill

Cambridge

Kress Hill, an impressive stone house in the Preston section of Cambridge, expresses its Gothicism without the customary pointed arches and steep gables. Its roof, in fact, is a truncated gable, and unlike most of the genre, the house is broader than it is tall. But it is Gothic nevertheless, especially in light of the hood mouldings over the upstairs windows. The iron cresting on the balcony and a modest point in the arch over the balcony door are other clues.

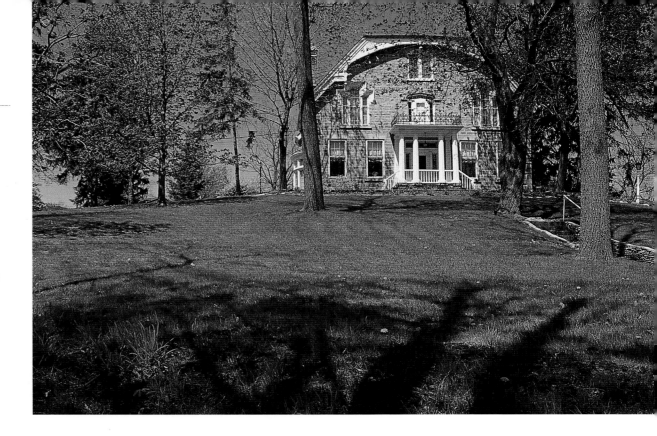

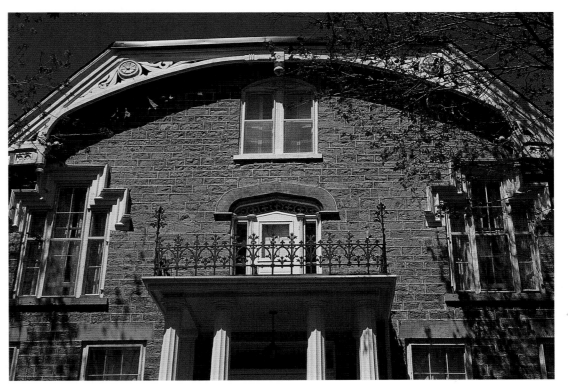

97

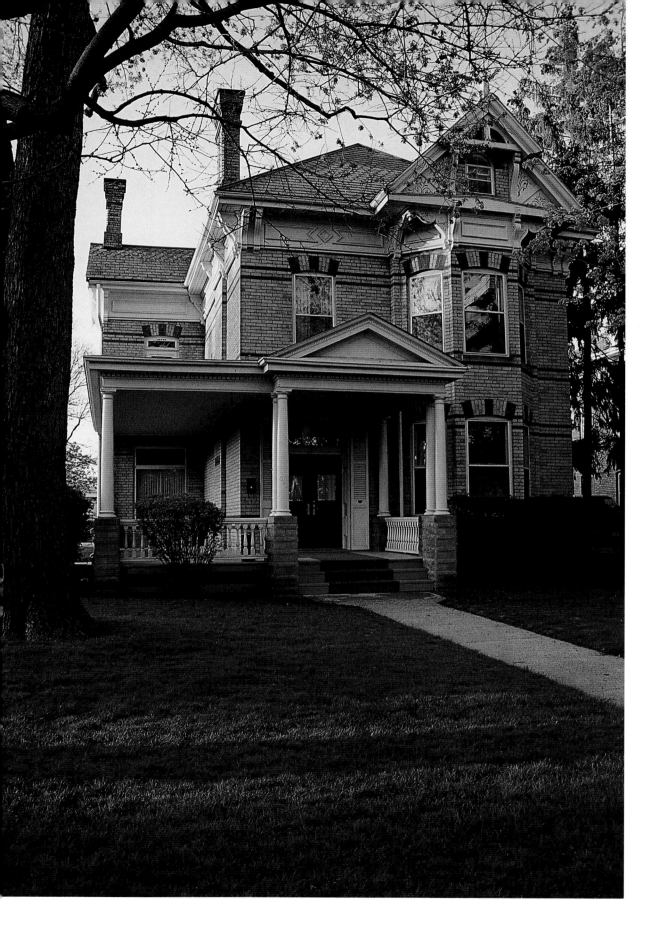

Crawford House

London

Compared with the restraint of the old Georgian tradition, this 1886 dwelling in downtown London is a riot of architectural whimsy, but still, for its time, it shows a definite sense of order that is light-years removed from Queen Anne contemporaries such as the exuberant Lawrence House in Sarnia (see page 158). It marks a safe middle ground: stylish but never outrageous. The only real nods to novelty show in the red-brick accents and the ornate gable over the bay window. The latter, supported from below by decorative brackets, is a device seen frequently enough on houses in and around London that it might be termed a local architectural anomaly.

The house was built as a rental property for a retired industrialist named Samuel Crawford, whose foundry was absorbed by the John Deere Plow Company. He chose his favourite architect, George F. Durand, to whom he had previously turned for advice in building several commercial buildings and his own house.

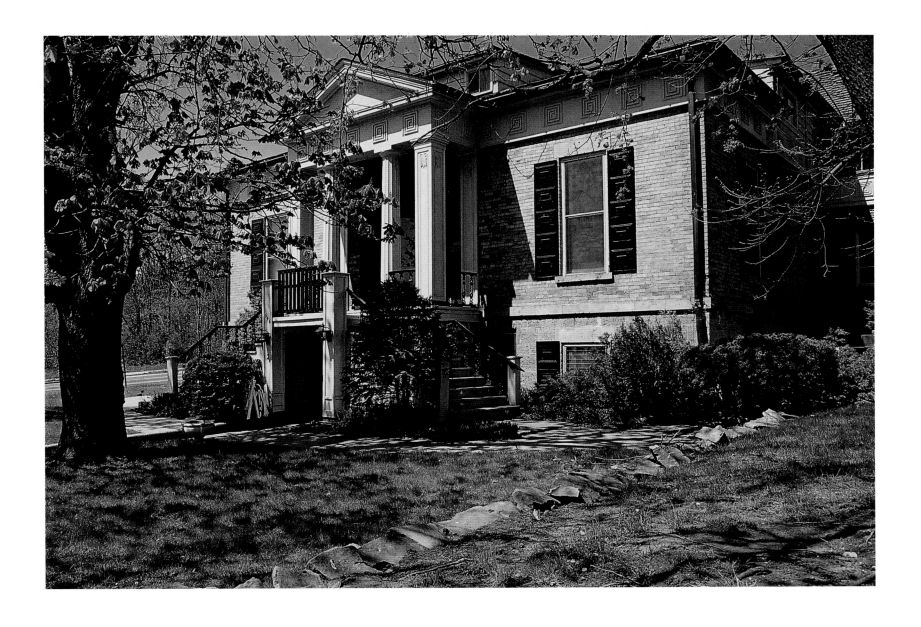

Beck House

Cambridge

The single-storey arrangement of this brick house suggests the Regency style, but everything else about it is Greek: the portico over the front door, the classical columns, the broad, sculpted cornice mouldings. Perched high on a raised basement, the house was intended to preside over its surroundings, contrary to the Regency penchant for verandahs and other devices that would help the structure blend into the land-scape. A close examination of the details shows an uncanny resemblance to Ruthven (see page 141); more than one architectural historian has surmised that the same architect was at work here. At one time or another, the house has been home to several of Cambridge's leading families. The builder was Jacob Beck, whose son Adam is immortalized in Ontario history as the founder of what is now Ontario Hydro.

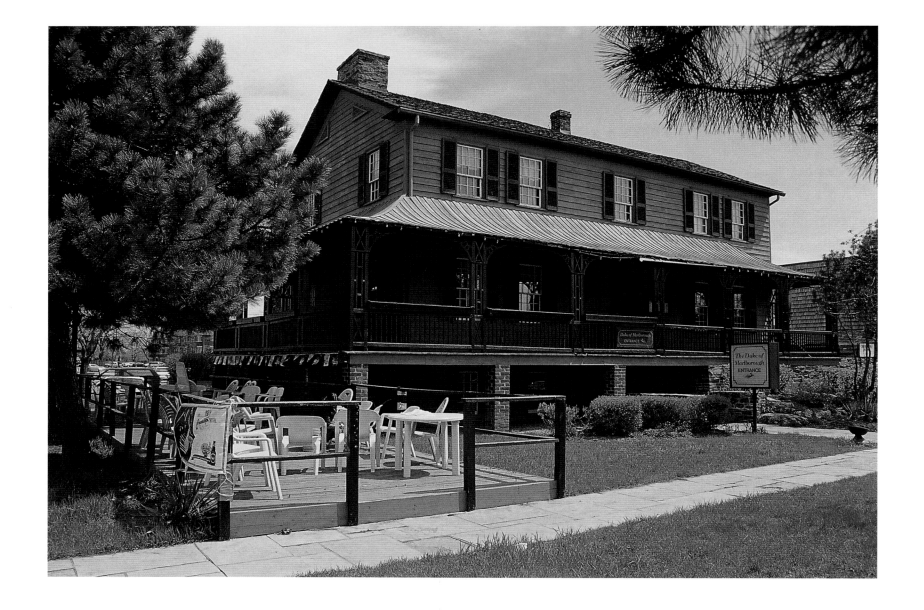

Cherry Hill

Mississauga

Before there was Mississauga, there was Cooksville, and before there was Cooksville, there was Cherry Hill, the farmstead settled by Joseph and Jane Silverthorn in 1807. The couple was among the first settlers in what was then a dense hardwood forest. By 1822, they had built a spacious Georgian home that quickly gained a reputation as the social hub of the community. No doubt the Silverthorns' nine eligible daughters had something to do with this.

As Georgian houses go, Cherry Hill is appreciably less formal than some. Its frame construction precludes any air of pretension, and the verandah, which wraps around the façade and down the side elevation, makes the house all the more inviting. Its bowed roof and trelliswork are exemplary of the early approach to verandah building: Conventional roofs and solid turned posts came later. By the late 1970s, its charms seemed lost—the house was derelict and directly in the path of the suburban juggernaut. Fortunately, a farsighted developer rescued the house and moved it to a new location. Cherry Hill is now a restaurant.

Dundas Street

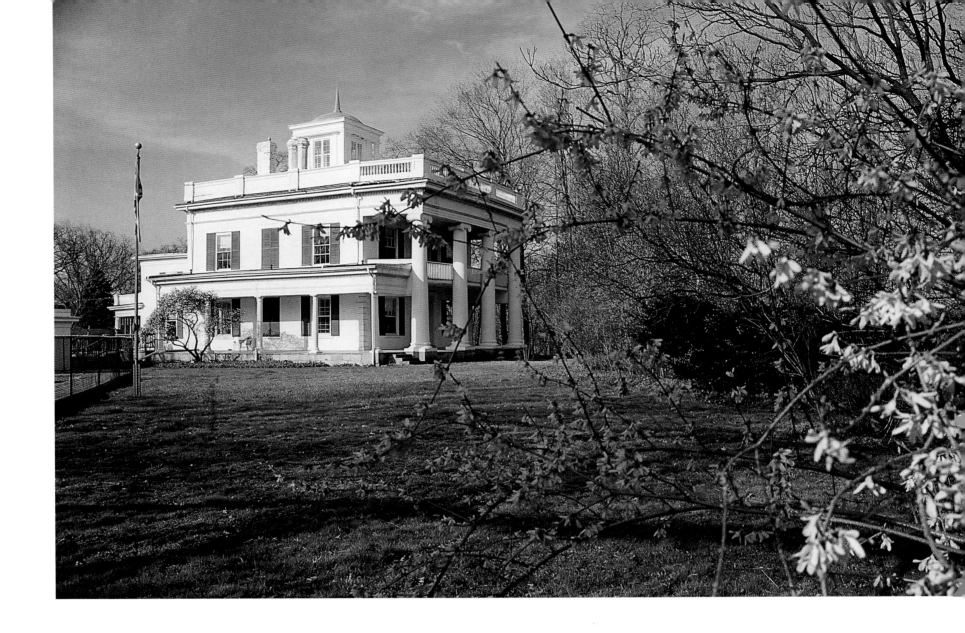

Mount Fairview

Dundas

If ever a house was given an appropriate name, it is Mount Fairview, which stands at the brow of a hill overlooking the town of Dundas. The view was obviously paramount to the builders, Hugh and Jane Moore, for the house sprouts verandahs and lookout decks in every direction, the most dramatic being a rooftop promenade that offers a glimpse of distant Hamilton.

Constructed in 1848, Mount Fairview is another of the handful of true Greek Revival man-

sions in Ontario (see Ruthven, page 141, and Willowbank, page 116). The colossal columns, capped with scrollwork consistent with the Ionic order, leave no doubt as to its classical inspiration, and likewise, detail is boldly fashioned. But even that takes a backseat to the enclosed belvedere that crowns the roof and has to be the most striking element in the architectural composition, the better to take in the view.

101

Woodend

near Ancaster

Woodend shares its unusual triple-gabled façade with at least one other Gothic landmark in the Ancaster area, but it remains the more ambitious on account of its consummate masonry. It took a skilled technician (not to mention an owner with sufficient means) to render the façade in ashlar—that is, all the stones are cut to uniform size and shape and laid in perfect rows. Such precision was expensive and usually reserved for public buildings.

The house was home to the John Heslop family and is best remembered locally as the site of an infamous murder. Heslop was killed when four burglars invaded late one night in 1891. Knowing he was treasurer of the township, the assailants expected to find money in the house. Instead, they found Heslop, 79 years old, at the top of the stairs, threatening the invaders with an upraised chair. In the fracas that followed, he was shot. None of the accused men was ever convicted.

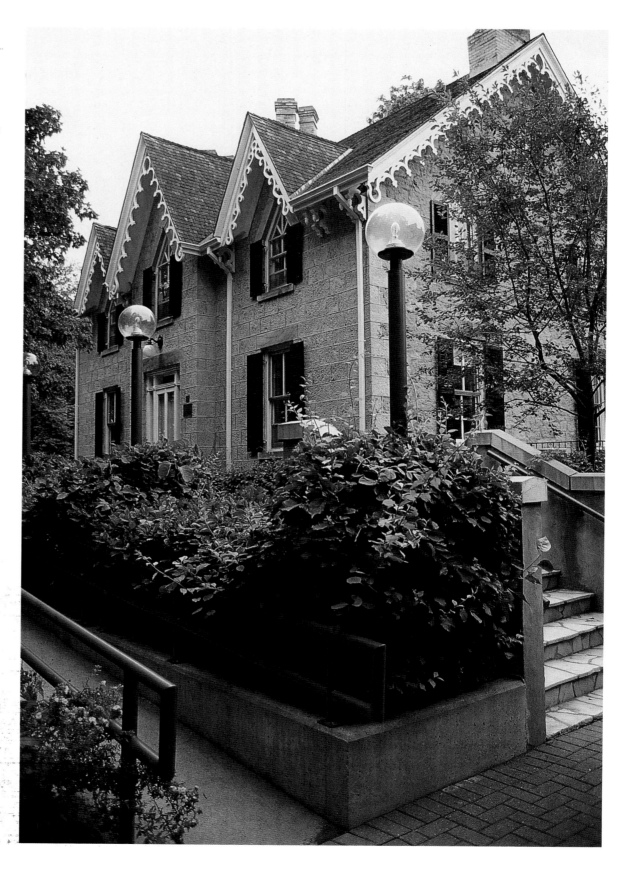

Dundas Street

Hamilton Place

Paris

Hamilton Place, built in 1844 for an up-and-coming expatriate American, wins the prize as the most admired house in Paris. Not only is it technically interesting—it is a fine example of the cobblestone building tradition for which the town at the forks of the Grand is famous (see George Brown House, page 95)—but Hamilton Place is also a stylistic triumph. Peering out from its estate lot from behind a cobblestone garden wall, the house can't help drawing admiring glances with its columned façade and rooftop lantern. It's a bold and unforgettable design, Greek Revival in execution, although it could be argued that the basic silhouette, especially the lantern, is a Regency inspiration. Nevertheless, the Greek influence sings the loudest, for there is no mistaking the broad and plainly rendered cornice and the sturdy square columns. The house is larger than it looks—there is actually a second storey (lighted by knee-windows under the verandah) wedged between the main floor and the lantern attic.

There is nothing understated about Hamilton Place, which seems to be a reflection of its builder Norman Hamilton, who, like many of his neighbours, came to Paris from upstate New York. Described in one local history as a "pushing, independent, success-at-any-price Yankee," he made his fortune in distilling and pork packing. It was actually a shrewd combination: The pigs fattened up on discarded mash.

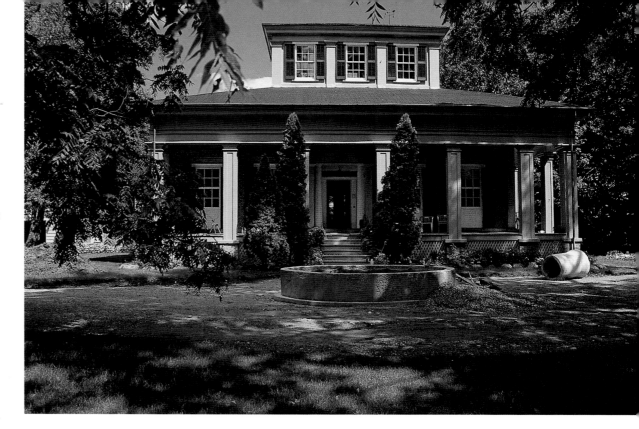

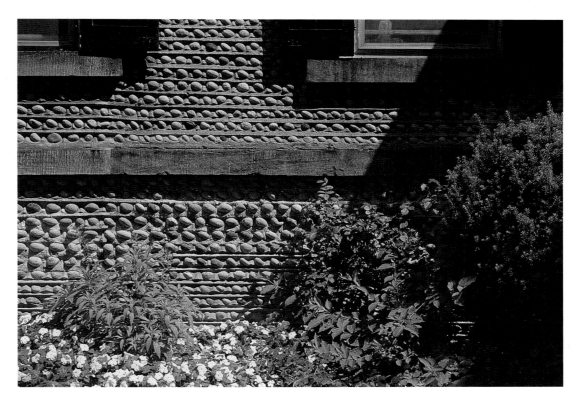

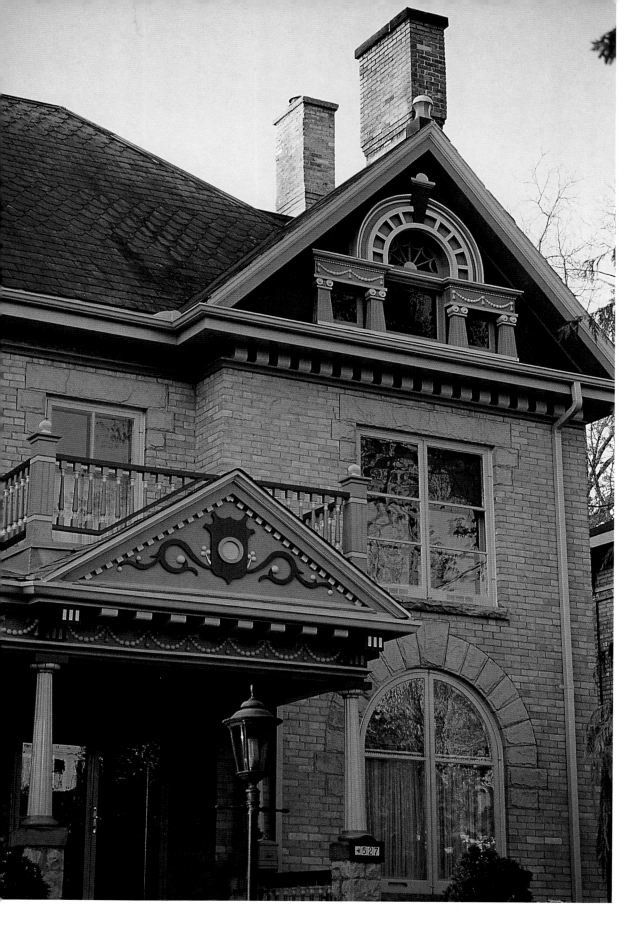

Cooper House

London

This striking essay in Queen Anne opulence had become a rooming house until rescued by new owners who recognized its historical charm and converted it back to single-family use. It began as the home of a photographer, Frank Cooper, in 1899 and must have caused quite a stir in its day with its ample verandah and three-storey corner tower. Its playful presence is typical of the Queen Anne style, but even this house pales beside some even more exuberant contemporaries such as the Lawrence House in Sarnia (see page 158).

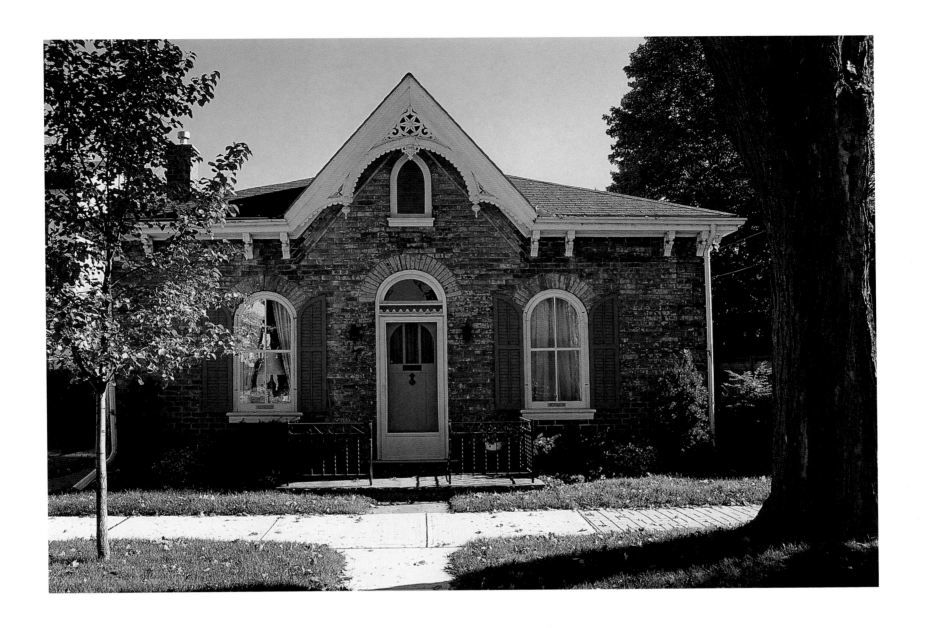

Victorian Regency Cottage

Brantford

In its purest form, the Regency style (see Robinson Cottage, page 96) was never much more than a passing fancy, but its legacy lived on well into the Victorian era. Although this handsome cottage in downtown Brantford lacks the picturesque setting so essential to the genre, it obviously borrows its basic architectural arrangements from the Regency prototype. The detail is unmistakably Victorian, but the single-storey layout and the inviting, ground-hugging stance are direct descendants of the Regency era. Indeed, these may be the most lasting legacy of the genre, for in many ways, it was the precursor of today's bungalow.

In the 1870s and 1880s, houses of this type—most built on speculation—were popping up by the dozen in Ontario's smaller cities. Brantford and London seem to have more than their share.

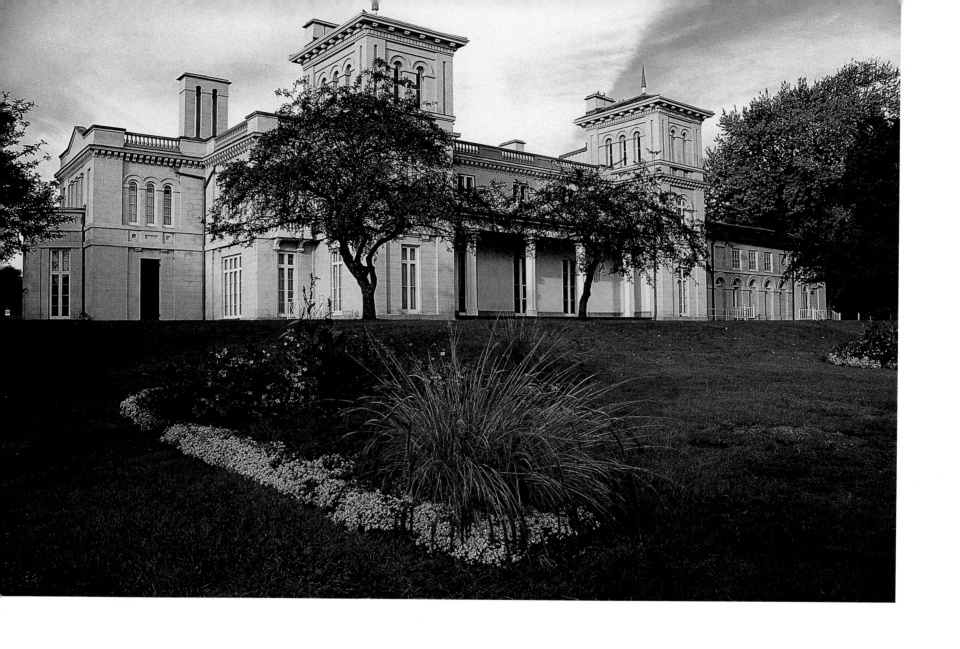

Right: Few homes in Ontario could rival
the splendour of MacNab's Dundurn.

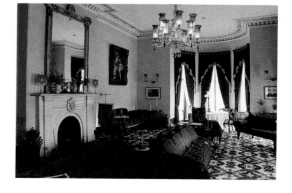

Dundas Street

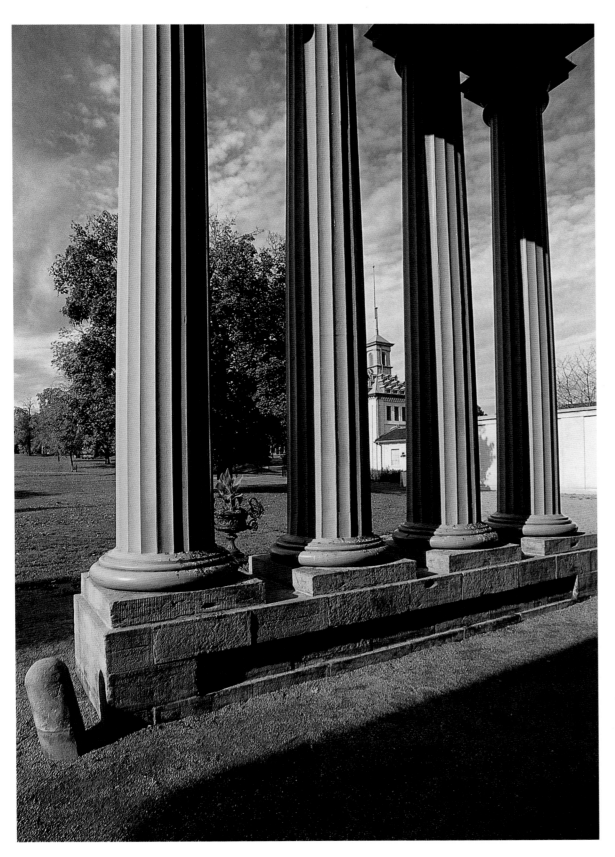

Dundurn

Hamilton

Sir Allan MacNab was the essence of the early Ontario aristocrat. Well connected to the ruling gentry, he was a lawyer and railway magnate who rose in the mid-1850s to preside over the united provinces of Canada West (Ontario) and Canada East (Quebec) as prime minister. He is also remembered as the man who, as leader of the Queen's forces, crushed William Lyon Mackenzie's populist rebellion in 1837. A year later, he was knighted for his efforts.

At the time, MacNab had only recently settled into his new estate, a stucco-over-brick mansion he called Dundurn. If you knew nothing about his status and power, surely the house would tell all: opulent, elitist and conspicuous. But Dundurn is also possessed of a superb sense of style and ranks as the largest and one of the most capable statements of the Regency ethic in the province.

Unlike their Georgian predecessors, Regency builders were sure to take full advantage of a picturesque setting, favouring houses that did not prevail over their surroundings but blended with them. Built on a promontory overlooking Burlington Bay, Dundurn accomplishes this despite its size. The lyrical twin watchtowers on the garden façade, joined by a gallery and a balcony, lend the composition an undeniable elegance. The street front, however, presents a more formal face, made all the more imposing when MacNab added a columned portico in the 1850s.

Dundurn also departs from Georgian convention with its innovative floor plan, which eschews the traditional centre hall for a rambling, less rigid layout. The dining room, with its vista over the garden, is probably the most memorable room and follows the Regency dictum that every room should have a view. MacNab's architect, Robert Charles Wetherell, obviously learned his lessons well, for Dundurn ranks with any of the Regency estates in mother England.

Dundurn is the most familiar architectural landmark in Hamilton, but the city, so often in the shadow of big brother Toronto, has much to interest architecture enthusiasts. Its underrated older neighbourhoods are well worth a stroll.

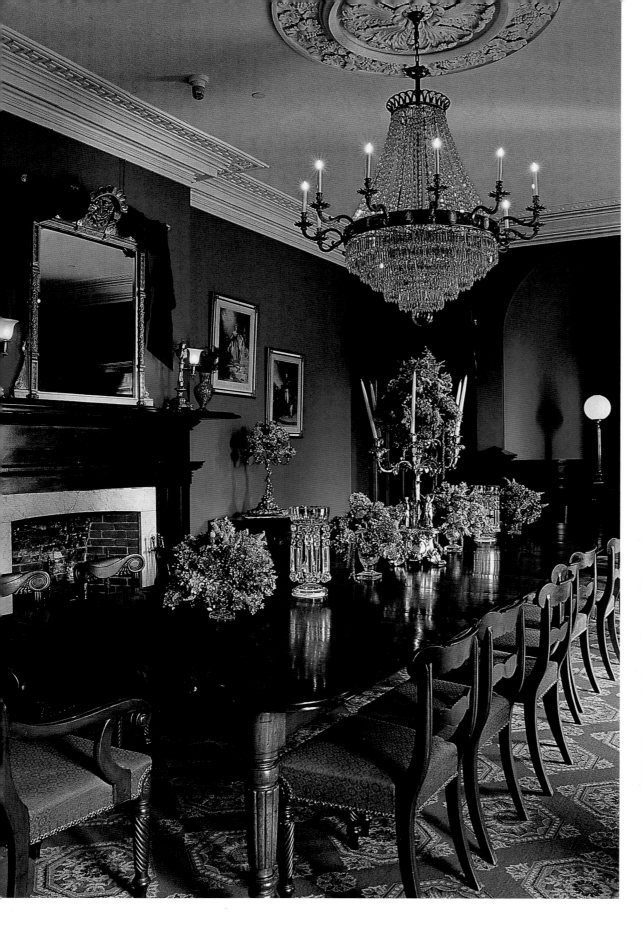

Left: In its original paint colours, the dining room adopts a pensive mood intensified by ornate plaster mouldings and a refined mantel.

Below: A freestanding staircase is one of Dundurn's remarkable assets.

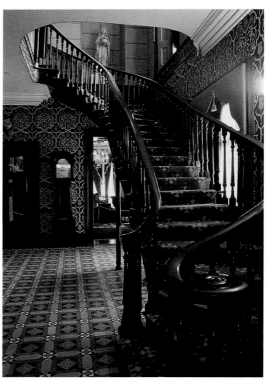

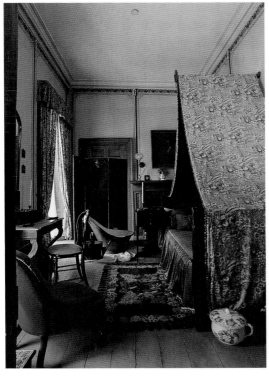

Clockwise from top left: A bedroom that has been carefully restored; even the dovecote (for raising pigeons) is a triumph; kitchen, pantry and scullery are in the basement.

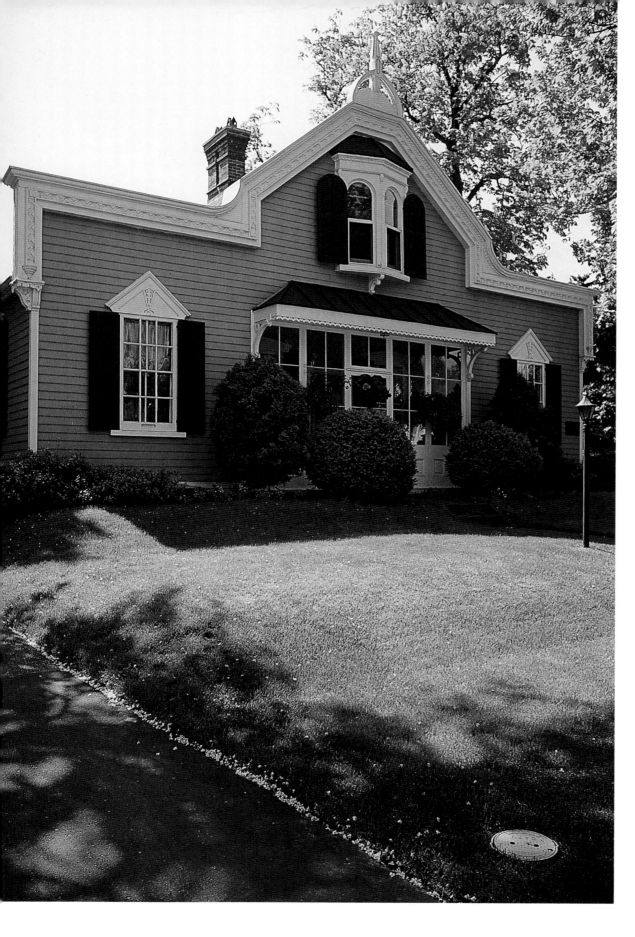

Blathwayte House

Burlington

Part Gothic, part Regency, part boomtown, this delightful frame cottage is a vernacular tour de force. Local lore suggests that it was built in the late-Victorian era by master carpenter James Bent for a shipping merchant named John Blathwayte. Even by Victorian standards, it is an eccentric composition, but research has yet to reveal whether it was contractor or client who was inspired to build such an unconventional home.

Beneath the gingerbread icing and ornamented windows is a simple gable-toward-the-street structure flanked on each side by lesser lean-to wings. The wings are disguised with false fronts, a technique often seen in Wild-West boomtowns but here used to heighten the storybook effect.

Compact in its interior arrangement, the house has no hall. The front door, sequestered behind a glassed-in verandah, opens directly into the dining room and hearth.

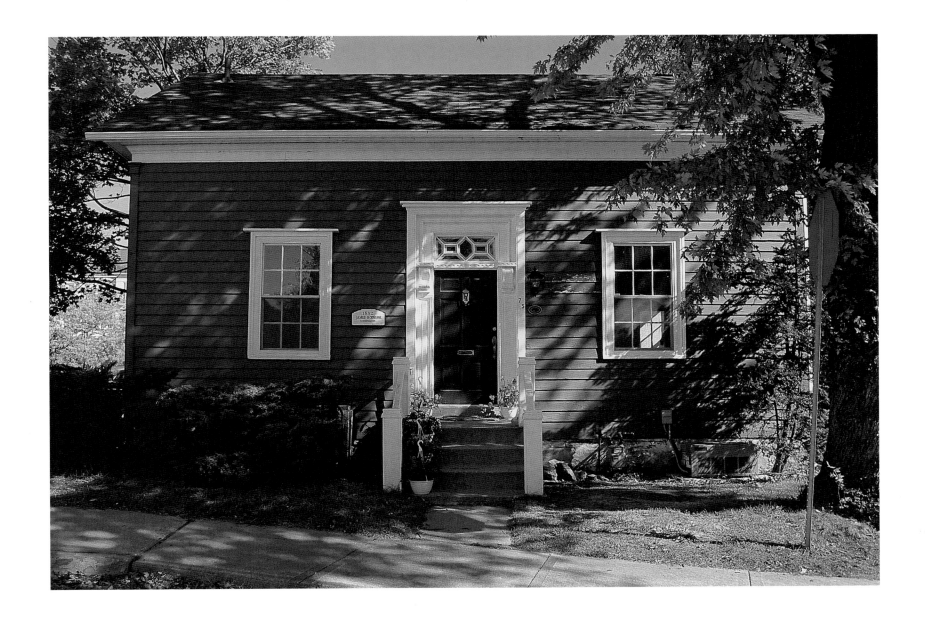

Connor House

Oakville

Midway between Hamilton and Toronto, Oakville is best known as a bedroom community for both cities, but its older neighbourhoods recall a time before the Queen Elizabeth Way made it a suburb. The streets of old Oakville are remarkably well preserved, and around every corner is yet another architectural treat. One of them is the diminutive James Connor House, built about 1852. Though modest in dimension, it has good proportions and surprisingly handsome trim. (Perhaps the trim is not so surprising, considering that Connor was a carpenter by trade who took great pride in his work.) The transom over the front door is the outstanding feature.

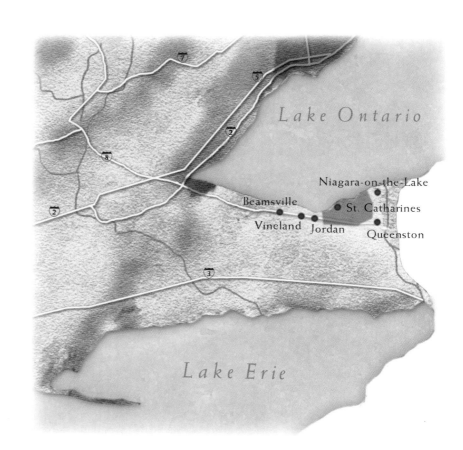

Lake Ontario

Lake Erie

Niagara-on-the-Lake

Beamsville

St. Catharines

Vineland Jordan

Queenston

NIAGARA

The Niagara Peninsula lies in Canada's banana belt, with a climate so mild that it blossomed into the nation's leading producer of tender fruit. But long before its fields were planted with orchards, Niagara had a military function. Like the upper St. Lawrence, it was too close to the American frontier for comfort, so settlement was a top priority for Upper Canada's founding fathers. Strategically, they awarded much of the land to retired soldiers who could be recalled into service in the event of enemy attack. It proved a wise move, for the military presence was a deciding factor in defending the peninsula from the American invasion during the War of 1812. To this day, the memory of the war—the last to be fought on Canadian soil—lingers.

In addition to the soldiers, Niagara was also home to the usual assortment of Loyalist and British immigrants. What made the region distinctive, however, was the presence of a significant number of German-speaking Mennonites for whom resettlement in Upper Canada had less to do with politics than with finding new opportunities for its younger generation. The sect settled in and around Vineland and Jordan, bringing their unique way of life with them. They shared their abiding admiration for Georgian architecture with the mainstream population but maintained their enthusiasm significantly longer. The style had faded by 1840, but the ever-conservative Mennonites were still building Georgian-style houses at the time of Confederation. Today, Georgian houses are better represented in Niagara than anywhere else in the province.

The dominant landform in the region is the Niagara Escarpment, which runs inland along the Lake Ontario shore. From atop the bluff, you can see the skyline of Toronto, but urban pressures feel even closer these days as the suburbs of St. Catharines and Hamilton gradually gnaw away at the fruit lands. Despite this, the peninsula still retains much of its historic character. Its most scenic assets are the smaller towns such as Niagara-on-the-Lake and Queenston, not to mention its estate vineyards, the Welland Canal and, of course, the Falls.

Above: Typical Georgian restraint shows in the design of the staircase and newel post.

Right: Early Niagara mantels are legendary among historians for their consummate design. The Breakenridge House doesn't disappoint.

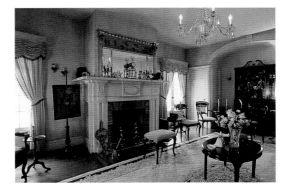

Niagara

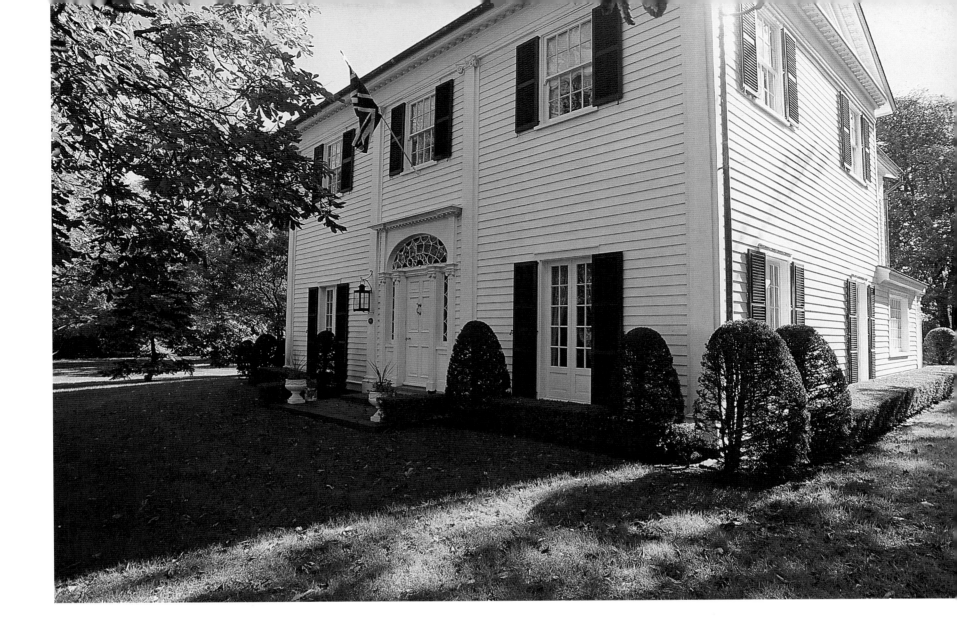

Breakenridge House

Niagara-on-the-Lake

When John Breakenridge died in 1828, the local newspaper reported, "He settled here shortly after the war and built several of the most elegant and tasty houses in town." The war was the War of 1812, which saw the entire town of Niagara burned to the ground by the Americans. During the reconstruction period that followed, Breakenridge built this handsome frame dwelling with a stunning semicircular transom above the doorcase. His roots were in Virginia, and it seems he brought at least one Southern building tradition with him: The kitchen was in a separate building, which quickly proved impractical in our climate. In 1823, he sold the property and built another "tasty" house nearby.

Willowbank

near Queenston

Willowbank is one of the purest expressions of Greek Revival style in all Ontario. It is also one of the most opulent, with its colossal paired columns that rise the full height of the building to support the expertly executed cornice and pediment. The latter are not only inspired by classical Greek architecture but replicate it virtually to the letter. While the eight columns command the eye, note also the grand dimensions and ornate treatment of the façade windows, doorcase and balcony. When the house was new in 1834, it was a grand architectural statement and a conspicuous departure from convention. Much of the credit goes to the skill of the architect, recorded only as Lathrop, to whom is also attributed Ruthven (see page 141) near Cayuga, which takes the Greek Revival one step further.

Standing on a rise facing the Niagara Gorge, Willowbank cuts a striking figure indeed. It was built by Alexander Hamilton, whose family lent its name to the bustling city at the western end of Lake Ontario.

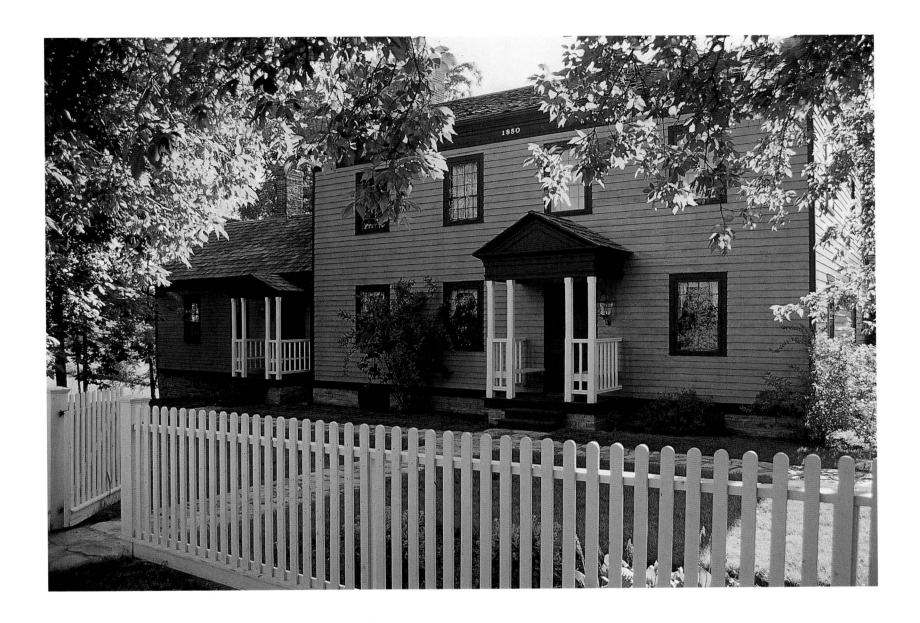

Honsberger House

near Jordan

Even if you didn't know that the Niagara Peninsula was once home to a sizable German-speaking Mennonite settlement, you might guess it on first sight of the Honsberger House, as its most obvious architectural asset is a *doddy haus*, the signature of Mennonite farmstead architecture. A kind of granny flat in its day, the *doddy haus* is a small addition built especially for the family elders upon their retirement from

farming. The concept was imported from the home counties in Pennsylvania when the first Mennonites emigrated at the close of the American Revolution and was a mainstay in Niagara's German neighbourhood for generations.

To some eyes, the house would have seemed out of date when it was new in 1850. After all, this was the period in which Victorian eclecticism took flight, and its basic Georgian shape

shows little interest in keeping pace with architectural fashion. The conservative lines and lack of ornament are actually clues to its origins, however, as they are an architectural reflection of the restrained, simple discipline that permeated every aspect of Mennonite life, from dress to dialect, politics to religion. The farm on which the restored house stands was in the Honsberger family from 1814 to 1975.

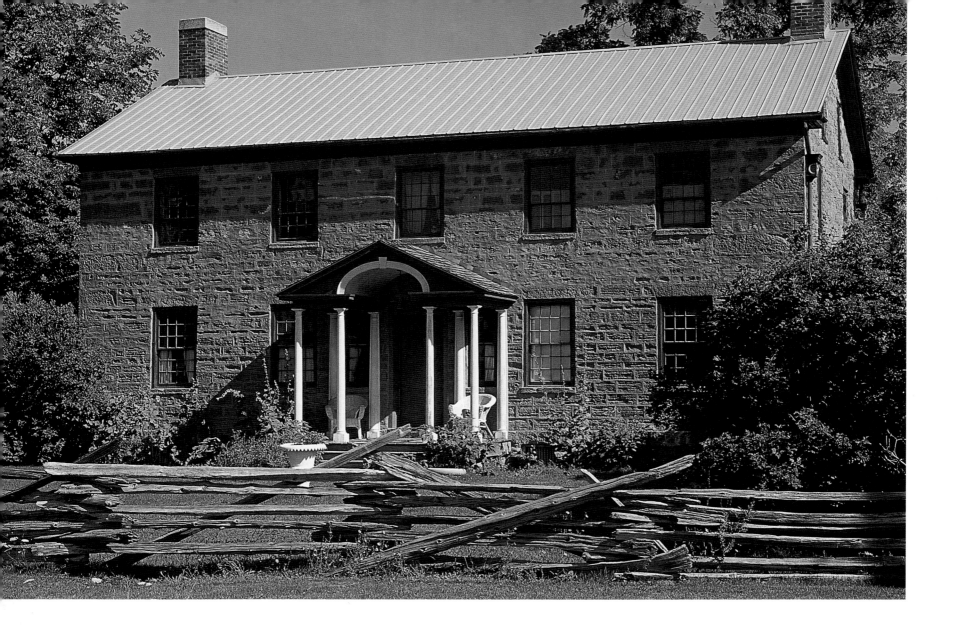

John Brown House

near St. Catharines

In 1796, Ranger John Brown and his oldest sons finished a small 20-by-20-foot stone home on their wilderness lot on the Niagara Peninsula. Brown, an officer who remained loyal to Britain during the American Revolution, like scores of other retired military men, took advantage of the Crown's offer of free land upon the close of hostilities. Although he had lost everything in the war, the stone structure was a sign that life was finally getting back to normal. But with a total of 10 children underfoot, he had something more substantial in mind.

In 1802, the family commenced work on expanding their dwelling into an impressive house that took its styling cues from Georgian conventions. Solid, symmetrical and simply appointed, it was larger than some and all the more impressive for its stone construction. It seems, however, that Brown never saw the house to completion. He died in 1804, and for some time afterward, his family operated the house as an inn and a tavern.

The house, including the 1797 section (which still stands as the kitchen tail), was struc-turally sound when it caught the eye of a heritage enthusiast in 1979, and ever since, restoration has progressed project by project. Inside, the taproom has been refashioned to look the way it would have during the Browns' time, while outside, much attention was devoted to replicating a four-columned portico over the front door. More formal than a verandah, the portico is about as close to architectural whimsy as Georgian custom would allow.

Above: The dining room has been restored with authenticity in mind, right down to the vivid colours on the walls.

Right: The hall is exceptionally wide. The wooden floor has been painted to suggest a fashionable canvas floorcloth.

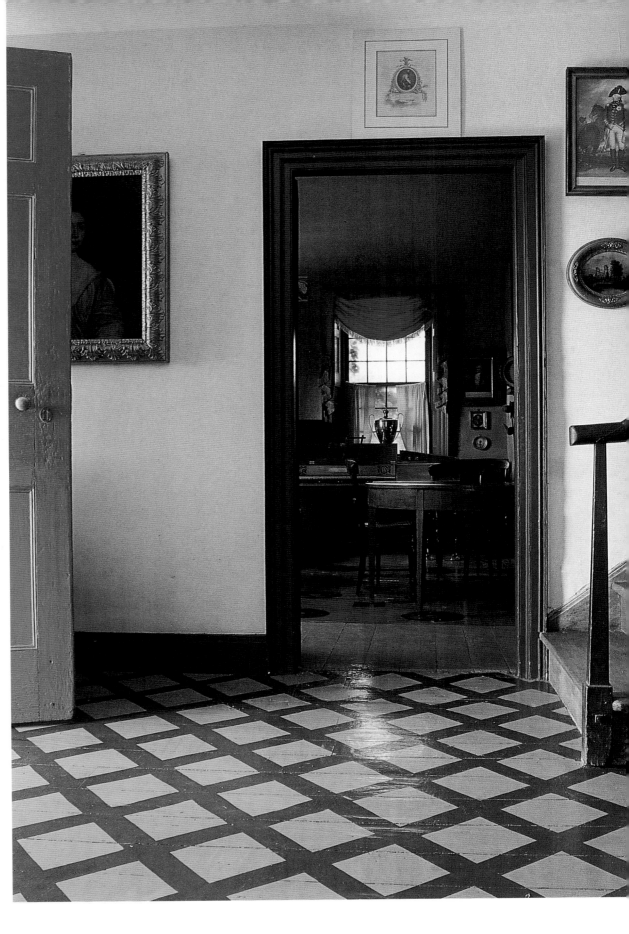

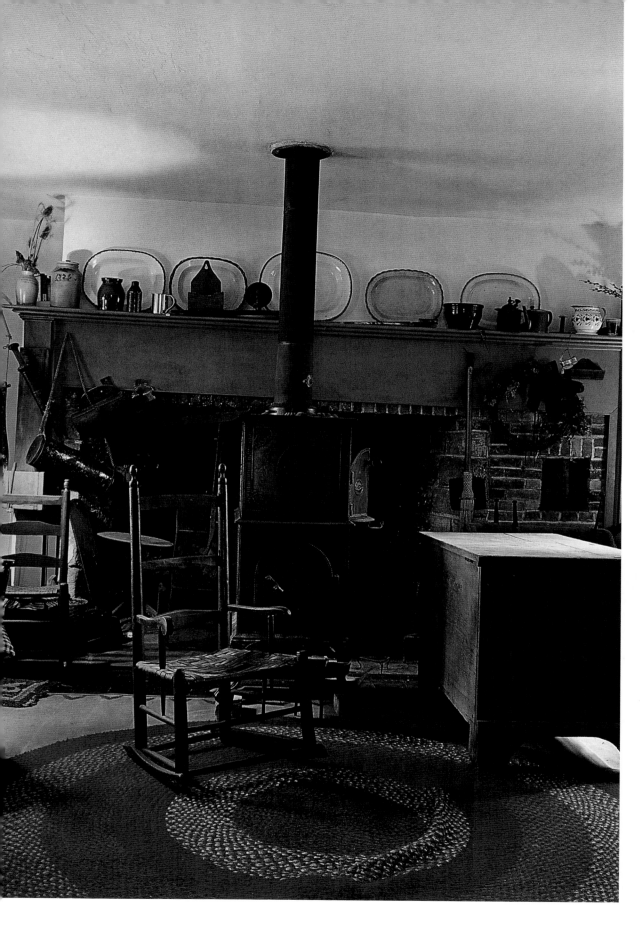

Left: The kitchen, complete with cooking fireplace, is part of the original 1797 tail.

Below: The taproom and bar have regained their early appearance.

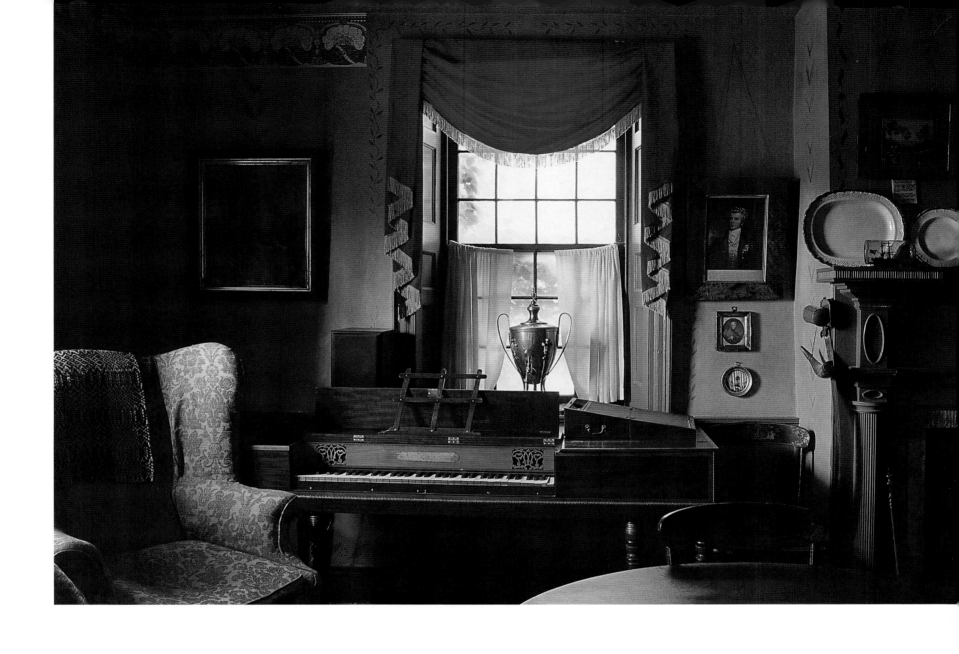

Above: The parlour adopts a formal air. The furniture, colours, window dressings and even the stencils, at right, are authentic to the pre-Victorian period.

Moyer House

near Vineland

Much has been written as to why the circa-1840 Moyer House (and others like it built in the Pennsylvania-German tradition) boast not one but two front doors. Some surmise that these dwellings were "double houses" shared by two generations of the same family. Others suggest separate entrances for men and women. Some simply note that two doors compensated for the lack of a centre hall: One entrance, which led to the parlour, received guests, while the other, opening directly into the keeping room, was strictly for family use. The Moyer House adds more food for thought, as the builder, Samuel Moyer, led a splinter group of Mennonites in religious meetings in the parlour, hence the extra door was required.

MacDougal House

Niagara-on-the-Lake

In a town chock-full of architectural superlatives, Colonel Daniel MacDougal's house in Niagara-on-the-Lake ranks among the best of the best, its restrained Georgian countenance augmented by two storeys of graceful arcaded brickwork. The arcades, an exceptionally rare decorative treatment, take centre stage, but the façade boasts any number of other refined details, including the elliptical fanlight transom that fits so neatly into its arch. Thought to date to the early 1820s, the house has a very urban look, especially with its parapet walls, which extend higher than the eaves to thwart the spread of flames from neighbour to neighbour. Colonel MacDougal didn't build the house, but as a local hero in the War of 1812, he was its most renowned resident.

Woodburn Cottage

Beamsville

On the main street of Beamsville stands a textbook study in Regency grace. Woodburn Cottage has all the hallmarks of the genre and makes a statement of its own. A verandah is conspicuously absent, and the tall foundation (presumably the kitchen was originally in the basement) also deviates from the prototype. Judging by the size of the windows, sunlight was a priority for the builder. Indeed, the front windows are so large, they dwarf the doorcase. It's a handsome composition nonetheless. It dates from about 1834.

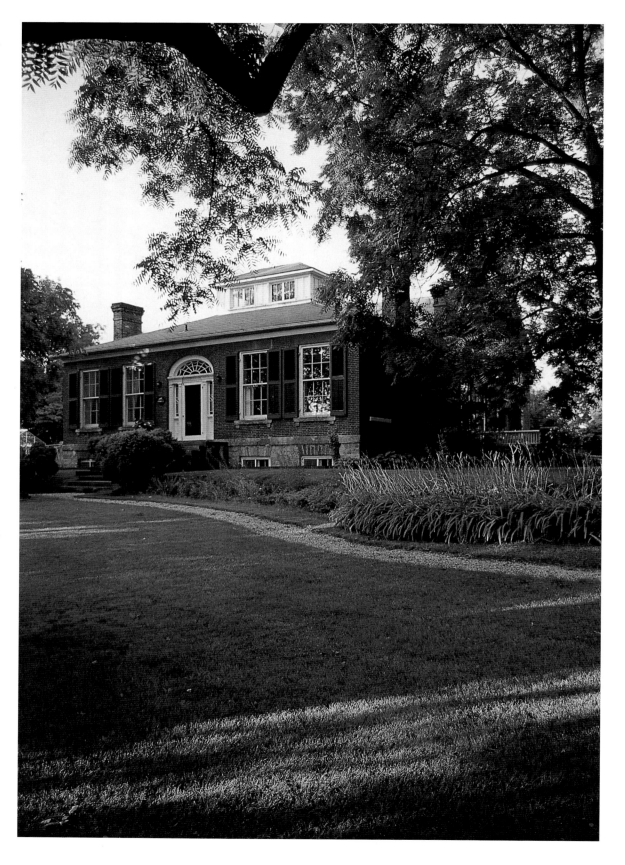

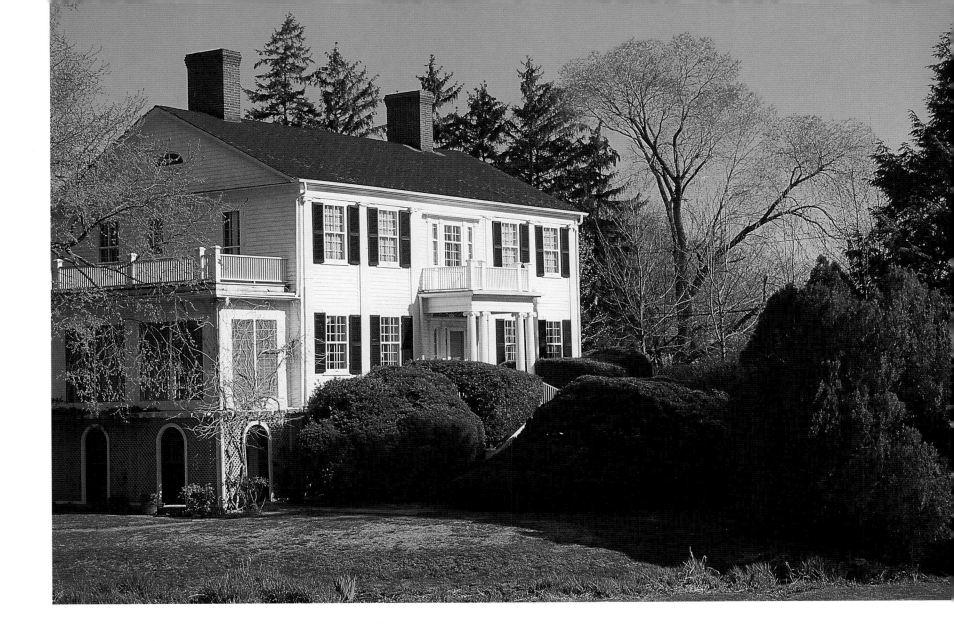

Clench House

Niagara-on-the-Lake

Details make the difference, and the Clench House shows how. Its Georgian finesse is impressive enough, but it really shines as a result of its component parts. Take a closer look at the fanlighted doorcase and the Venetian window above; the chimneys, placed well to the inside of the gable ends; the restrained cornice mouldings; and, of course, the fluted pilasters that divide each bay. Each adds a measure of refinement that easily elevates the Clench House into a league of its own.

Ralfe Clench was a lieutenant in Butler's Rangers, the military corps that was awarded much of the land in Niagara-on-the-Lake as a reward for service against the rebels in the American Revolution. He was a member of the provincial government and a judge of surrogate court, and when the War of 1812 broke out, he was a colonel in the militia and taken prisoner. He died in 1828, only a few years after the house was built.

125

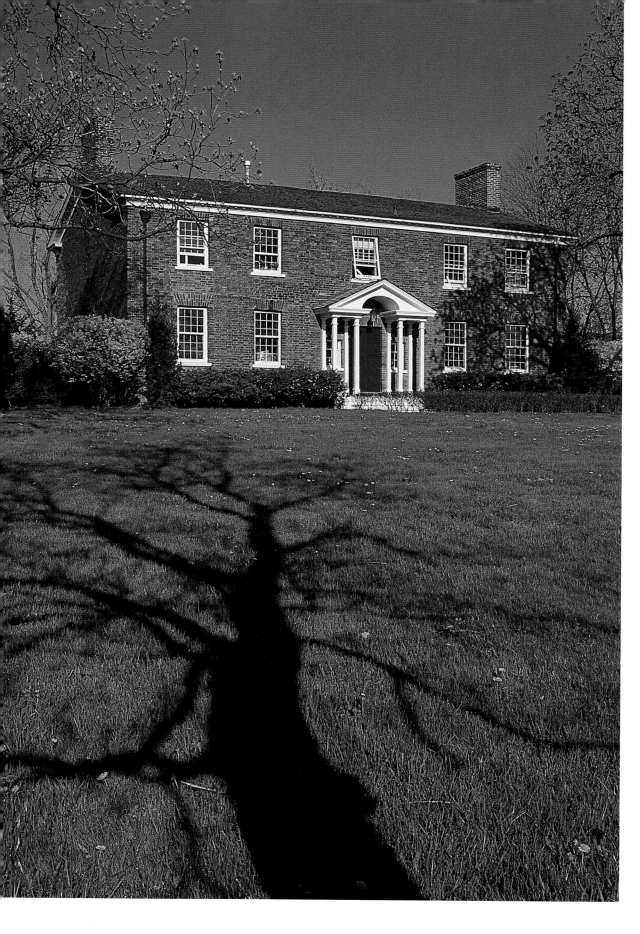

Field House

near Niagara-on-the-Lake

In 1795, William Dickson, a merchant in Niagara, petitioned the lieutenant-governor for more land. He claimed he was entitled, at least in part, because he had built the first brick house in the province. Since then, historians have debated over which residence deserves the honour of being considered the second brick house in Ontario. Certainly, the Field House, which in its original form is said to have been built in 1797, could be a contender, and even if it weren't, it would still rank as an exceptional dwelling.

The house faces the Niagara Gorge south of Niagara-on-the-Lake. It was built by John Field, a Loyalist and gentleman farmer who served in the American Revolution and the War of 1812. During the latter, the house was shelled by enemy troops and damaged to the extent that it was rebuilt with a second storey when the hostilities subsided. So does it really qualify as the second-oldest brick dwelling in the province? Even the historians can't agree.

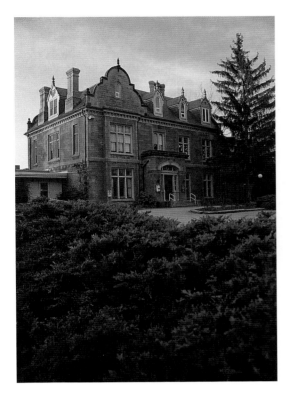

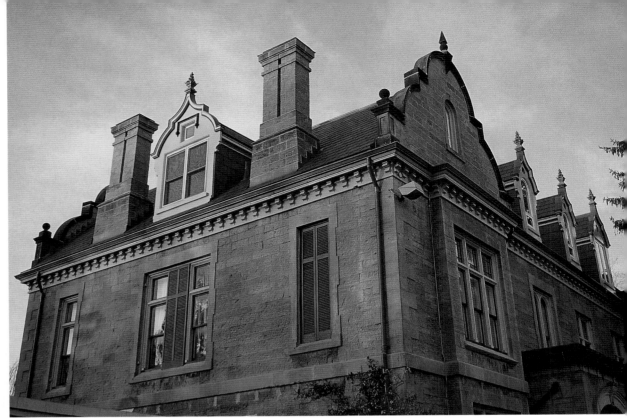

Rodman Hall

St. Catharines

The Tudor stylings of Rodman Hall say something about the values of early Ontario. Taking its cues from the castles and baronial manors of Henry VIII's England, it displays a regal dignity and a reverence for the motherland, but what is particularly Canadian about the house is that it is not American. In fact, the Yankees didn't have much use for anything British, and homes like this more often found favour on the northern side of the Great Lakes.

Now converted to an art gallery, Rodman Hall was built for Thomas Rodman Merritt, who owed his status to his father, William Hamilton Merritt, the man behind the Welland Canal. The house dates from 1853.

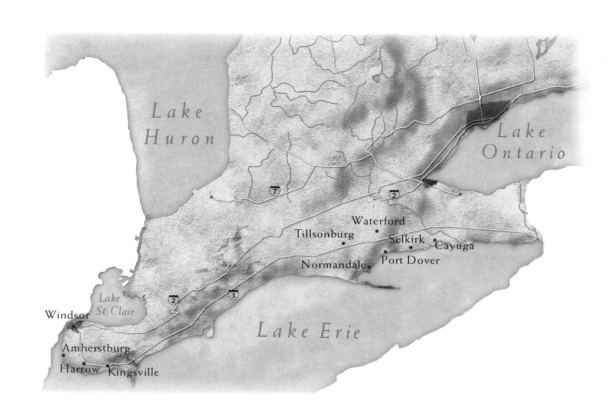

LAKE ERIE SHORE

Look at a map of Lake Erie, and you'll quickly see that all the most populous cities are on the American side. Toledo, Cleveland and Buffalo are at or beyond the million mark, while Detroit (not actually on the lake but several miles up the Detroit River) ranks among the largest metropolises in the United States. By contrast, the Canadian shore is decidedly rural. Port Colborne, with a mere 20,000 people, stands as the largest of the lakeside towns, with the possible exception of Windsor, which, like Detroit, is not technically on the lake.

In their day, the Canadian ports—Port Ryerse, Port Dover, Port Stanley and Port Burwell, among others—aspired to greatness, but the early-20th-century industrial boom that fired the growth of the American cities would bypass them. Toronto and, to a lesser extent, Hamilton would see to that, siphoning off the Great Lakes

trade for themselves. Hence, the Lake Erie ports chugged along, servicing local farmers much the way they always had since the area was settled by Loyalists at the close of the 18th century. Today, many of these villages are remarkably well preserved in picturesque settings and are home to the region's oldest buildings.

In the townships north of the lake, tobacco emerged as the lifeblood of local farmers, and although the demand waned a few years ago, the future of agriculture seems assured, considering that the Lake Erie counties have one of the most benign climates in all of Canada. Though the area prospered, the farmhouses left behind by previous generations are, as a rule, self-consciously prim and Presbyterian, but here and there in the larger inland towns—St. Thomas, Tillsonburg and Simcoe, to name a few—are some real Victorian showpieces.

Second Empire House

Amberstburg

What could have been a heavy and forbidding façade was treated with a light, skilful hand in the blending of Second Empire and Italianate motifs. This house, which dates from about 1880, owes its basic form to the French Second Empire style—the mansard roof is the obvious hallmark—while the profusion of slender, Italian-inspired windows adds vitality to the composition. The whimsical trim helps too. Note that under all the fanfare lurks the steadfast solidity of Georgian symmetry.

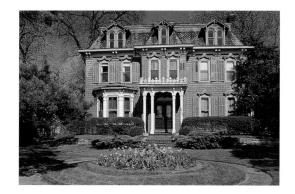

Lake Erie Shore

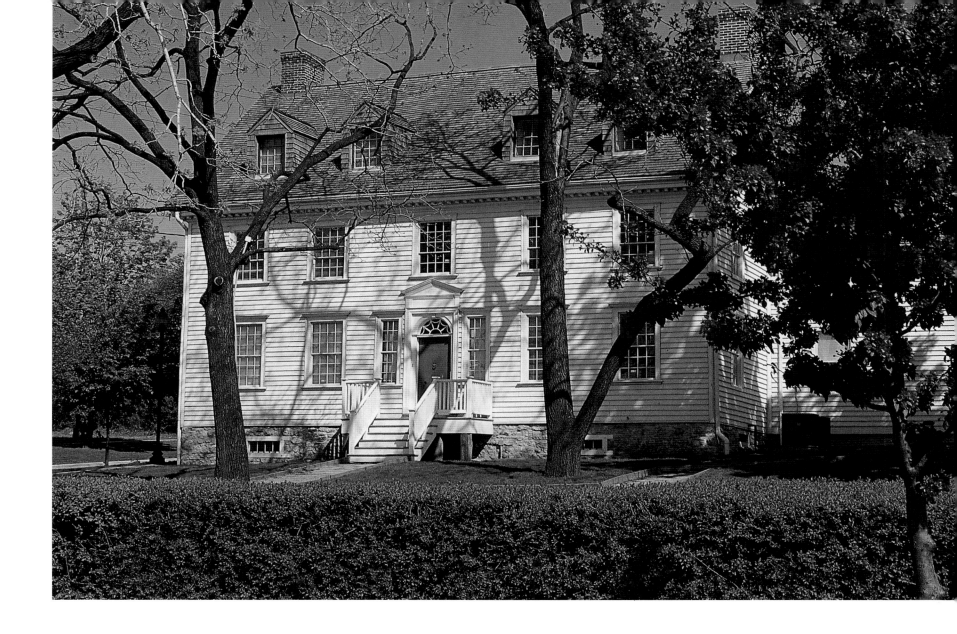

Baby House

Windsor

The name of fur-trader-turned-Detroit-Loyalist Jacques Baby (pronounced Bobby) is a reminder of Windsor's early days as a French stronghold, but the house he built at the close of the 18th century was anything but. It is the quintessential English residence, its restrained lines a shining example of Georgian simplicity. No unnecessary ornament here: The house ably demonstrates the clean, unadorned look so favoured by the gentry in Upper Canada's early years. By 1820, houses like this were no longer the height of architectural fashion. Roofs were less steep, sidelights were incorporated into the doorcase, and details took a turn toward the elaborate (see Clench House, page 125).

Now in the hands of the Ontario Heritage Foundation, the Baby House currently contains government offices.

131

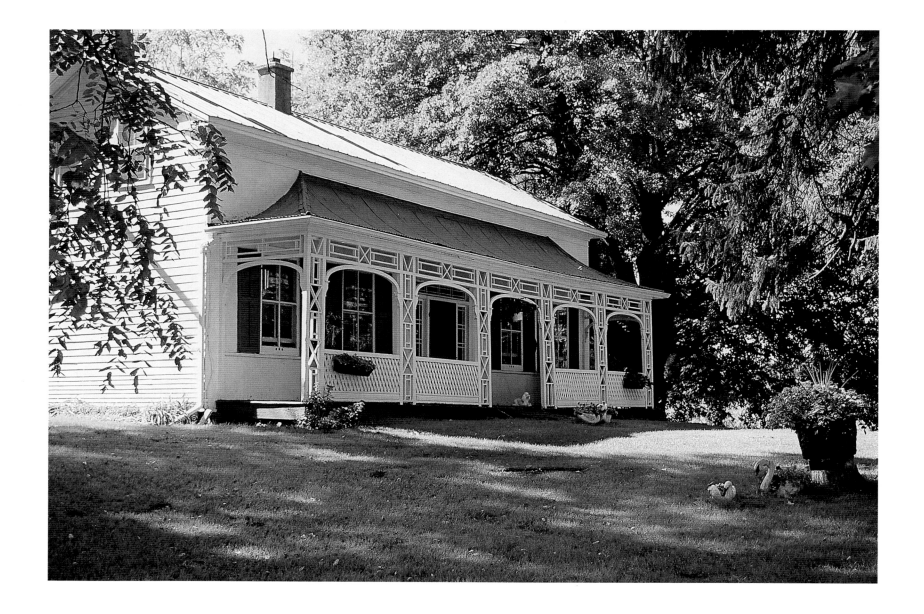

Walker House

near Port Dover

Local histories suggest that this simple frame
saltbox dates to about 1825. Its austere lines are
greatly enhanced by a whimsically styled veran-
dah, an excellent example of the early trellis
type. Few of its kind survive today, as keeping
them painted is a thankless chore. But survive
it has—the fanciful bowed roof and delicate
treillage speak volumes about the elegance of
Regency style.

Van Norman House

Normandale

This handsome 1841 Regency cottage is a
testament to Romaine Van Norman, heir to
the iron foundry that put Normandale on the
map. The testament almost didn't last, however,
for although his house is a stylistic coup, it was
plagued by a nasty structural problem. Built
without interior load-bearing walls or columns,
it sagged, even when new. The doorway trim
had to be planed before it could be squeezed
into place. It took about 130 years and a new
owner bent on preservation, but the flaw was
finally stabilized with pneumatic jacks placed
at regular intervals in the basement. Today, Van
Norman's cottage looks no worse for wear.

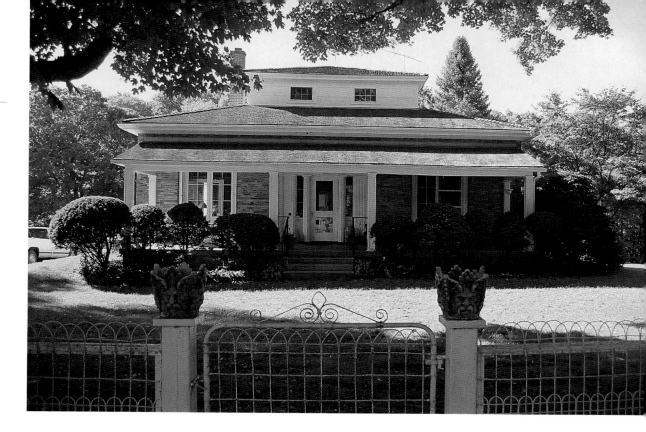

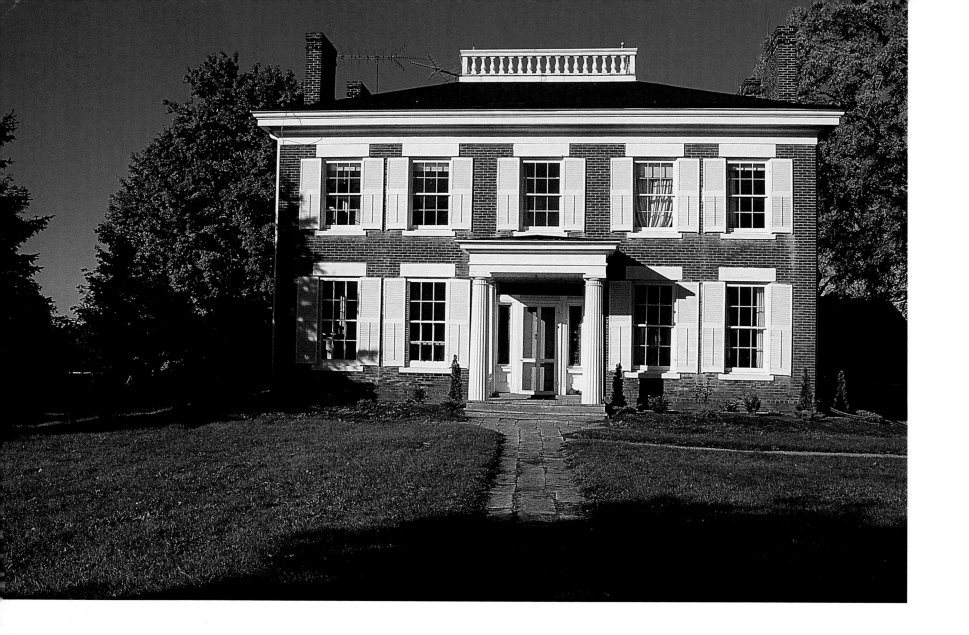

Sovereign House

Waterford

Like Cottonwood Mansion (see facing page), the Sovereign House is a marriage of styles, albeit a generation older. Once again, it's the tried-and-true Georgian mode that has come a-courting, but here, the bride is the de rigueur Greek Revival. The former shows in the regular placement of windows around the front door, while the newer style is apparent in the wide

cornice and entrance portico, which is supported by thick Doric columns.

The house was built by Leonard Sovereign, who presided over commercial affairs in Waterford, although unlike many a small-town business baron, he never dabbled in politics. The property remained in his family until 1937.

Cottonwood Mansion

Selkirk

This is what happened when the new Italianate style mated with the old Georgian principles of symmetry and proportion. Cottonwood Mansion, the landmark of Selkirk built in 1865 by William Holmes, shows the influence of new and old. The regular arrangement of windows around the central front door is, of course, an old Georgian custom, and although the house lacks the characteristic watchtower, the rest is pure Italian, from the paired brackets that line the eaves to the profusion of Florentine (double-arched) windows. The widow's walk and belvedere are handsome touches, but the limelight really belongs to the verandah—its delicate posts and tracings wrap around three sides of the building, tightening the composition considerably.

For almost 80 years, Cottonwood Mansion stood vacant. Then in 1992, a Holmes descendant headed a campaign to restore the building and turn it over to the public for use as a museum and community facility.

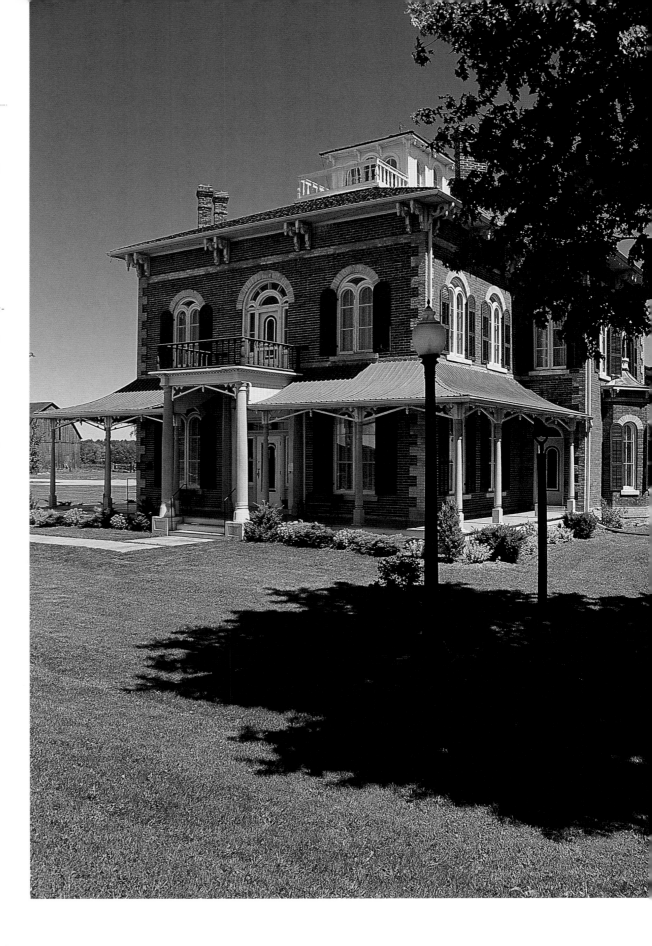

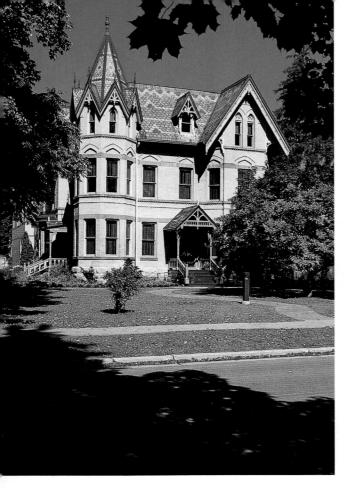

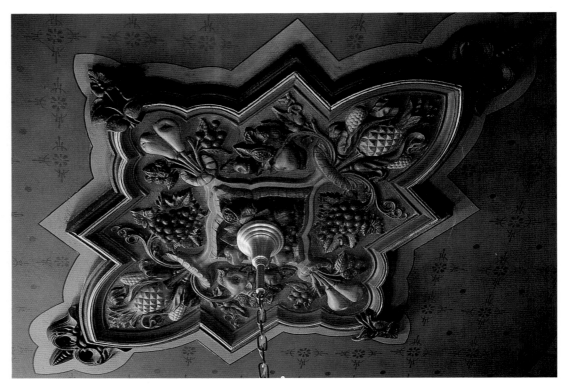

Annandale

Tillsonburg

Tillsonburg's founding family was living very comfortably by the late 1870s. Not only was the patriarch, E.D. Tillson, a leader in civic affairs—at one time or another, he was postmaster, magistrate and mayor—but the town had him to thank for transforming it from just another farming village into a thriving industrial centre. Tillson money was in everything: a lumber business, grist, oat and cornmeal mills, a brickyard and commercial developments along the main street. E.D. Tillson was also the brains behind the first local waterworks (prompted by the death of his daughter from typhus) and is credited with ensuring that not one but three

railways ran through town. By the late 1870s, it is no wonder that he felt the time had come to build a house more worthy of his status. Nor is it a surprise that more than a century later, his town saw fit to restore the house as a museum.

Tillson chose his design from a book of ready-to-build house plans called *Villas and Cottages, or Homes for All*, published in Albany, New York, in 1876. Adapted with hardly a change, Annandale, as the family named their estate, is a grand and eclectic composition, borrowing details from the Gothic and Italianate styles. The exterior is handsome enough, but it's the interior that really shines. To modern tastes, the dazzling

patterns and colourfully rendered walls and ceilings, many of them stencilled, are busy beyond belief, but by Victorian standards, they were very innovative and actually quite orderly. The décor takes its inspiration from the Aesthetic movement, whose geometric appearance was a reaction against earlier Victorian interior stylings, which were, believe it or not, even more exuberant. Aestheticism could count William Morris and Oscar Wilde among its champions.

The Tillsons weren't the only family in Ontario smitten by *Villas and Cottages*. A virtual clone of Annandale stands in Lindsay, obviously inspired by the same plans.

136

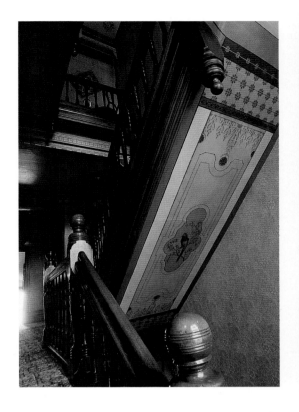

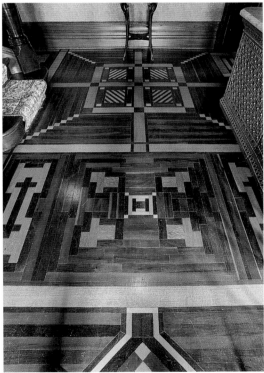

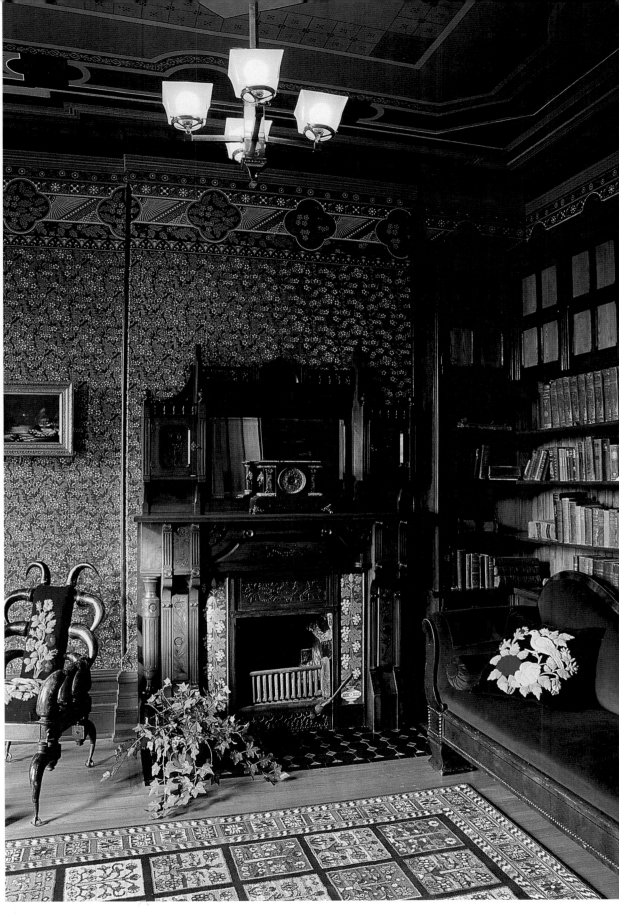

Clockwise from top left: No surface was left unembellished, be it stairway, walls, ceilings or floors.

Gordon House

Amherstburg

It is sometimes assumed that the austerity of Ontario's Georgian houses is somehow related to primitive conditions. The truth is that while the pioneer era was less than ideal for home-building, the better Georgian houses were re-strained not because local carpenters were inca-pable of anything fancier but as a consequence of architectural fashion. Even in mother Eng-land, the buildings of the Georgian period show a similar reserve.

The Gordon House was remarkably sophisti-cated for its day, considering that in 1798, the townsfolk had barely settled in after moving lock, stock and even entire houses from across the river in Detroit when the fort was ceded to the Americans. The plain façade and balanced proportions display good Georgian manners.

The Gordon House was shelled during the American siege of Amherstburg in 1813, but its darkest days came in the 1980s, when demoli-tion seemed imminent. The town stepped in, purchased the building and carted it 600 feet away, but its ultimate fate wasn't decided until several years later. Today, the house is head-quarters for the H.M.S. *Detroit* project (whose mandate is to build a replica of a tall ship that once patrolled the river), and the plain Geor-gian exterior has been restored to the letter. Documents from an 1813 war-compensation claim still exist and provided many details for the restoration.

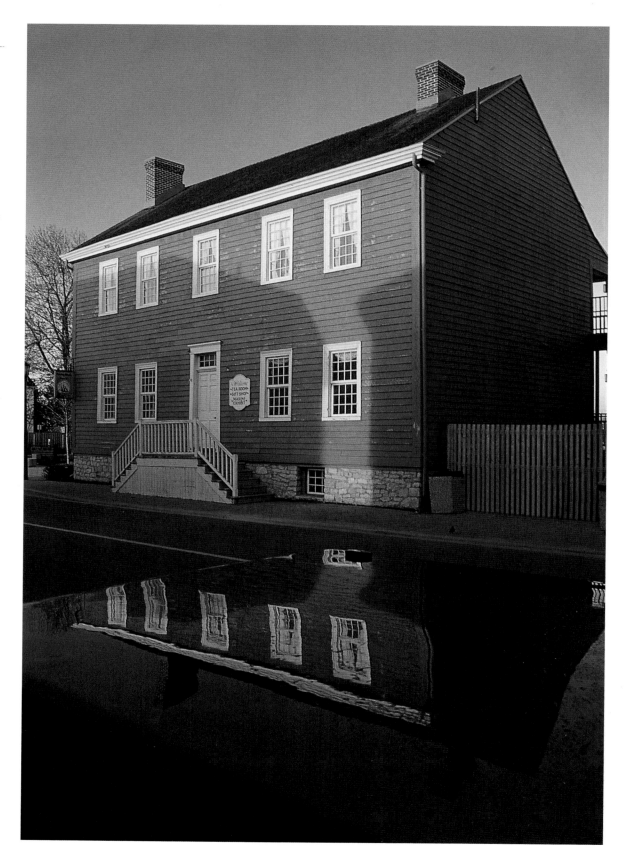

Lake Erie Shore

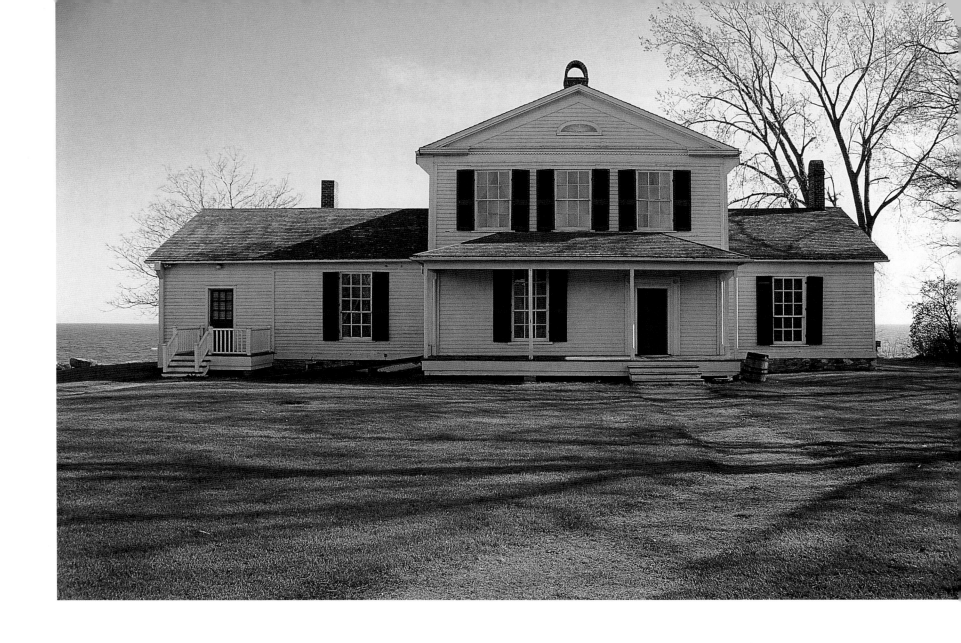

John R. Park Homestead

near Harrow

The John R. Park Homestead might be described as a poor man's Crysler Hall (see page 15), not that the Park family was poor. Both houses take their basic outline—a two-storey centrepiece flanked by two lesser wings—from the same source, namely the architecture of ancient Greek temples, but when it came to finishing them off with lavish detail, the Parks couldn't keep up with the Cryslers. Nevertheless, the Park home is an elegant vernacular composition in its own right, with ample windows, restrained trim and a handsome fan medallion in the gable. Built in 1833, it is now open to the public.

139

California Bungalow

Kingsville

Today, "bungalow" is used to describe just about any single-storey subdivision house, but when the concept was new, the term referred to a specific style that first surfaced in California and crossed the Canadian border just after World War I. Ironically, most bungalows, like the house pictured here, had upstairs bedrooms, but the characteristic hallmarks are the low, sprawling silhouette and the broad, overhanging roof. Verandahs, dormers and chimneys seem to pop up at random, but that's all part of the rustic formula. The darling of the Arts and Crafts movement, the bungalow revelled in a snug, comfortable, homemade look, an antidote to Victorian pretension. In the roaring '20s, developers took the idea one step further, but by then, the bungalow was so watered down that even the true examples such as this one grew old fast. They're worth a second look today.

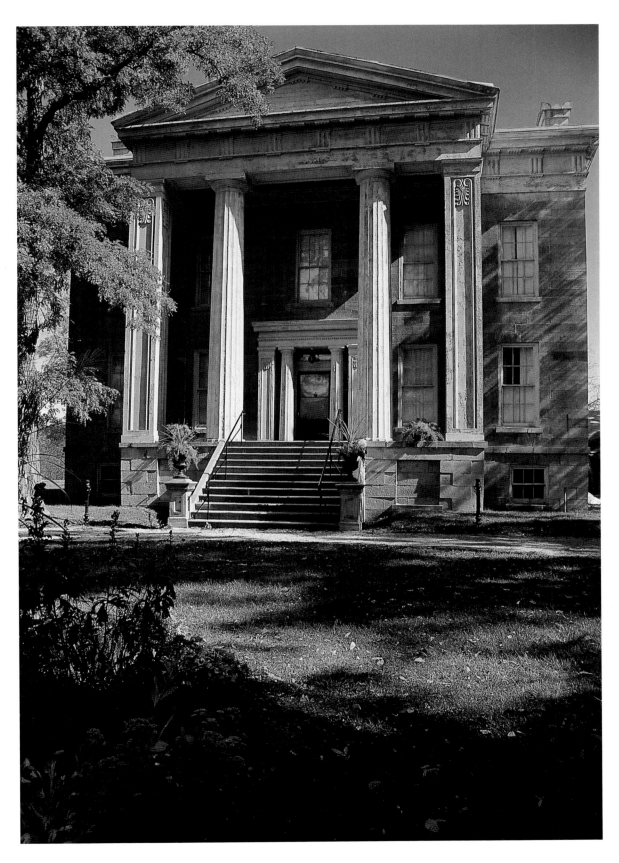

Ruthven

near Cayuga

Ruthven, built for the wealthy David Thompson family of Indiana (later renamed Cayuga), was cut from the same cloth as Willowbank (see page 116) and designed by the same architect. Both houses are essays in Greek Revival glamour, but it is Ruthven, built 11 years later in 1845, that stands out as perhaps the more daring of the two, more upright in proportion and, if possible, even more Greek.

The Revival took its inspiration from ruins in the eastern-Mediterranean area that became popularly known through the work of archaeologists in the 1820s and 1830s. To New World entrepreneurs such as the Thompsons, the ancients represented enlightenment and idealism, hence the penchant for Greek forms in their new houses. The better Revival architects learned their lessons well, adopting the lines of different "orders" or periods from ancient Greece. Willowbank borrows from the Ionic order. Outside, Ruthven adopts the stark lines of the Doric, although inside, the characteristic scrollwork of the Ionic capital is clear in the columns that divide the double drawing room.

The Thompsons had a hand in almost every commercial pursuit in Cayuga, including mills, a distillery and a general store, not to mention politics. They also owned more than 2,000 acres of land, some of which was still in the family when the last of the line died in 1993. At that time, the house was still in sound condition, and the interior was graced with an eclectic collection of furnishings, some original to the house when it was new in 1845. Little known outside architectural circles, the house and grounds are gaining a higher profile under the guidance of the Lower Grand River Land Trust, whose goal is to restore the property. In "as found" condition, Ruthven is already open to the public.

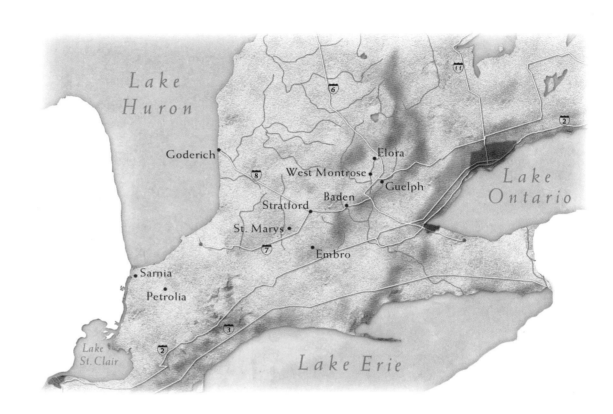

SOUTHWESTERN BREADBASKET

Were it not for their mutual ties to Toronto, western and eastern Ontario might seem to have remarkably little in common. Where the eastern landscape rolls in drumlins, the west, especially the rich breadbasket past Kitchener, is as flat as a tabletop. Here, the grid survey spills across the landscape uninterrupted by hills or any other landform, and the concession roads run for miles without a curve. The land, once the bottom of an ancient glacial lake, is far more productive and supports a larger farming population, hence towns occur more frequently.

In the east, the farm lots are narrow, especially those fronting a navigable body of water. This was less important in the inland western counties, so the lots are wider and the farmsteads are spaced farther apart. Typically, houses are perched on a high point of land toward the centre of the property, as was the British cus-

tom, which, again, differs from that of the east, where farmers often took a lesson from New England and New York and built their houses and barns near the road. Moreover, the western counties came of age a generation or two later; generally, the oldest houses still standing were built after Confederation. Indeed, a house past its 140th birthday is a rare find.

But of all its distinguishing features, the mark of western Ontario is the almost universal preference for yellow or buff-coloured brick. The exceptions are Waterloo and Wellington counties and parts of Perth County, where stone was the building medium of choice. The northern reaches of Waterloo, in particular, have a character all their own, reflecting the legacy of Mennonite-German settlers who brought a unique approach to homesteading with them when they immigrated from Pennsylvania.

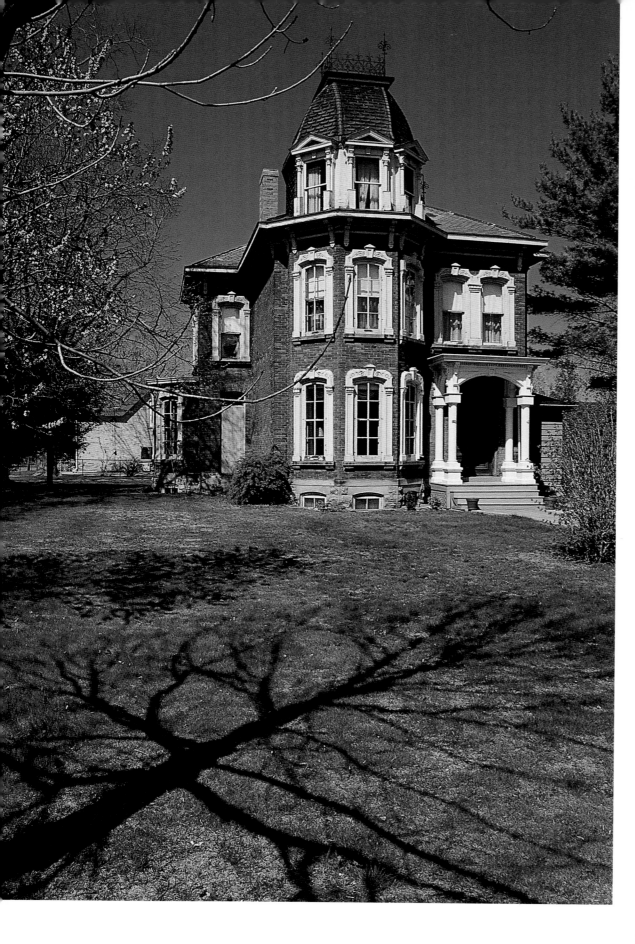

Strachan House

Goderich

Sheer off the oversize dome, and this house, built for merchant Donald Strachan, is not unlike scores of other 1880s Victorians, albeit better than average with its profusion of windows and elaborate windowcases. Still, there's no question that the dome and the two-storey bay window supporting it are the elements which lend the composition its abiding presence. Its mansard roof was obviously inspired by the Second Empire movement. When it was new, the local press called the house "one of the most elegant and substantial in our town."

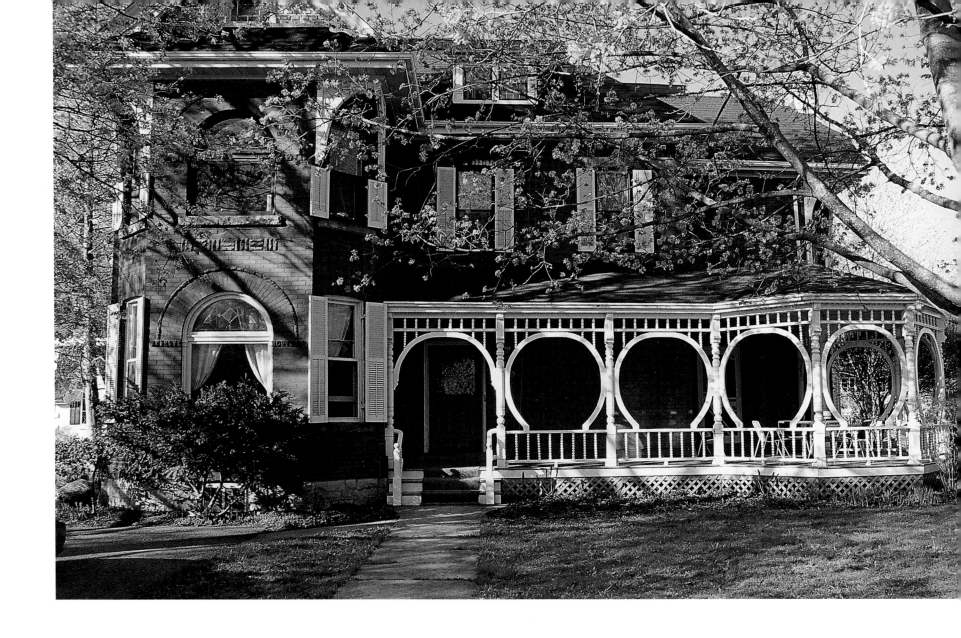

Barron House

Stratford

Never underestimate the value of a verandah in making a bold architectural statement even bolder. This proud Victorian, built by Judge John Barron, was grand enough when it was new, but the verandah, which is thought to have been added several years later, steals the show with its gazebo-like corner and fanciful hoop motifs.

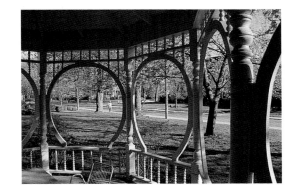

145

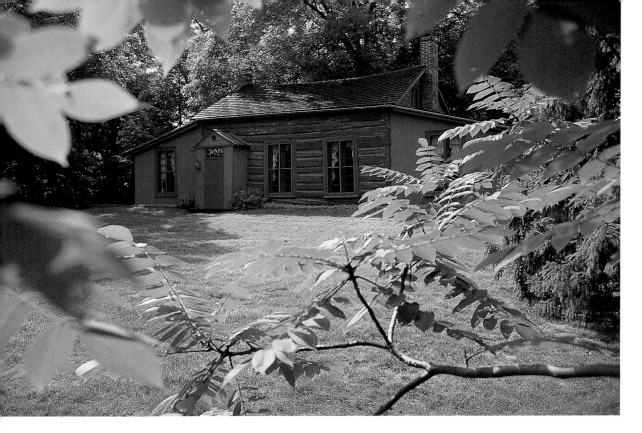

White Log House

Guelph

Not every log house was a settler's shanty. Indeed, some were built as permanent structures, and a few were unabashedly romantic in design. Although they look rugged enough, the latter were not built by destitute immigrants but for a more genteel class, those for whom Susanna Moodie's notion of "roughing it in the bush" was an amusement, not a way of life.

The little cottage shown here, now surrounded by the suburbs of Guelph, was built by Robert White around 1840. Although his business was in town, he chose to live in the country. He could probably have afforded something more pretentious but preferred the crude charm of log. With its stylish windows and lean-to wings, it was hardly a makeshift cabin. More proof is inside: The wings have vaulted ceilings, and the woodwork, including the fireplace mantel, is far from rudimentary.

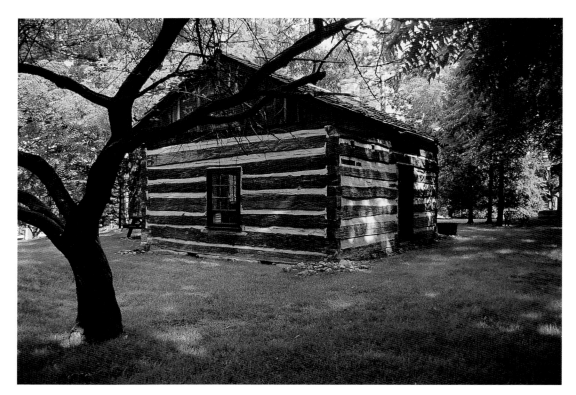

146

Above: The current owners were so enamoured of log buildings that they bought an old structure near Arthur and relocated it to their property. It functions as storage space.

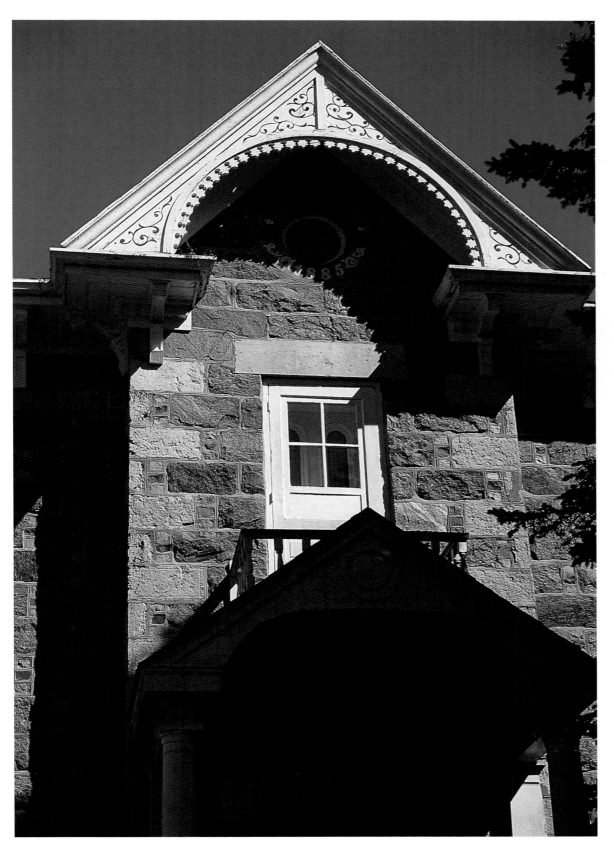

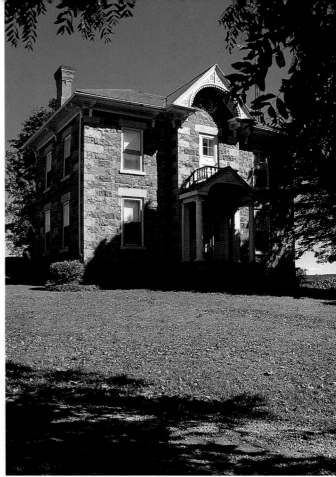

Reid House

near Embro

Most of the masonry houses west of Waterloo County are brick, but here and there, as in the environs of Embro, are pockets of stone. Built about 1885, the Reid House is a rather late expression of the mason's art and is more a technical triumph than a stylistic one. Although prim and plain, the house is notable for its consummate stonework. The cut-granite fieldstones were laid with precision, enhanced at regular intervals by small "closers" to create a patterned effect. Quoins and lintels, picked out in contrasting colours, also distinguish the house as a cut above.

147

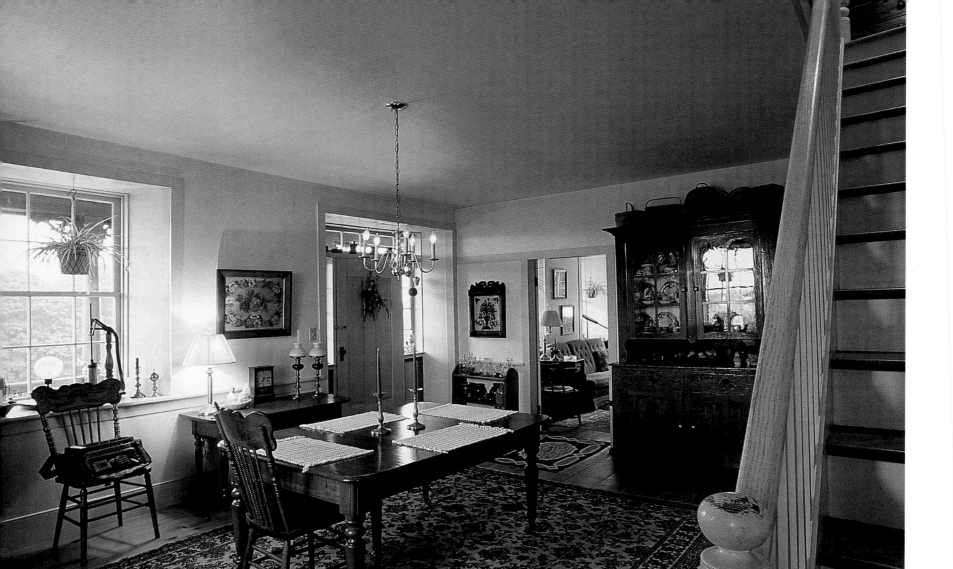

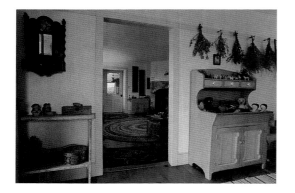

Above: Stairs rise not from the front door but from the side entrance.

Left: The basement living area is simply appointed. Note corner fireplace.

Swope House

West Montrose

It isn't always easy to date a dwelling, for aside from the occasional diary or commemorative date stone, written records of house construction are frustratingly scarce. But a search through land titles and deeds tells at least part of the story, and sometimes we can guess the rest. In 1866, when Isaac Swope sold the property on which this quintessential Mennonite homestead stands, its value had tripled in eight short years. That's usually a good indication that the lot was substantially improved in the mean-

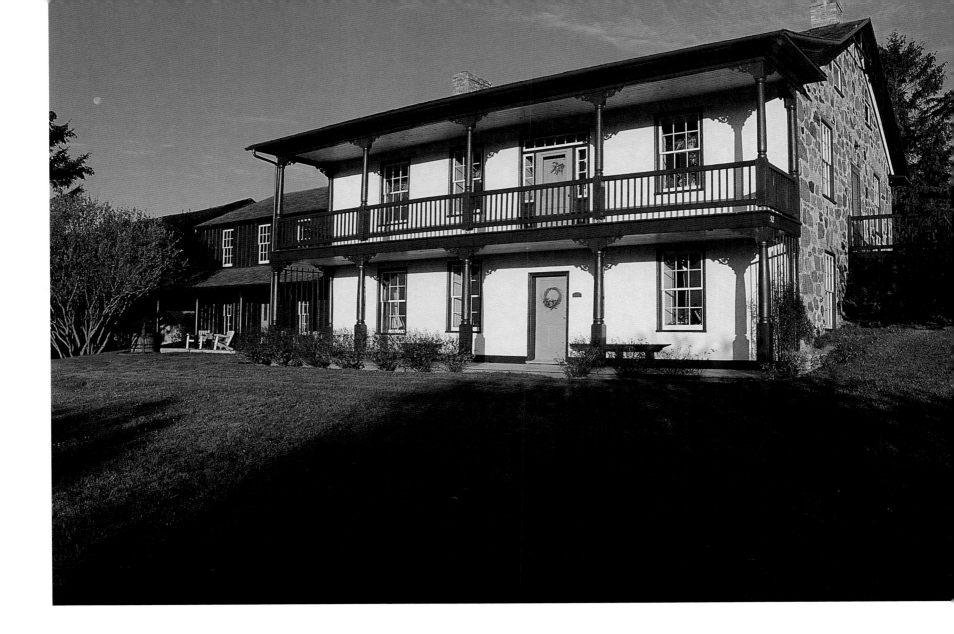

time. In other words, it's safe to assume Swope built the farmhouse between 1858 and 1866.

Considering that this was the era in which Victorian architecture rose to new and fanciful heights, Swope's house in the northern reaches of Waterloo County looks a little dowdy. But this was Mennonite country, where traditions were revered and there was little room for architectural fanfare. This is not to say the house lacks character, for it is rich in the nuances of a genre first brought to Upper Canada with Men-

nonite immigrants from Pennsylvania. It bears the unmistakable austere lines, the characteristic random stonework and a conspicuous lack of detail. The stuccoed façade—a nod toward formality—is also a Mennonite trait. Even so, there was still room for indulgences, namely the second-floor verandah, which offers a panoramic view over the lawn toward the Grand River. The interior displays the same lack of pretension. There is no centre hall, and the stairs rise from the side door.

Built into the side of a hill so that the basement opens at ground level, the house has a beguiling look, especially since the "front" door is inaccessible from the ground. Although meticulously restored and furnished with Mennonite antiques, the Swope House is not the only landmark in the neighbourhood. Just a stone's throw away is the last remaining covered bridge in the province.

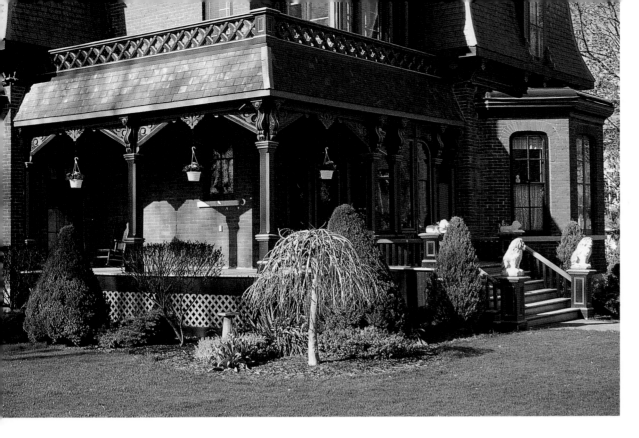

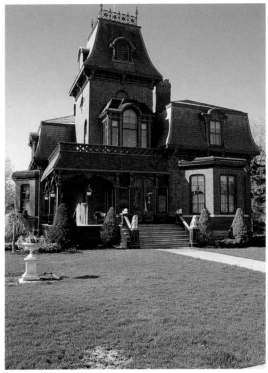

Ercildoune

St. Marys

In the 1870s, local boosters boasted that more grain was shipped through St. Marys than through any other Canadian town save London and Toronto. At the helm of one of the most profitable grain dynasties was George Carter, whose success is demonstrated in no fewer than four of St. Marys' best houses, all on the same block just off the main street. Carter built this rambling Second Empire dwelling for his daughter Charlotte as a wedding gift.

Dating back to 1881, the house was a bit of a latecomer to the Second Empire fad. It carries the signature bell-cast tower and mansard roof, but the proportions are a departure from the tried-and-true. The corner tower soars over the composition, a little at odds with the graceful, ground-hugging verandah. The house was named Ercildoune by later owners in reference to the birthplace of the Scottish poet Thomas the Rhymer.

150

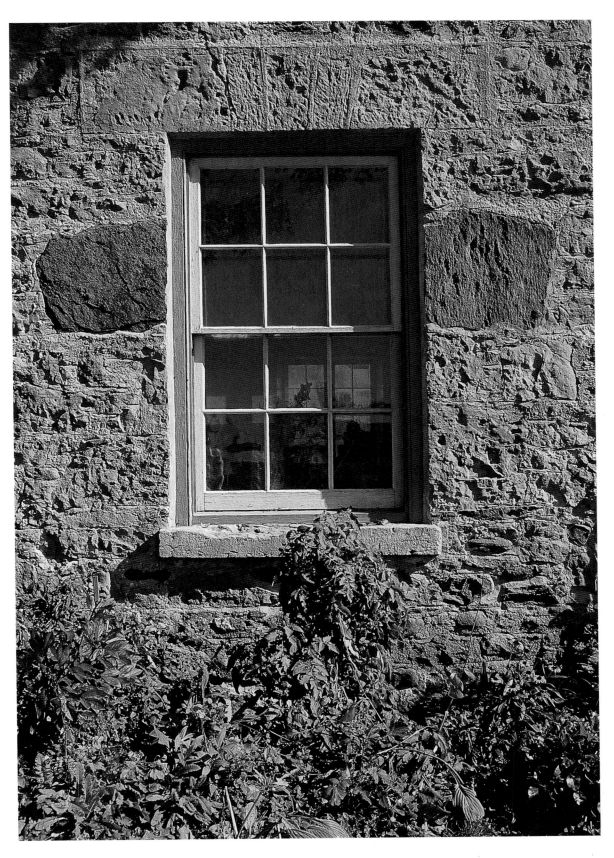

Bowles House

near Guelph

Much in its interior trim suggests that this stalwart Georgian was built long after the style had had its day, but here it stands, proof positive that keeping up with the latest architectural trends wasn't necessarily paramount in every farmer's house-building plans. Whether it was built in the 1810s or the 1860s, a Georgian house was undeniably practical—the centre-hall arrangement was never obsolete. And that was good enough for the Bowles family, who preferred this simple fieldstone farmhouse over the fancier Victorian styles that were all the rage at the time.

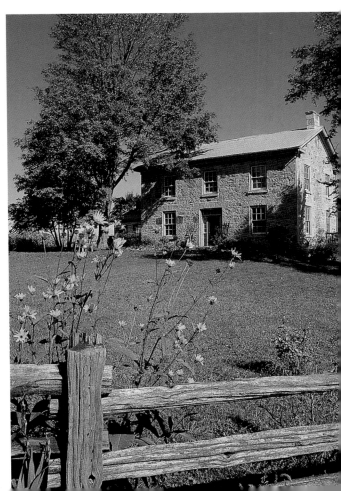

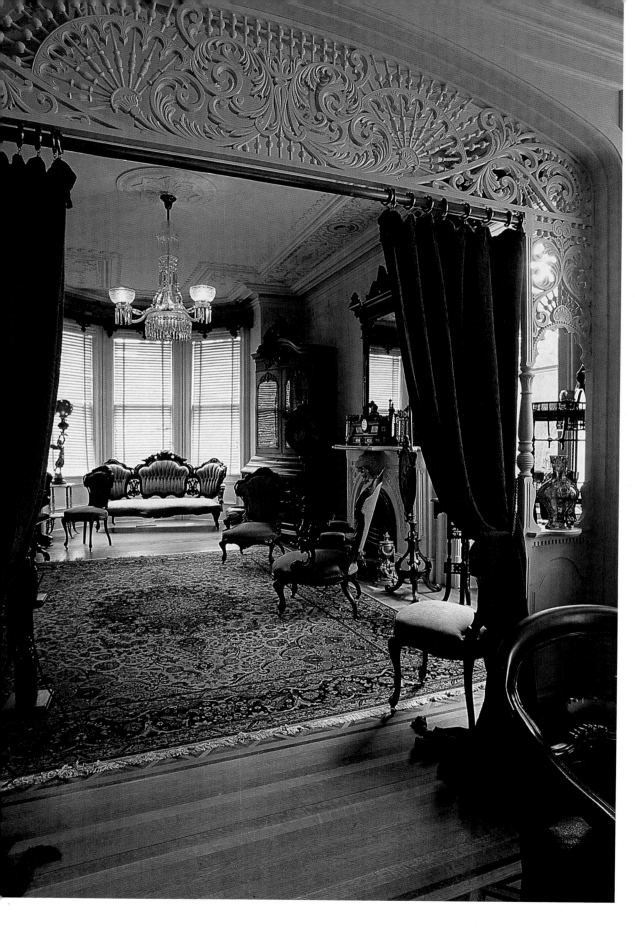

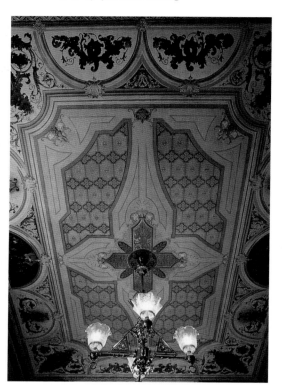

Left: The fanfare starts with opulent details such as the grille that separates the drawing rooms.

Below: A lavishly painted ceiling

Castle Kilbride

Baden

Not every house in Waterloo County is modelled after the staid, no-frills ethic of the Mennonite tradition. Castle Kilbride, built in 1877 by James Livingston, is its very antithesis: a boastful and personal architectural statement that speaks of money, style and influence.

The oversized belvedere lends the house its commanding presence, but in some respects, Castle Kilbride is surprisingly conventional in its symmetry and its centre-hall plan. The real showstopper, however, is the grandly painted interior—the principal rooms are rendered in stunning frescoes and wall murals right out of

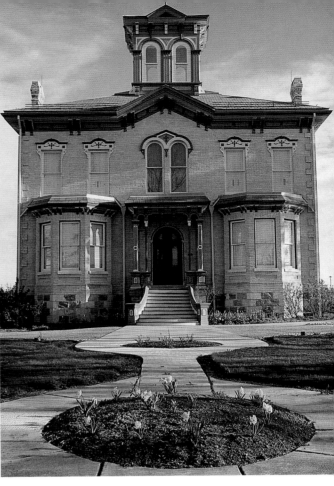

the Louvre. It is somehow poetic to learn that Livingston's vast fortune was founded in none other than the paint industry. As cofounder of the Dominion Linseed Oil Company, he was at the helm of Canada's largest paint manufacturer.

The last of the Livingston line put the house up for sale in 1987. Its future was uncertain until the Township of Wilmot bought the property and adapted it to municipal use. To the rear is a new administrative wing, while the paintings, meticulously restored, remain the crowning glory in a public reception area.

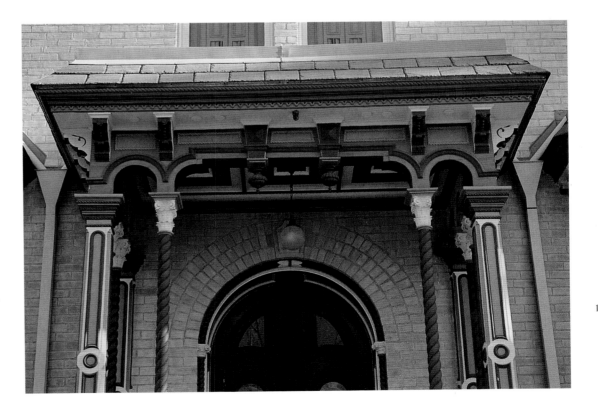

153

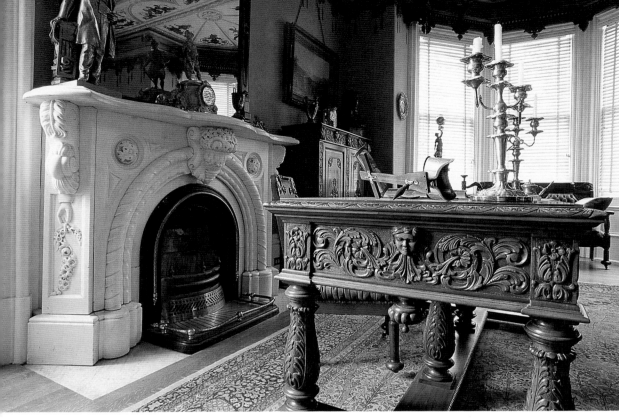

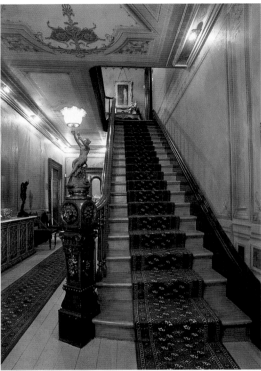

154

Clockwise from top left: The Victorian opulence of
the parlour; the extravagantly crafted newel and
stairs; a trompe l'oeil rendering; and decorative
paintings that fill a bay-window ceiling.

Above: At once inviting and grandiose, the exterior staircase leads to the front door landing, leaving no doubt that there is more architectural spectacle inside.

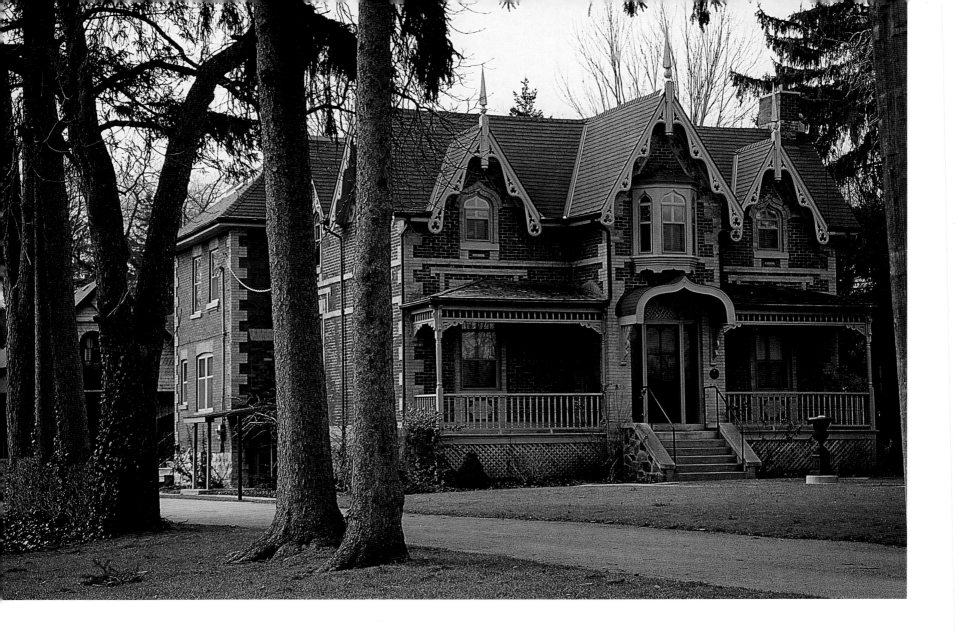

Holmes House

Stratford

Exceptions to every rule exist—such as the one stated elsewhere in these pages that Prince Edward County can claim as its own a certain unusual façade treatment: the front door housed in a vestibule bay and flanked by twin verandahs. Well, here's one in Stratford, 200 miles to the west. It was built sometime around Confedera-tion by a very able contractor named John Holmes. Despite the similarities, there are significant differences. Holmes' house abounds in spiky gables and other Gothic detail, while the Prince Edward County houses have a more Italianate flavour (see page 31).

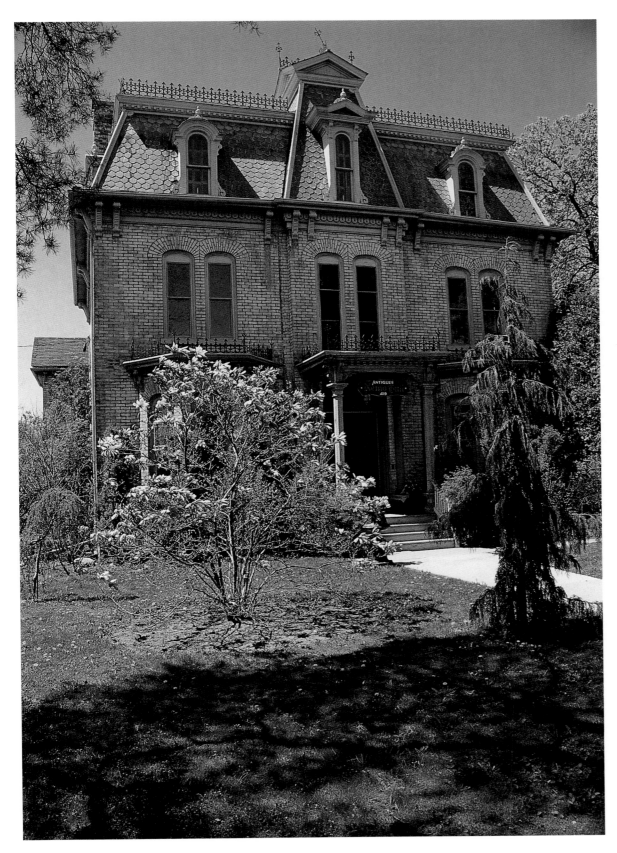

Nemo Hall

Petrolia

You need only know its name to suspect that Petrolia owes its very existence to the petroleum industry. When oil was discovered locally in the late 1850s (the first commercial strike in North America), it wasn't long before everyone had an oil well in the backyard and was actively trying to upstage the neighbours by building as extravagant a home as they could afford. John Kerr chose the Second Empire style, whose mansard roof and urbane presence were inspired by the lavish reconstruction of Paris in the 1850s. With its connections to the Second Empire of Napoleon III (the first belonged to his uncle, Napoleon Bonaparte), it had a certain worldliness that made it the favourite of the nouveaux riches by the time it reached Ontario in the 1870s. Nemo Hall is more graceful than some, with its slender windows and iron cresting. It was built in 1878 and still turns heads today.

157

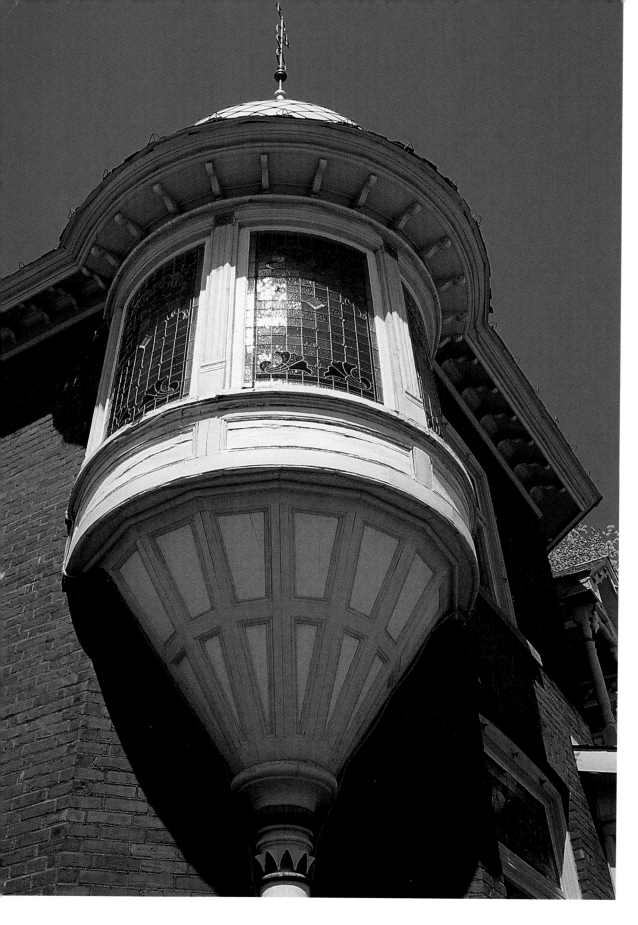

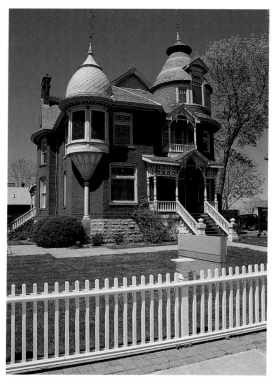

Lawrence House

Sarnia

This is the kind of turn-of-the-century creation that used to make architectural purists wince. Brash and unabashedly boastful, the Lawrence House reeks of affluence, but like the debutante who wears too much jewellery to the ball, it lacks the refined good manners of more established tastes. It took about a hundred years, but the house and others like it have finally earned respect both for their bold departure from convention and for their sheer whimsy. They have even earned a royal name, the Queen Anne style, although they have little to do with the 18th-century monarch. With its oversized turret, huge corner tower and two-tiered porch, the Lawrence House is typical of the breed, although it is rare to see one built of brick.

Board-and-Batten House

Elora

You see them all over Ontario in stone, brick, clapboard and, here in Elora, board and batten: storey-and-a-half workingman's cottages and farmhouses, symmetrically arranged. Nothing special, really, but possessed of an undeniable country charm. The gable over the front door is what makes them quintessentially and uniquely Ontario. Yes, such gables appear elsewhere, but they are so prevalent here that architecture buffs like to claim them as our own.

Front gables were standard fare on Ontario houses by 1850. Their upward proportions were a natural for the pointed-arch windows of the Gothic Revival, to say nothing of the possibilities for whimsical gingerbread, but first and foremost, the gable was as practical as it was decorative. In a province where storey-and-a-half houses were the rule, a gable lent the upper half-storey more headroom and better light. What's more, it shed rain and snow away from the front door, much to the relief of anyone paying a formal call.

Sightly aggrandized in recent years with the addition of a lean-to family room complete with long Regency windows, this exemplary Ontario dwelling is still blessed with ample character.

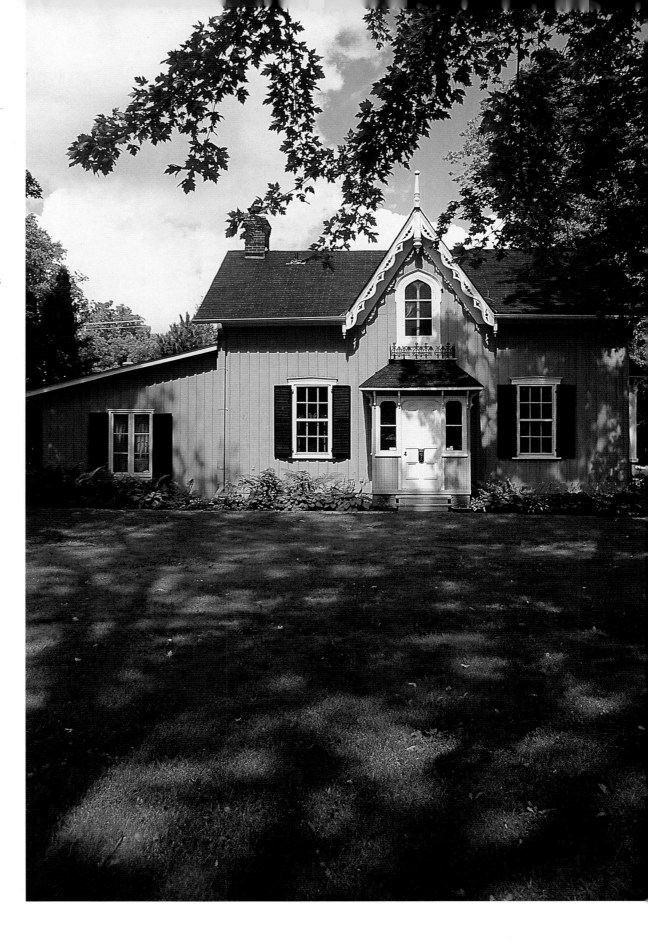

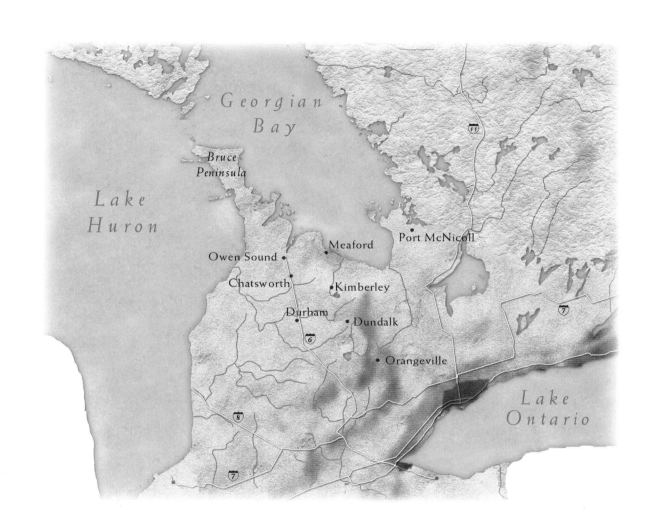

WESTERN HIGHLANDS

Although some of the land is less than exemplary and the climate is a tad cool, the high counties northwest of Toronto have been synonymous with the family farm ever since they were first cleared. This is another of the province's rich agricultural belts, and its orderly farms and neat houses say much about the values of the founding settlers. Here, architecture was not driven by style or one-upmanship. Local houses tended to conform to certain tried-and-true patterns, and although pragmatism prevails, there was still room for self-expression, particularly in the choice of details.

The northwestern counties were late to mature, so as a rule, few buildings are older than Confederation. It wasn't until the 1850s that a road was pushed north from Guelph to encourage and disperse new settlers, but by the 1870s, most of the land toward Owen Sound was in production, while new towns, including Orangeville, Hanover and Mount Forest, were competing successfully with more established places farther south.

The Niagara Escarpment, the same ridge over which Niagara Falls spills many miles to the south, is the dominant physical feature in the region. The rocky ridge is at its most scenic in the Beaver Valley, where the tilted landscape offers unsurpassed panoramic vistas. But for the early farmers, the escarpment was merely a nuisance that interfered with the progress of agriculture. At least it was a source of good building stone. Indeed, fieldstone houses are the rule in the environs of Guelph and Elora, and the penchant for stone extends all the way up to Georgian Bay. Venture a township or two away from the escarpment, however, and the familiar sight of brick is once again the standard.

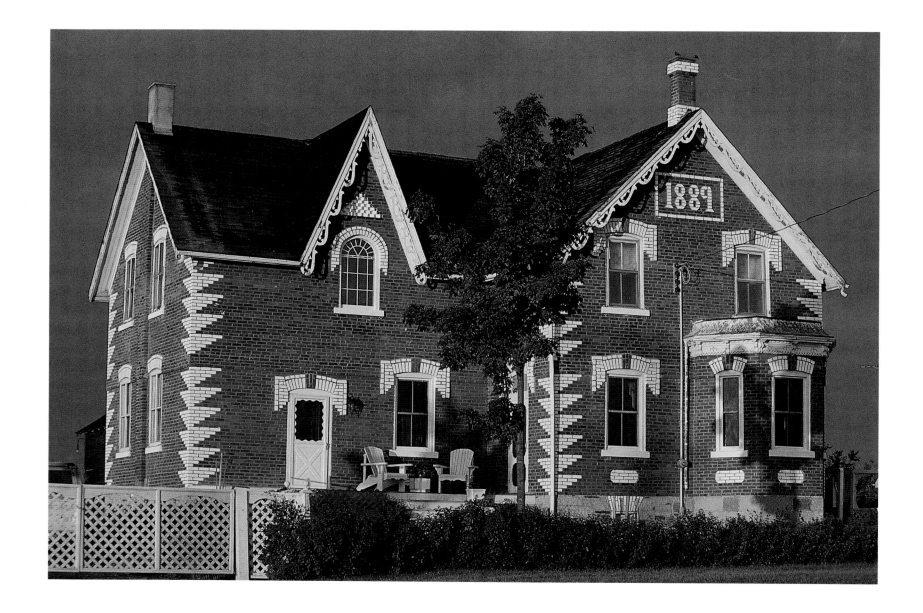

Stinson House

near Dundalk

Guess what year this house was built? With its
date of construction proudly proclaimed in the
gable, this is one of the most exuberant displays
of a type of decorative masonry, a signature
style of contrasting shades of brickwork that is
found throughout the back concessions of Peel,
Dufferin, Grey and neighbouring counties. Typ-
ically, the polychromatic accents are picked out
through a contrasting buff-coloured brick, but
here, they are painted on to similar effect.

162

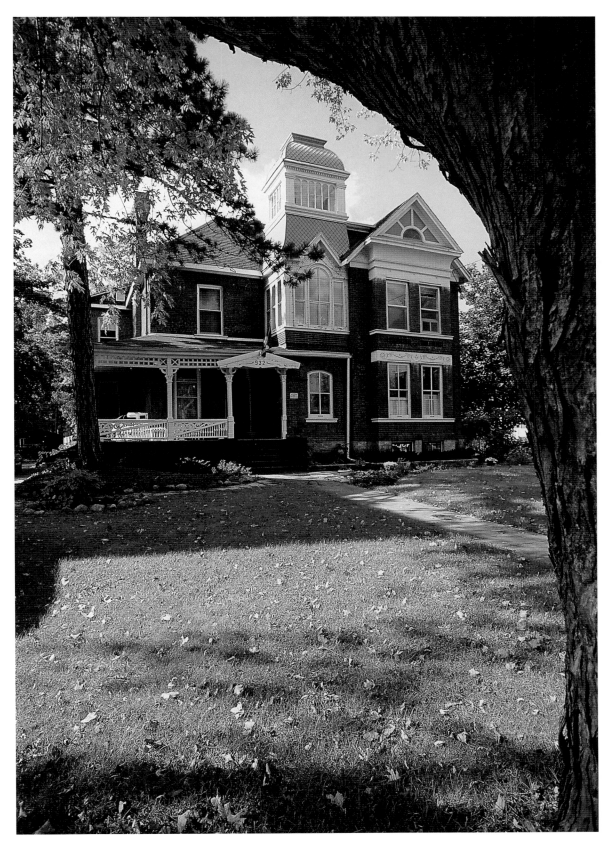

Redfern House

Owen Sound

There is no denying the bravado of this downtown gem built by hardware merchant John W. Redfern in the 1890s. Typical of Victorian dwellings, eclecticism still reigns, but the plain, bold trim, especially the flat cornice mouldings and the striking sunburst in the gable, is less fussy than that of some period houses and predicts a trend that would hit its stride in the Edwardian era. Even so, the house is very much a showpiece and can't fail to impress with its striking pose. The signature detail is, of course, the tower, its delicate glazing lending a romantic touch to the composition.

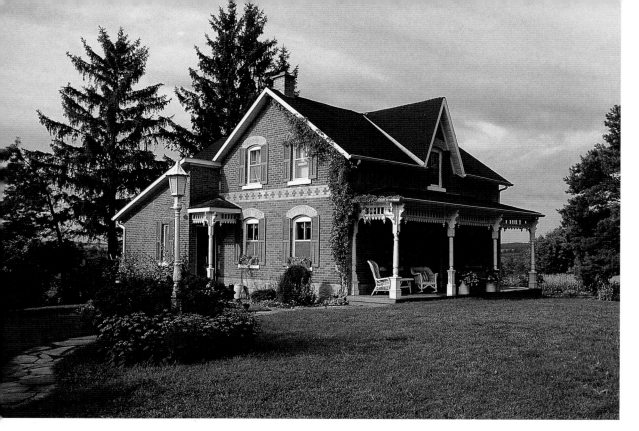

McEwen House

near Chatsworth

Spoolwork trim purchased off the shelf from the local lumberyard has perhaps a less sculptural quality than the earlier type of gingerbread made in the craftsman tradition (see Eckhardt House, page 72), but it still shows to good effect on houses of late-Victorian vintage. This is not the only item of note on this Grey County farmhouse, built by Robert McEwen perhaps in the 1880s. The lean-to kitchen is also of interest and so, of course, is the contrasting pattern of buff and red in the masonry.

164

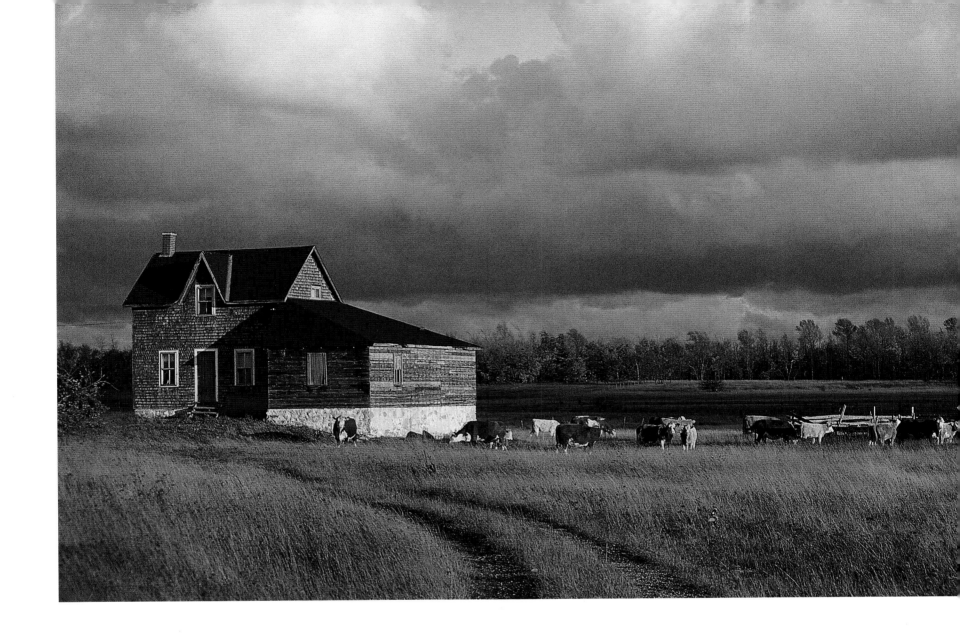

Abandoned House

Bruce Peninsula

Some of the province's most successful beef producers can be found in the southern reaches of Bruce County, but the Bruce Peninsula, which divides Georgian Bay from Lake Huron, is another story. As early as 1815, survey crews reported that the neck of rugged land "is covered with stunted timber and has no soil whatsoever, being loose rock and moss only." Despite the warning, the region was nevertheless opened to settlement, but most of the peninsula proved so poorly suited to agriculture that farmers had to turn to fishing and lumbering to make ends meet. Frustrated with subsistence living, many gave up altogether and headed for greener pastures. The humble homesteads they left behind are reminders of hard times and dashed dreams.

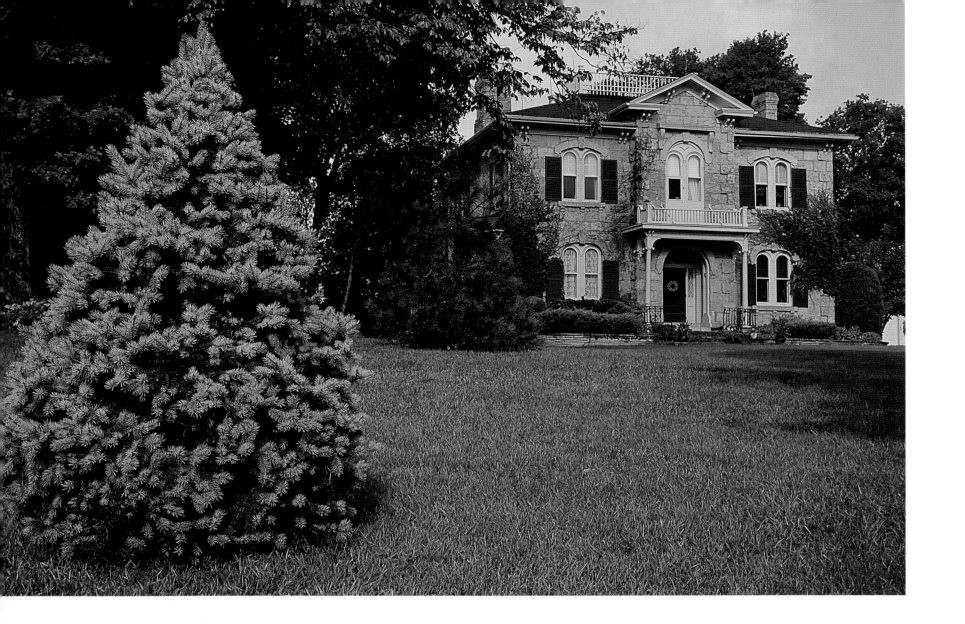

Squire House

near Owen Sound

The Canada Farmer, published by George Brown, founder of *The Globe* and a father of Confederation, was a must-read in 19th-century rural Ontario. Among its columns were occasional house plans, some of which proved enormously popular among city and country folk alike. The April 1865 edition carried a sketch of a two-storey hipped-roof "villa" that looks vaguely Italianate to our eyes but was then described as a "straightforward square house." The sketch inspired a whole generation of homebuilders, and its influence would endure for years. Samuel William Squire didn't build his version of the house until about 1879. His interpretation is more elegant than that suggested in *The Canada Farmer*, but the source is unmistakable, including the emphasis on the façade. "The monotony of the front," said the journal, "is relieved by projecting the hall two feet forward of the main building. This is carried up and finished with a gable." Squire followed that formula to the letter.

Cleland House

Meaford

The Second Empire hasn't aged well. Contemporary critics dismiss it as ponderous and stuffy, while Hollywood chose it as the style of architecture preferred by such spooky characters as Norman Bates and the Addams Family. But in skilled hands, the Second Empire could be surprisingly inviting, as this late-1870s house just up from the shore of Georgian Bay in the town of Meaford so ably illustrates. In a house this size, the style has a humbler presence, and its upright proportions give it an almost Wild-West air. Similarly, it is rare to see the style rendered in frame. Nevertheless, the house was meant to impress, and like so many of the genre, it was home to a man of means. James Cleland was a local hardware merchant who also sat in the provincial legislature.

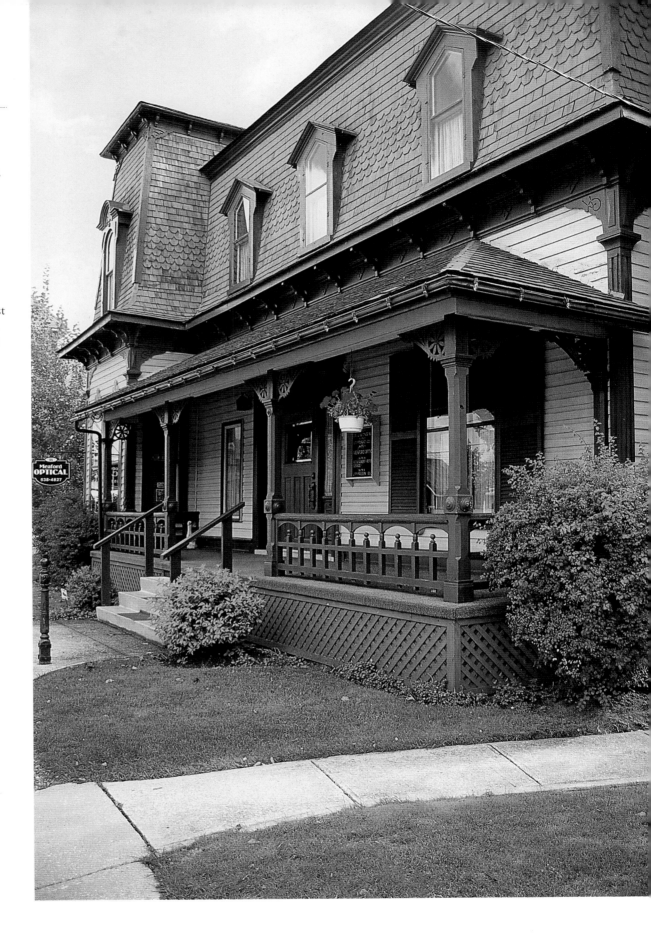

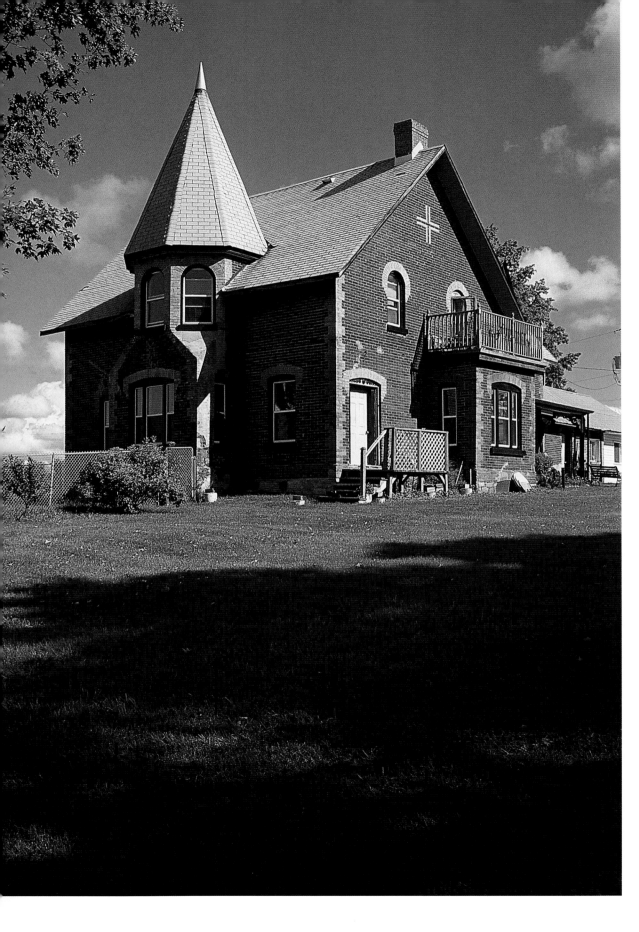

McDermott House

near Port McNicoll

Architecture snobs would be inclined to turn up their noses at this little charmer not far from Midland on the southern shore of Georgian Bay. But they'd be missing out. True, this is obviously the work of an untrained eye, but what the house lacks in savoir-faire, it more than compensates for in sheer whimsy. With a lyrical turreted tower plunked in front of a conventional late-Victorian façade, the brick dwelling has a sparkle about it. Like a Maud Lewis painting, it is possessed of a sense of fun that elevates it from the everyday to the realm of folk art.

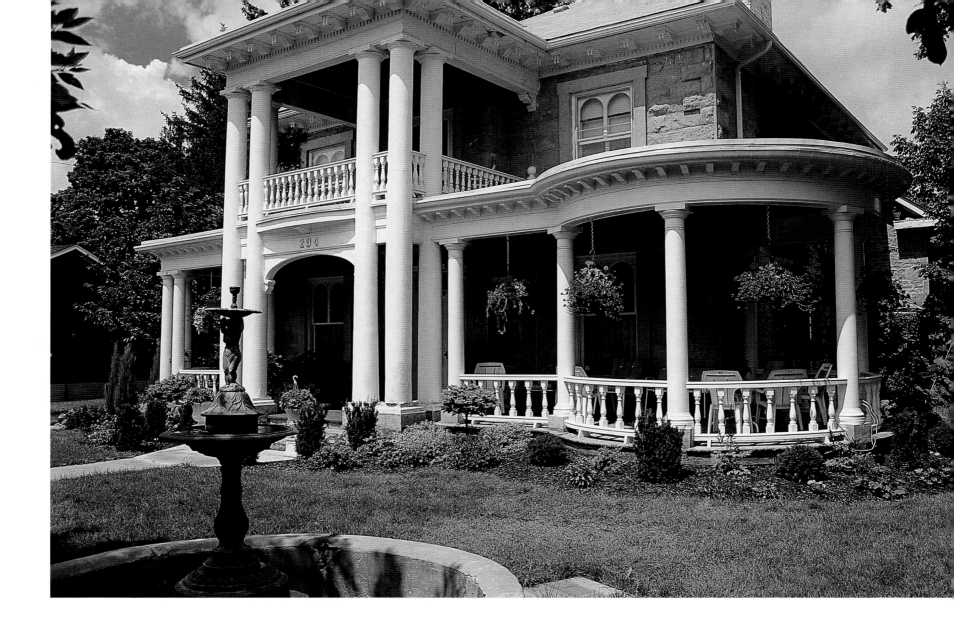

Bon Accord

Durham

Bon Accord offers a lesson in how to make an ambitious house even more so with the addition of a colossal portico and verandah. These were added in 1906, just as the stone house was approaching its 40th birthday, and they bring a taste of the Greek Revival to a house that was already a mélange of various architectural flavours. The paired windows and bracketed eaves are Italianate, and the attic window boasts a Gothic arch. Meanwhile, the symmetrical arrangement of doors and windows is solidly Georgian. Bon Accord's many stylistic influences make it hard to imagine a house that better defines the vernacular tradition.

Mackenzie House

Durham

This brick dwelling on the main street of Durham bears all the hallmarks of the ubiquitous Georgian style. Were it not for the narrow proportions of the windows (which give it away as Victorian), it would be easy to assume the house is much older than it is. Truth to tell, it was new around 1869, some 20 years after the rules on such staid symmetrical stylings were rewritten. Although hardly on the leading edge of fashion, the house shows just how durable the Georgian mode could be. Indeed, in another decade or two, it would be all the rage once again, revived by a new generation of builders smitten by nostalgia and the Georgian principles of architectural dignity.

Part of this house was used as the Durham post office. The builder, Archibald Mackenzie, was postmaster from 1869 until his death 30 years later.

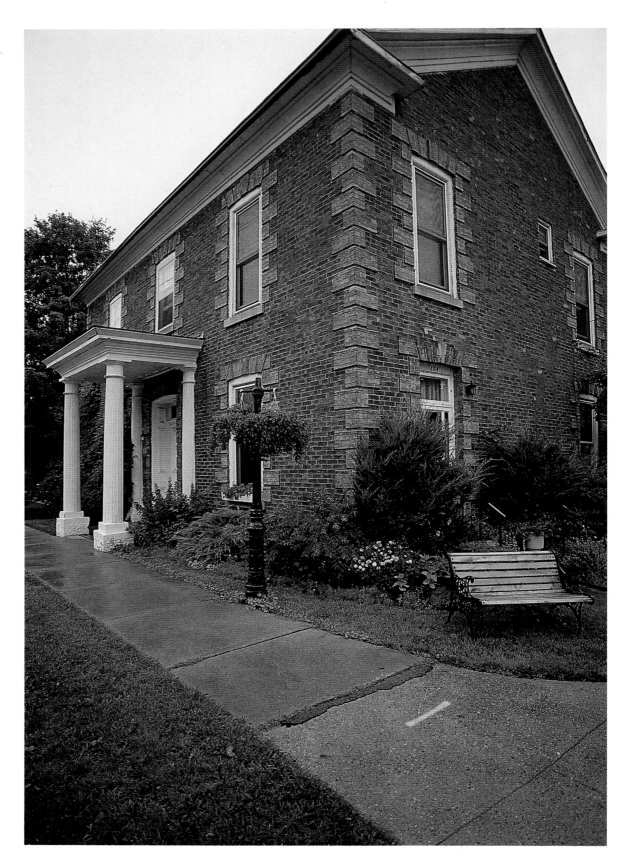

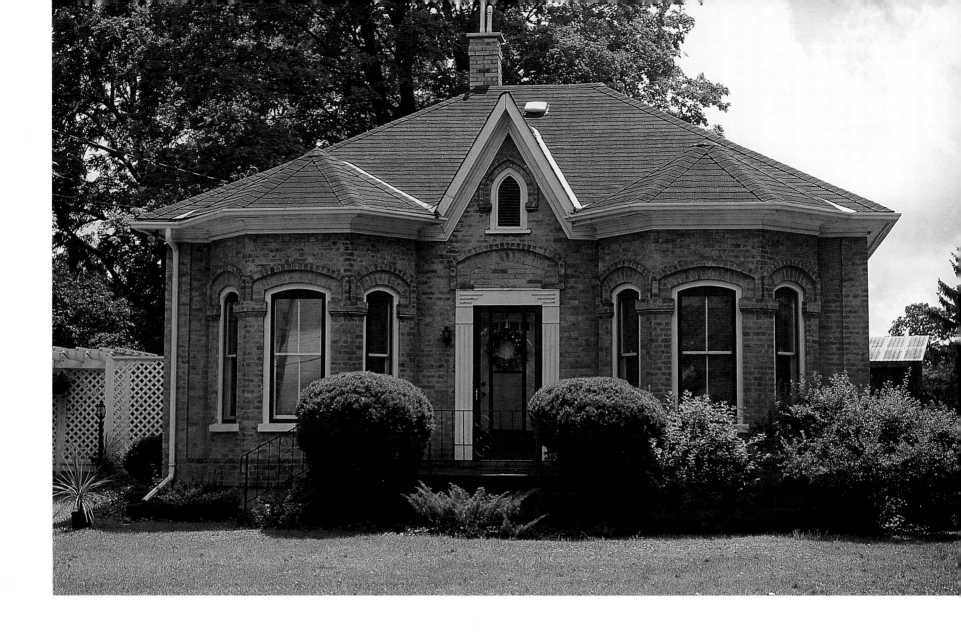

Stillmeadow Acres

Durham

Georgian symmetry, a Regency silhouette, Victorian details and a Gothic light in the attic: Is there a better definition of eclecticism than this beguiling brick cottage? As was so often the fashion among Victorian builders, a little of this and a little of that went a long way in creating a unique architectural expression. But borrowing from several styles was not without aesthetic risks: Here, the airy Regency proportions seem at odds with the hulking twin bay windows.

171

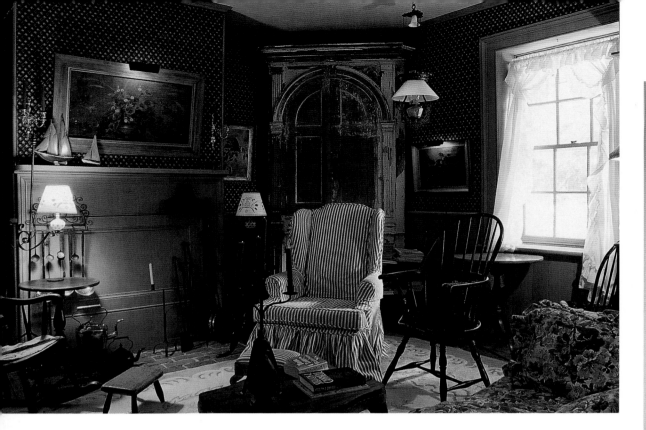

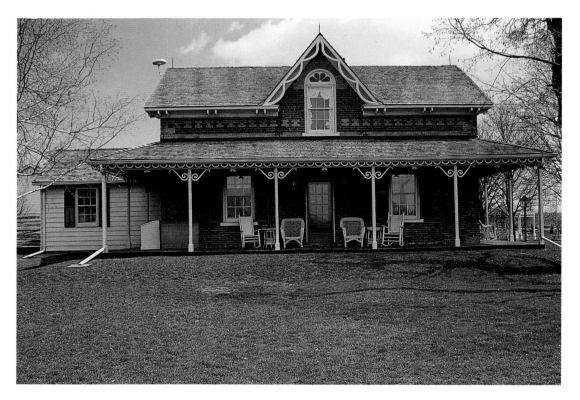

Top left: As is typical in country houses, there is nothing pretentious about the parlour.

Top right: The staircase barely fits into the hall.

Keough House

near Orangeville

In eastern Ontario, local brick displays a decidedly red tint—perhaps because of the amount of iron in the clay—while in the west, it is characteristically buff-coloured. The twain meet somewhere around Orangeville, where builders found a clever way to put the two colours to decorative use. Scores of local houses have banded brickwork, contrasting geometric patterns created by clever arrangement of the bricks. Some historians call it "gingerbread in masonry," and it adds excitement to what might otherwise be an ordinary dwelling. The practice actually originated in Italy and was first seen in at least one civic building in Toronto around 1855 before it spread to the countryside northwest of the city. The Owen Keough farmhouse, built in about 1865 north of Orangeville, is exemplary, with quoins and cornice picked out in buff brick against a red background. Just like the trillium and the Toronto Maple Leafs, houses like this should be Ontario icons, especially when they feature a gable laced with fancy bargeboard.

Western Highlands

Springbrook

near Kimberley

Verandahs and gingerbread trim tickled the fancy of Victorian builders across Ontario, but to later generations, they were merely something else that required paint. So if it didn't rot off from neglect, fancy woodwork was routinely pulled off in the name of easier maintenance. Fortunately, enough original examples survive, such as that on the James Myles, Jr., house pictured here, to ably demonstrate how some playful trim adds another dimension to an otherwise average farmhouse. Myles proudly announced the date of construction—1878—with a date stone over the Gothic gable window.

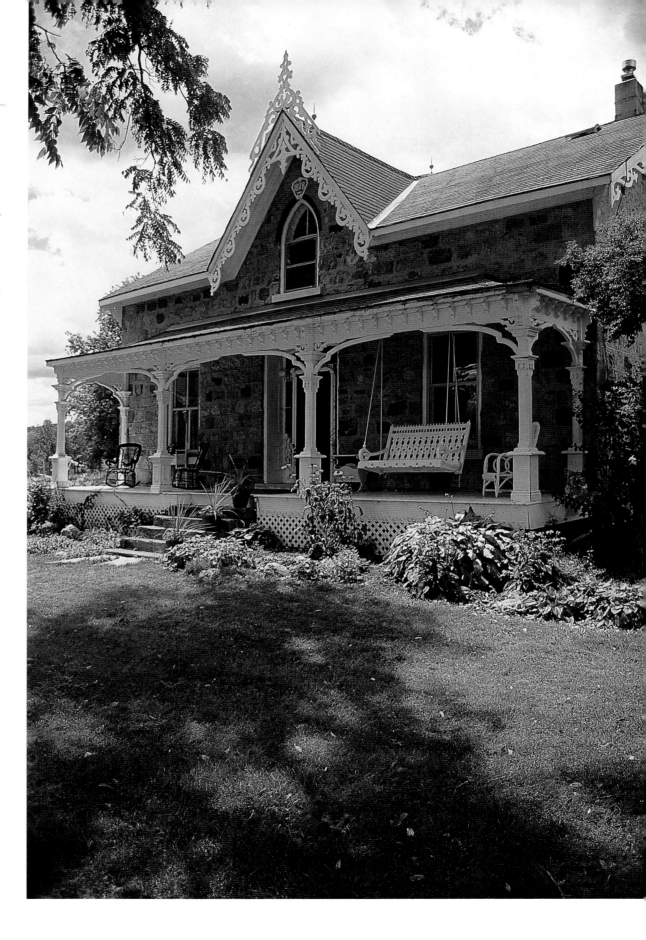

ON THE EDGE OF THE SHIELD

Head north from Lake Ontario, and in less than an hour, the farmscapes abruptly change. The land becomes noticeably more rugged, and the crops don't seem as lush. Farm fields are smaller, interrupted by rock outcroppings, and towns are farther apart. Farmhouses are typically straight-forward and functional with little of the fanfare and frippery that distinguish the Victorian home-steads in the south. It's no coincidence, for the farther north you go, the less suited the land is to agriculture and the harder it is for a farmer to earn a living.

This is the last agricultural frontier before the landscape is swallowed by the Canadian Shield. It forms a broad swath across the breadth of southern Ontario from Ottawa to Georgian Bay.

Parts were settled early—at the western end, Penetanguishene was founded as a naval base in 1818, while the eastern townships around Perth and Ottawa were well established by the 1820s—but it took a few generations for the area between to fill in.

Not every house is a plain Jane, however. In the more prosperous regions, local architecture often took a turn toward the fanciful and the re-fined. This is especially true in Ottawa, which was chosen, almost by default, as the seat of government for the united provinces of Canada East (Quebec) and Canada West (Ontario) in the late 1850s. Its more stylish houses defy its roots as an upstart lumber town.

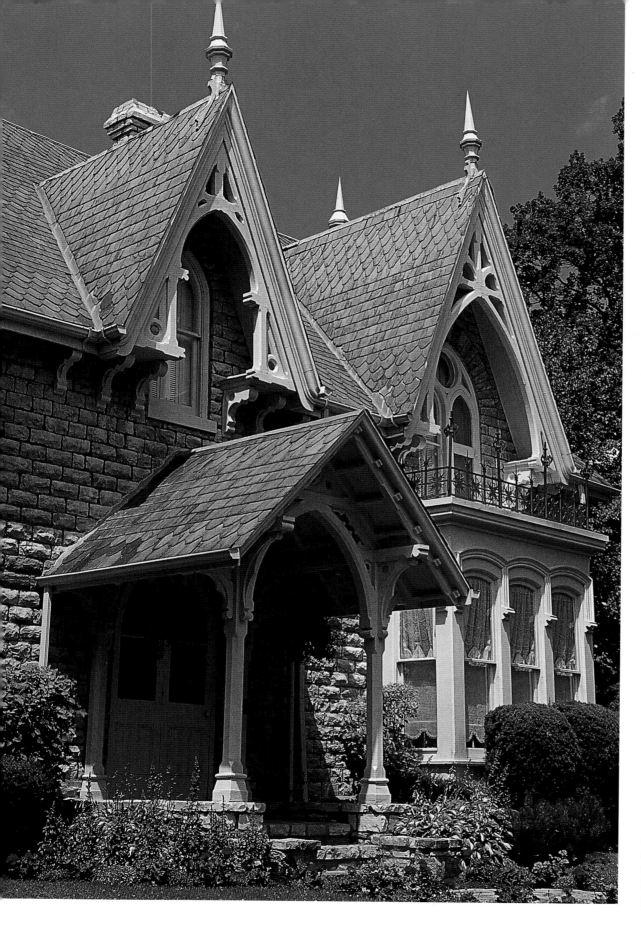

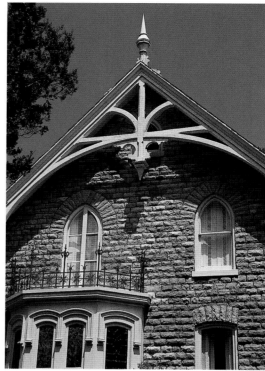

Seymour House

Madoc

Madoc may have had a reputation as a rough-and-tumble frontier town, but its main street probably displays as much architectural refinement as any village its size farther south. Never mind that it took so long to get here.

Gothicism was waning when it reached Madoc in the late 1870s, but it arrived with a bang in the romantic stylings of the Seymour House. The building bears all the hallmarks of the genre, made all the more impressive set against coursed-stone walls. The self-consciously asymmetrical façade is a distinguishing trait. How remarkable it is that so much original detail—bargeboard, iron cresting and even the fish-scale pattern of the slate roof—remains intact.

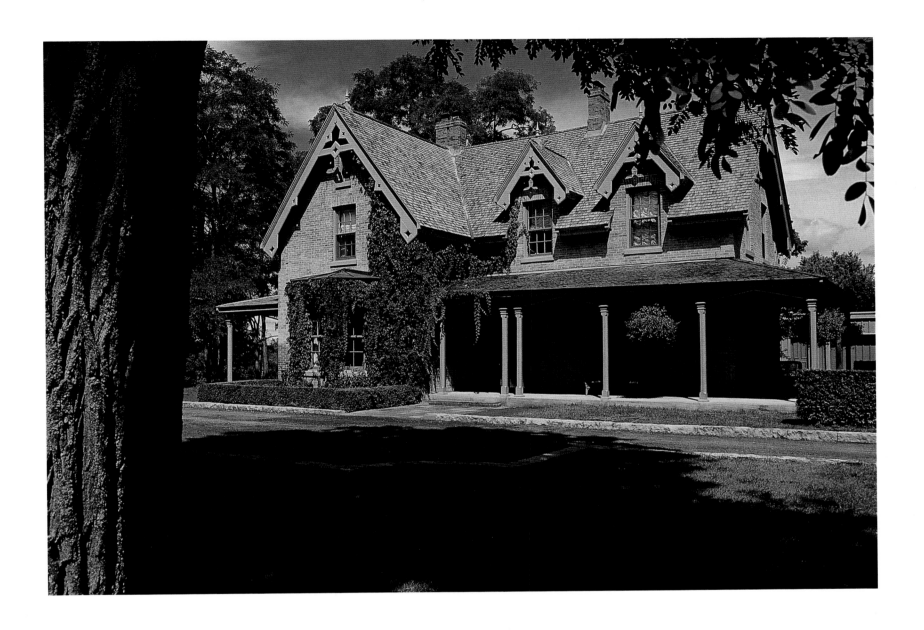

Reydon Manor

Lakefield

Reydon Manor has no rival for the honour of best-remembered house in Lakefield. And no wonder. Not only is it the most striking vintage architectural presence in the community, it also has literary ties, for it was built by Samuel Strickland. His sisters, Susanna Moodie and Catharine Parr Traill, are legendary in the annals of early Canadian literature for their views and advice on settlement in the Ontario wilderness.

Samuel, although not as well known, was an author in his own right, with *Twenty-Seven Years in Canada West* to his credit.

Born into the middle class in England, the Stricklands were perhaps a little genteel for roughing it in the bush, but they persevered with much success. Samuel was a colonel in the military and a prominent businessman. The house was built shortly before his death in 1867.

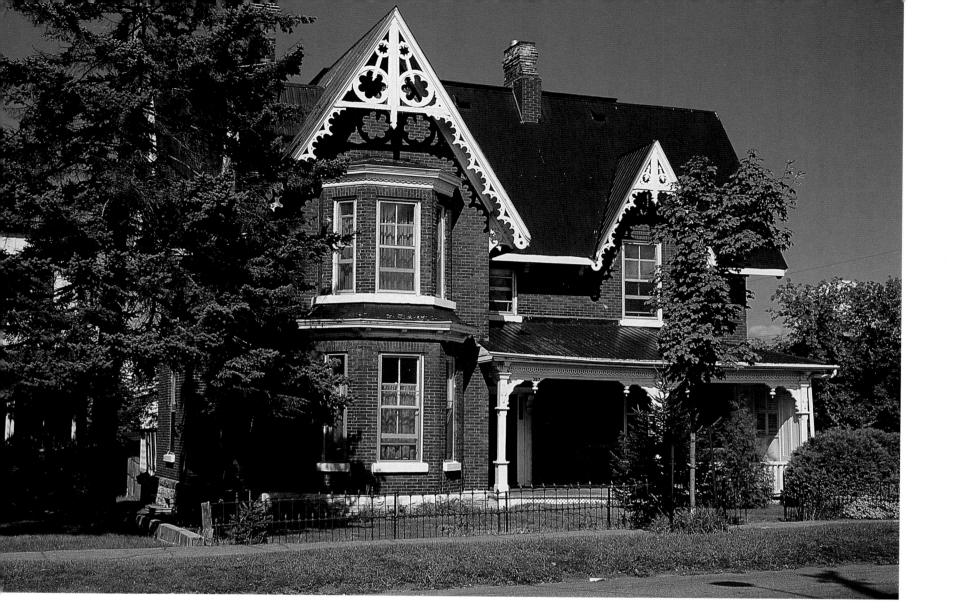

Victorian House

Pembroke

The stacked bay windows give this house away as a product of the 1870s or 1880s. With its attractive gingerbread, it is a handsome expression of high-Victorian manners, but it is still very much a country cousin when compared with similar dwellings at urban addresses. It shares its basic outline—the lofty gables, the L-shaped façade—with Earnscliffe (see page 190), a house that is at least 20 years older and more confidently executed. Nonetheless, this house has its own vernacular charm, and its good state of preservation makes it all the more memorable.

178

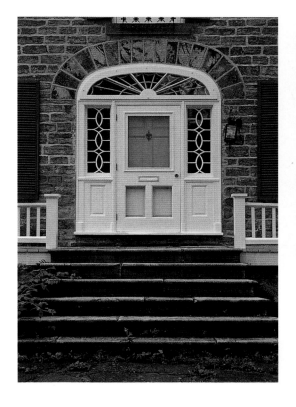

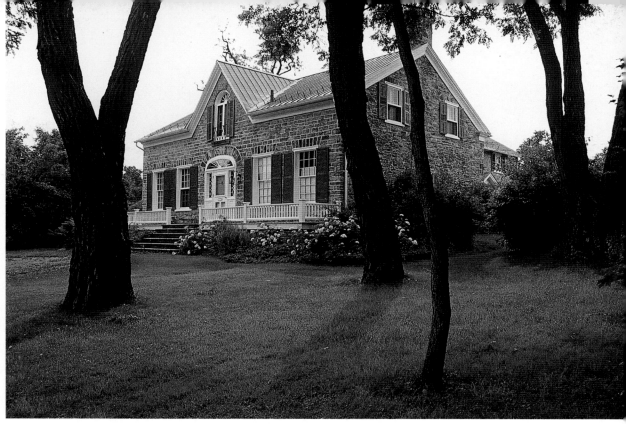

Inge-Va

Perth

Inge-Va is one of the great old chestnuts of Ontario architecture. Sooner or later, every old-house buff admires its beautifully proportioned doorcase and its handsome stonework. Less pretentious than some dwellings its age, the unassuming lines of the 1823 landmark can't help pleasing. That it has stood so well preserved for more than 175 years is its trump card. Time has not passed without a few changes, however. Sometime, perhaps in the 1830s, the façade was "Ontarioized" by the addition of a

gable and arched window over the front door.

The name, which means "come here" in Tamil, is also an addition, coined by the most recent private owners, who willed the property to the Ontario Heritage Foundation. Inge-Va is remembered for more than its architecture, for it is also connected to one of the most infamous events in local history. It was to this house, in 1833, that the body of the victim of the last duel in Upper Canada was brought.

Tin House

near Kirkfield

Tin? As siding? For as long as frame houses have existed, folks have tried just about everything to windproof them. In the 19th century, they stuffed their walls with newspaper, straw and even brick nogging (bricks stacked between the studs). The 20th century saw the introduction of sheet-asphalt siding, better known as Insulbrick and Insulstone. Neither did much for draughts and accomplished even less for aesthetics. (One critic still refers to Insulstone as "instant slum.") Tin—more precisely, steel panels coated with a fine layer of tin—was another alternative, but most agree it made a better ceiling than siding. Today, we have better results from aluminum and vinyl, although the most pleasing solution is genuine clapboard insulated from the interior.

180

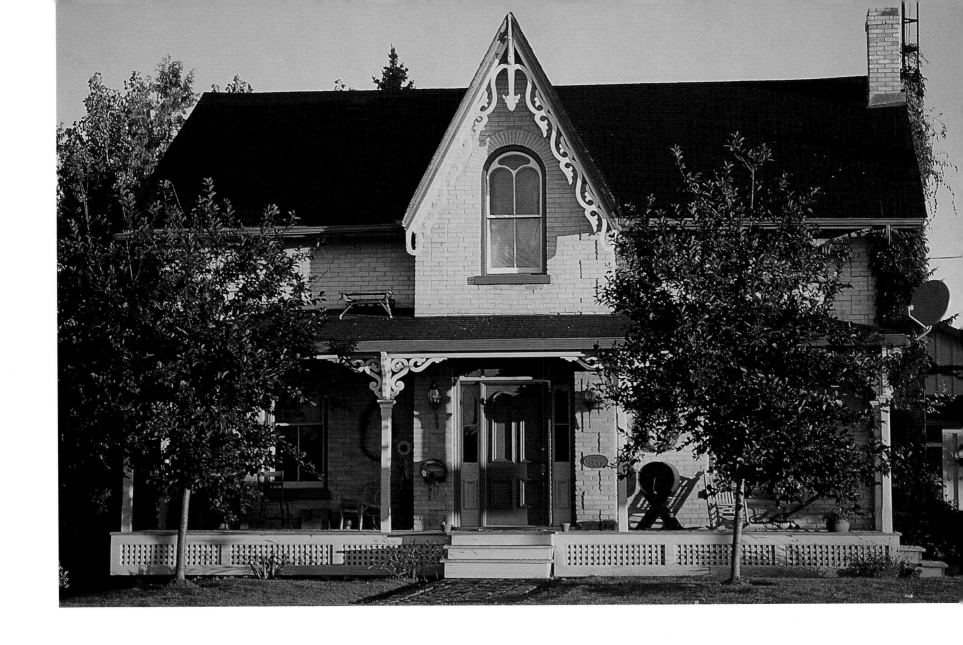

Brick Farmhouse

near Lindsay

Another variation on a familiar theme, this Confederation-era dwelling has all the accoutrements synonymous with vernacular Ontario houses: a storey-and-a-half silhouette, a gable over the front door, a verandah and a few touches of Gothic whimsy. It is blessed with handsome proportions and even steps beyond the everyday with a noticeable projection in the façade, just enough to announce the gable. The buff-coloured brick is unusual in the eastern counties but not unheard-of locally.

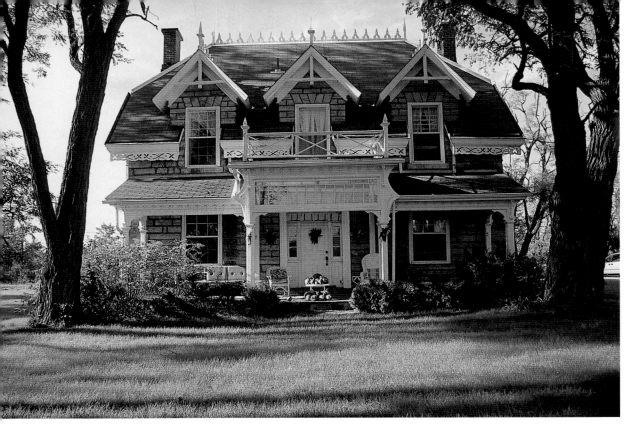

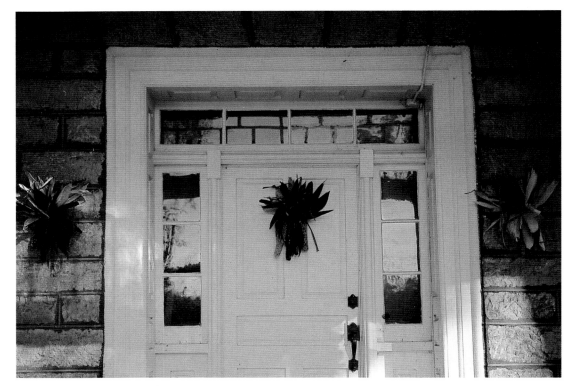

Mitchell House

near Lansdowne

What began as a simple 1830s farmhouse turned into an essay in Victorian glamour when the Mitchell family, postmasters at a crossroads hamlet called Mitchellville, decided to renovate in the 1870s. They raised the roof (the unusual shape is called a jerkin head) and added all manner of decorative adornments: gingerbread, a verandah and, most striking of all, three pop-eyed dormers across the façade. The effect is arresting, and the house still draws admiring glances.

Look beyond the fanfare, however, to the consummate stonework. Each stone was cut to a consistent size and laid in courses of even height. Sills, arches and other masonry details were executed with equal precision.

Although it looks like an anomaly, at least two other local houses display the same triple-dormer façade and unconventional roofline. The Mitchell place is the best preserved.

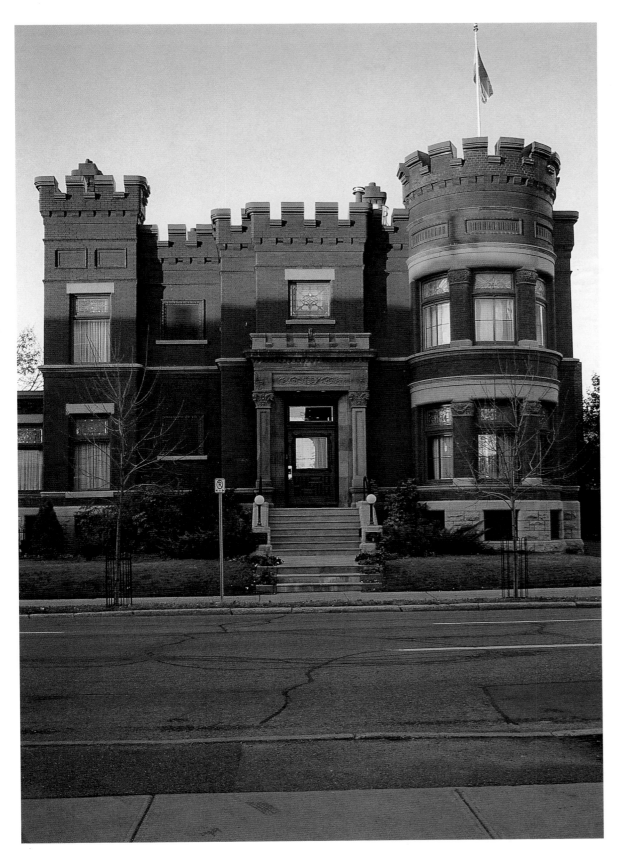

Birkett Castle

Ottawa

Most would agree that a man's home is indeed his castle, but only a few would take the old maxim to heart and actually build a house that looks like something out of King Arthur's day. But scattered across 19th-century Ontario was a handful of homebuilders, usually nouveau-riche entrepreneurs, who showed off their newfound wealth by literally building a castle.

Hot on the heels of the romantic novels of Sir Walter Scott, the castle craze was the architectural expression of a revived interest in the pageantry of the Middle Ages. To established tastes, the "sham castles" were ostentatious, but they had an irresistible appeal, especially to successful businessmen who had struggled up from poverty. Thomas Birkett of Ottawa was typical of the castle barons, having risen from rags to riches by age 22. His castle on Metcalfe Street, a little more restrained than some, was built in 1895. In good repair today, it has been converted to commercial use.

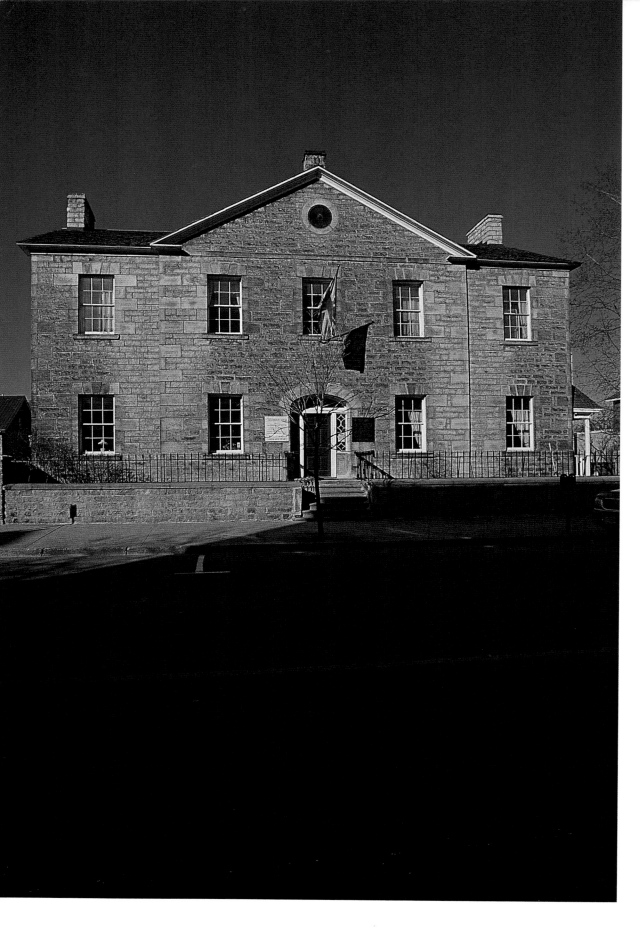

Matheson House

Perth

Like Port Hope, St. Marys, Bayfield and a number of other places, Perth is one of Ontario's small-town gems. It is a stone town whose old-time character has been preserved through the diligent restoration of its heritage streetscapes. Among the star attractions is the Matheson House, built by the richest man in town in 1840. Roderick Matheson was the owner of a store and warehouse at Perth's four corners, who later in life served as a senator during the Macdonald years. His descendants lived here until the 1930s, and for a time, the house was home to the local branch of the Legion. When demolition loomed in the 1960s, however, townspeople rallied to its defence. The subsequent restoration of the Matheson House as a museum signalled a turning point in Perth's history. Ever since, people have thought twice about knocking down a heritage building.

The Matheson House was built on such a majestic scale that it could be mistaken for a courthouse or some other public building. Its signature stamp is the sheer mass of its stone-work. By comparison, the windows and front door, which are usually the focus of pre-Confederation dwellings, seem small and insignificant. Although it is undeniably imposing, it might be said that the Matheson House is less inviting than some of its contemporaries.

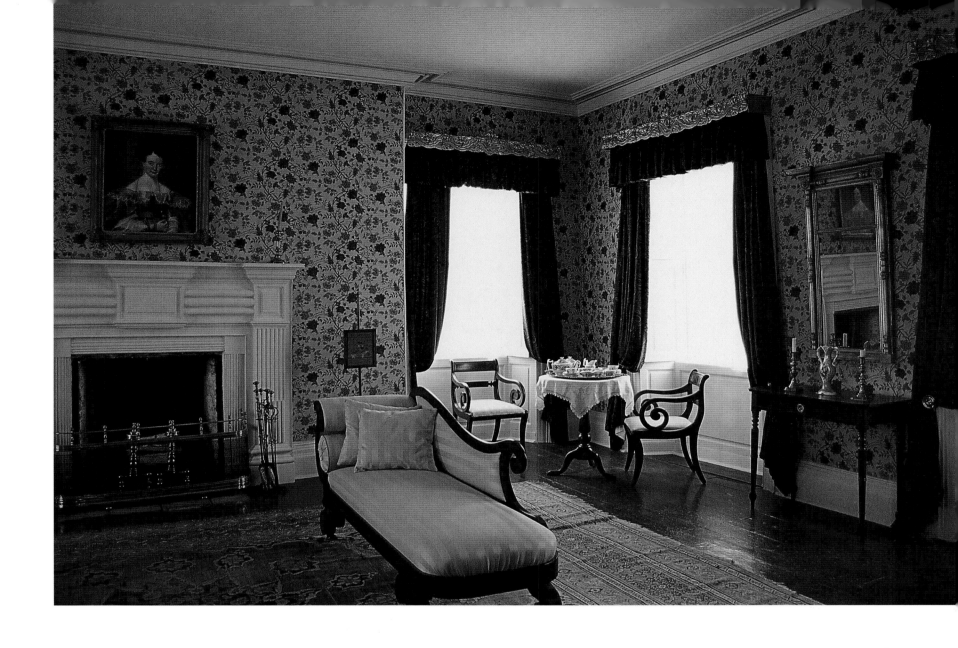

Above: The millwork in the parlour has a Greek Revival flavour that is more dramatic and bolder than earlier Loyalist Georgian stylings.

Right: The parlour may be elegant, but the kitchen is another story, a workaday room appointed with everyday furnishings.

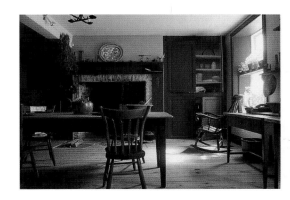

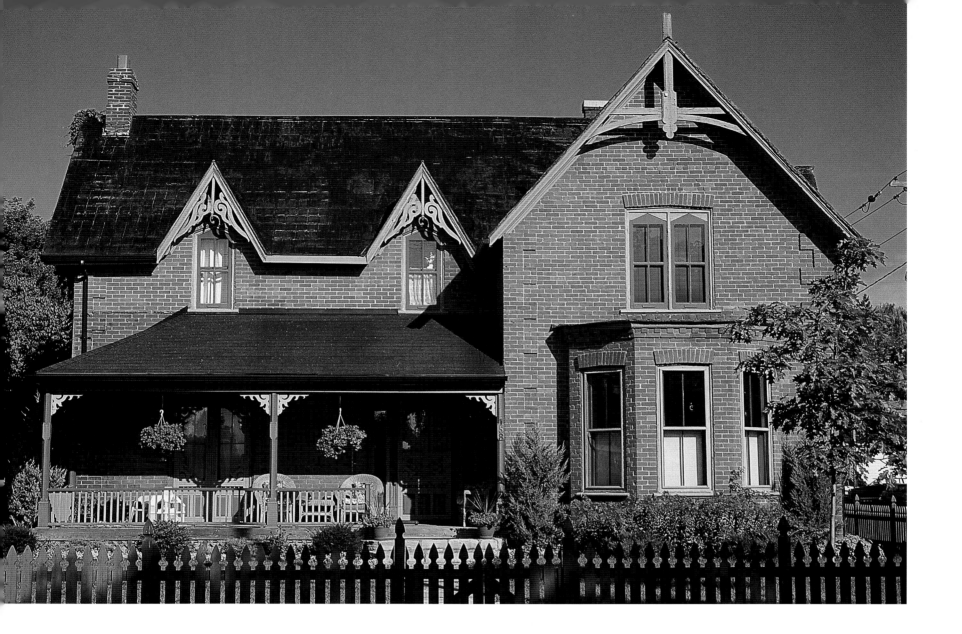

Victorian House

Campbellford

The Victorians devised more than one way to
liven up the ubiquitous centre-hall plan, the
standard in Ontario homebuilding ever since
the province was settled. In this unpretentious
brick house, the centre hall still prevails, but the
parlour has been pulled forward and capped
with a prominent gable. The prototype was seen
in an 1864 edition of a journal called *The Canada
Farmer*. Nicely restored using period colours (not
a speck of white), the house has a certain pan-
ache with its renewed bow-roofed verandah.

186

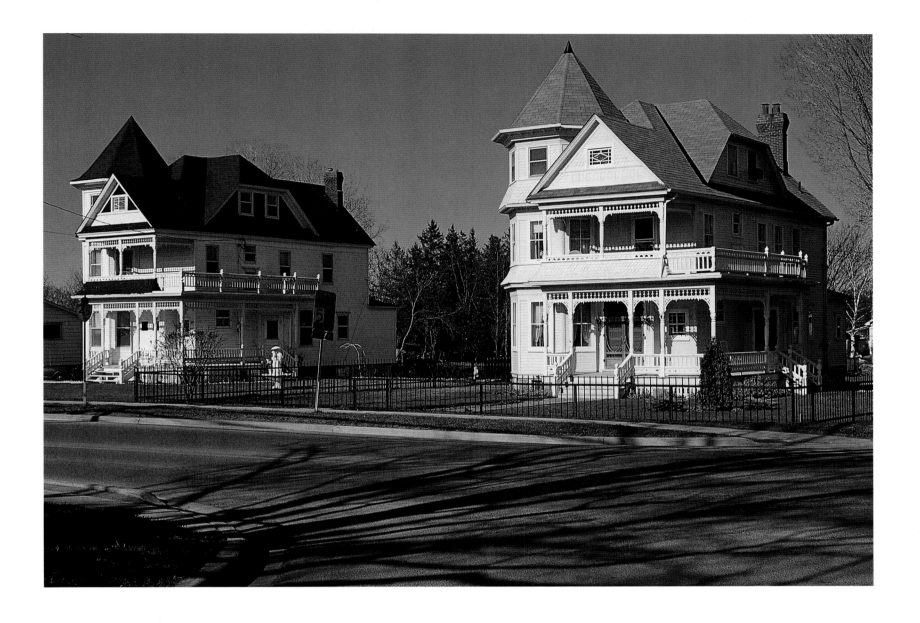

Doxcee Houses

Hastings

Not one but two dazzling essays in Queen Anne exuberance grace the south end of Hastings. There is a carefree air about these twin houses that suits a riverside town on the edge of cottage country. Each boasts a profusion of stained-glass windows, spoolwork trim and fish-scale shingles, but it's the cone-roofed towers, bay windows and, of course, the tiered verandahs that really lend the houses their storybook appeal. Although ornately detailed, they have a

light, airy appearance that is absent in many other Victorian styles.

Built around 1900, the houses were the work of the Doxcee family, who owned the local lumberyard. They were constructed according to plans drafted by a New York architect named Stanley A. Dennis, who appears to have sold mail-order blueprints to prospective home-builders. Interestingly, the original plans and builder's specifications were discovered in the

attic when new owners set about renovating one of the houses (the yellow one) in the late 1980s. The documents make interesting reading, revealing that the houses were to be equipped with central heating, indoor plumbing and other Victorian innovations.

The restoration of the first inspired that of the second. Today, the twins are once again the talk of the town.

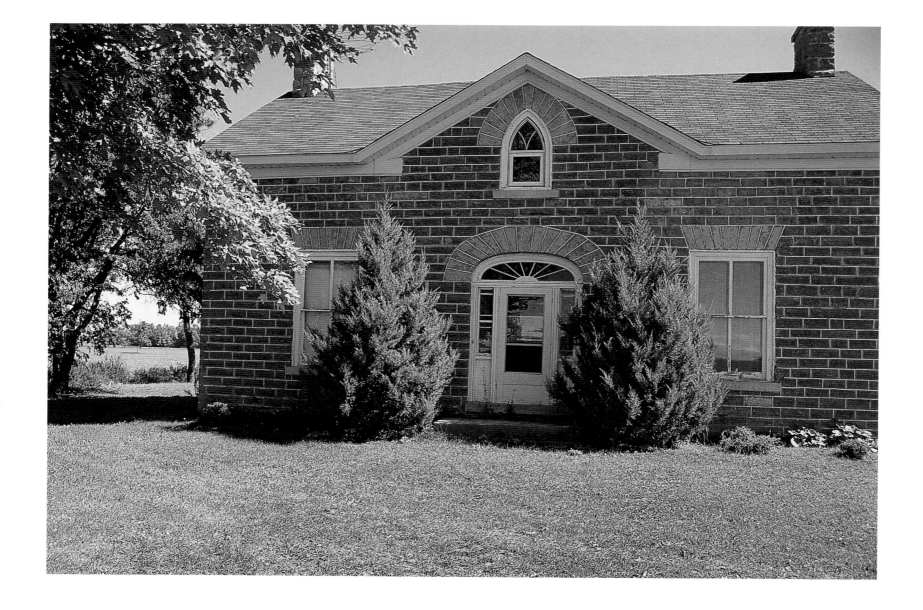

Wood House

near Pakenham

Like a bird species at the edge of its range, the grey limestone houses of the Rideau corridor reach their northern limit somewhere around Pakenham. North of town, they give way to the brick and frame farmhouses of Renfrew County, which are younger and have an entirely different character. This house, just to the south of the great stone bridge that has lent Pakenham a certain fame in historical circles, is typical of the Rideau breed, with low storey-and-a-half proportions and the abundant warmth of stone construction. It probably dates from the Confederation era and is said to have been built by the Wood family.

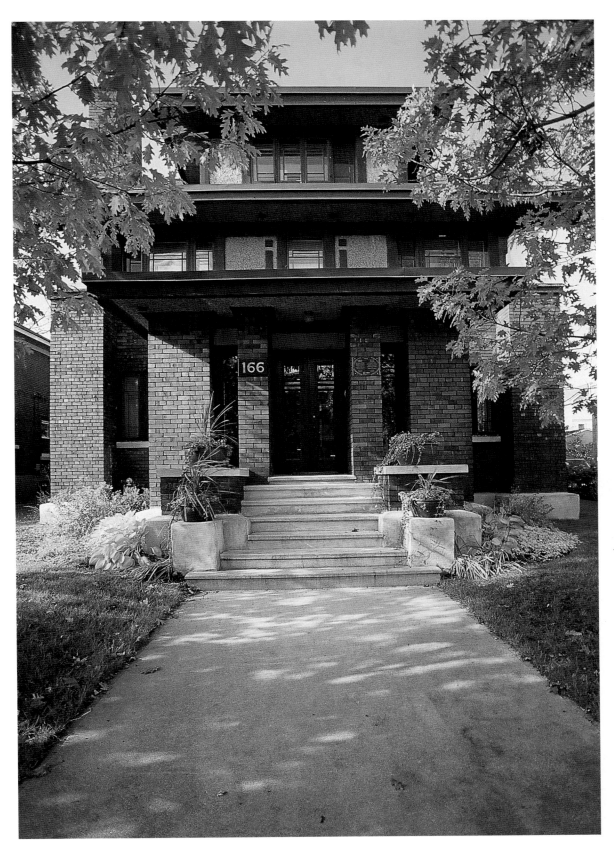

Connors House

Ottawa

Frank Lloyd Wright had a disciple in Francis Sullivan, an Ottawa architect who studied under the great innovator. As the brains behind what came to be known as the Prairie style, Wright freed himself from the conventions of his craft to create his own uniquely 20th-century approach to homebuilding. The old rules of symmetry and ornament were gone in favour of a style more organic and responsive to earth, sun and site.

You can see Wright's influence in the trademark wide eaves and the decided horizontal emphasis of Sullivan's 1914 design for a home for Edward P. Connors. Although in its day a dramatic departure from the ordinary, the Connors house is more conventional than anything ever produced by the master. Indeed, Wright would never have placed a front door in such an obvious place. Nevertheless, the house shines as a handsome representative of the Prairie school, a style that is remarkably rare in Ontario.

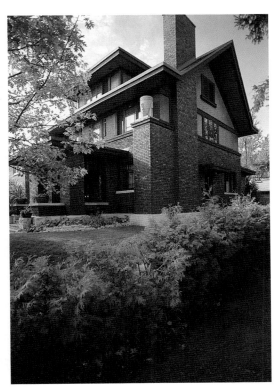

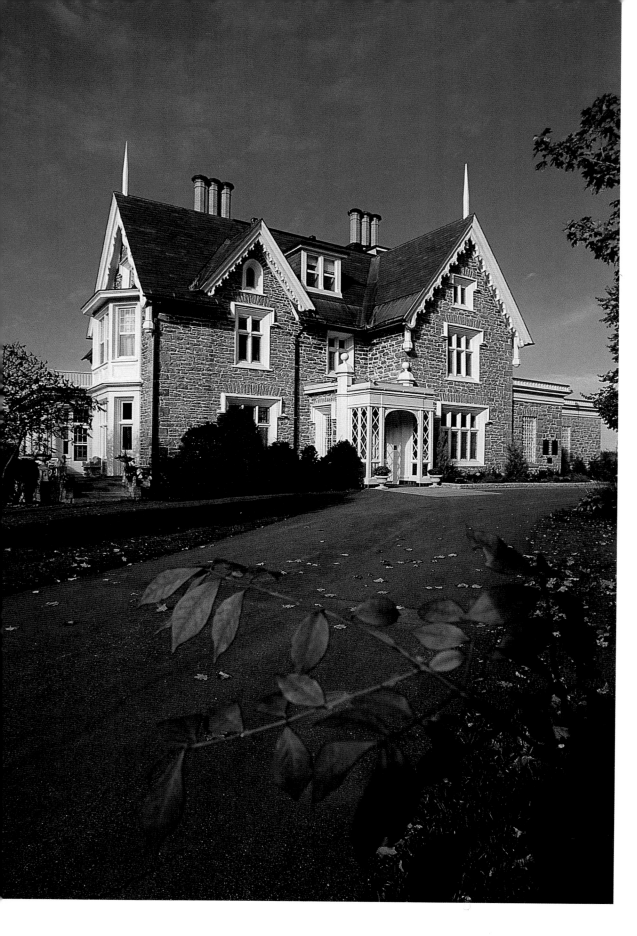

Earnscliffe

Ottawa

Through most of his political career, Sir John A. Macdonald lived in a succession of rented houses, depending on which city was the nation's capital at the time. When Ottawa was chosen as the seat of the newly confederated government, he rented this stone house with its dramatic view across the Ottawa River. Macdonald liked it so much that in 1883, he bought it. He was prime minister during most of his tenure here, and much of the nation's business was conducted from his private study on the main floor. He lived here for the rest of his life.

The history of Earnscliffe goes back to 1857, when it was built for John MacKinnon and his wife Annie. MacKinnon was the son-in-law and junior business partner of Thomas McKay, whose enormous success was founded on his position as contractor for the Rideau Canal. McKay built Rideau Hall, which was bought and expanded by the Canadian government as the residence for the governor-general. Earnscliffe is more conservative, but it nevertheless cuts an impressive figure, its sheer mass accented by steep gables and mediaeval-style windows. Solid rather than elegant, Earnscliffe embraces the Gothic mode. Yet it doesn't take full flight—no trademark pointed arches, towers or verandahs, although the MacKinnons could easily have incorporated them.

After Sir John A. died in 1891, Lady Macdonald rented the house to various tenants until 1900, when she finally dispensed with the property. It came up for sale again in 1930, and for a time, the federal government considered acquiring it as the official residence of the prime minister. The idea came to naught, largely because the prime minister at the time, R.B. Bennett, on the advice of his sister, who kept house for him, balked at the thought of taking on such a large property. Instead, Earnscliffe caught the eye of the government of the United Kingdom and has been the residence of the British high commissioner ever since. The deciding factor in the purchase was the ease with which the stables could be converted into offices. Every owner has left a mark on the building, but the house has weathered the years well.

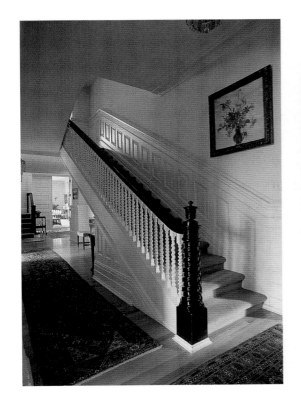

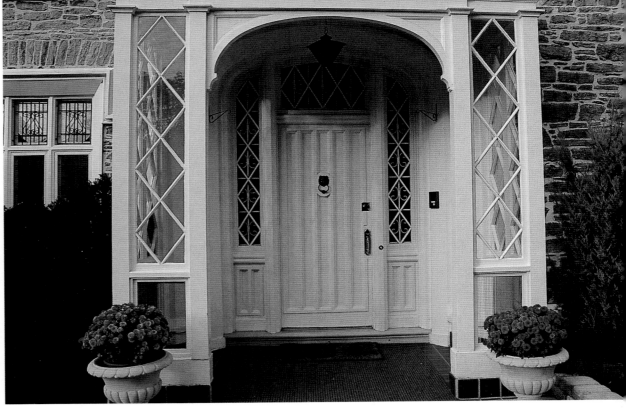

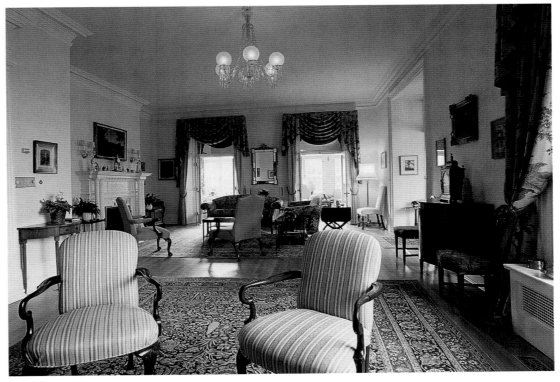

Clockwise from top left: Earnscliffe presents an essay in Victorian glamour—the boldly executed staircase, the mediaeval-style entrance and the grand scale of the drawing room.

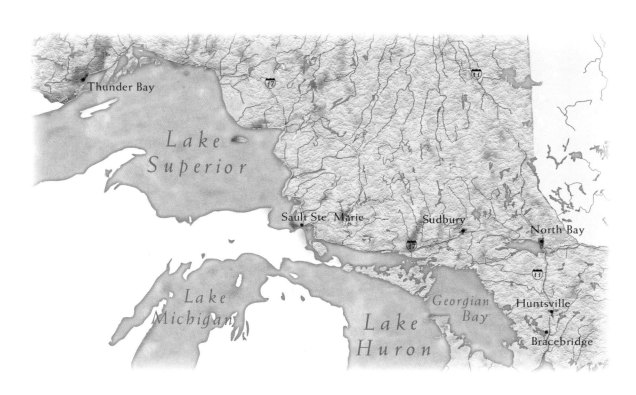

CANADIAN SHIELD

In hindsight, you have to wonder whether the farmers trying to eke out a living on the Canadian Shield felt cheated. Lured from the southern counties by the promise of free land, they must have found it disheartening to learn that their farms lay on a few inches of topsoil and that the summer was barely long enough to grow a crop. Perhaps the region should never have been opened to farming, but opened it was in the 1850s as the townships in the south were nearing their capacity for farm development.

Taking a page from John Graves Simcoe's book, the province encouraged settlement by building a number of "colonization roads" north into the wilderness, but given the inhospitable conditions, they were a dismal failure. The roads were a bonanza for the logging industry, however, making vast stands of primeval white pine accessible for the first time. Many of the towns along the southern edge of the shield—Gravenhurst, Haliburton and Madoc, for instance—owe much of their early prosperity to the timber trade.

The colonization roads never penetrated beyond what we now call cottage country. The remainder of the shield, the vast northern expanse that covers almost 90 percent of the province, has never been densely settled save for company towns in the forestry and mining sectors. Most of these are still too new to have earned the cachet of "heritage," but scattered across the region are some historical anomalies. Both Sault Ste. Marie and Thunder Bay (known in its earlier life as the twin cities of Port Arthur and Fort William) are surprisingly old towns with houses every bit as interesting as those down south.

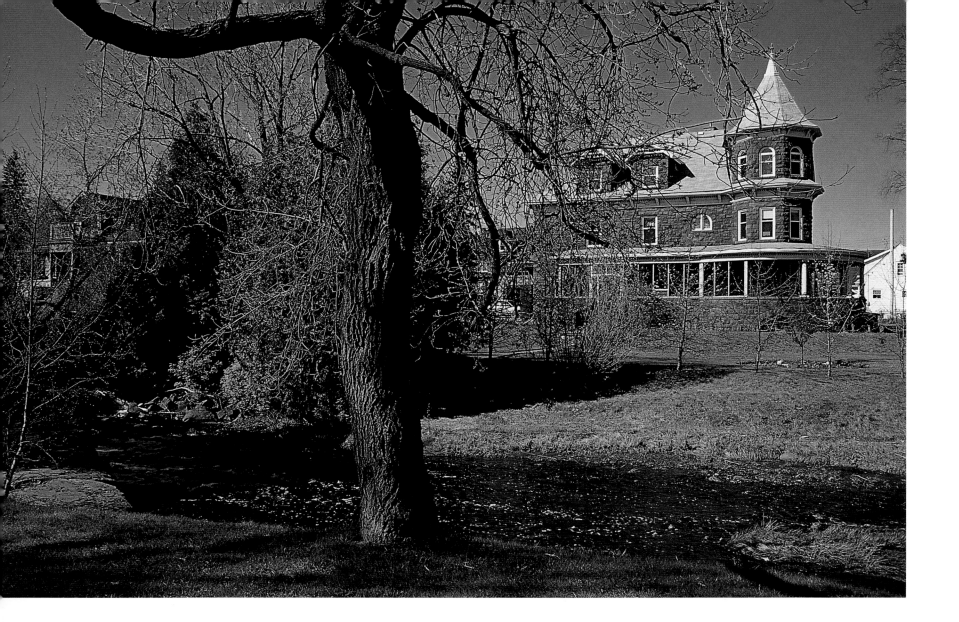

Walsh House

Thunder Bay

The Queen Anne style came to the Port Arthur side of the Lakehead in 1906, when Louis Walsh pulled out all the stops to build a grand house overlooking Lake Superior. With its characteristic corner turret, the style was a natural for taking in the view, but as Queen Anne houses go, Walsh's is surprisingly tame. As in the prototype (see Doxcee Houses, page 187), there is plenty of architectural whimsy, but the house's composition is more orderly than that of some, and the stone construction gives it a stern, weighty countenance, although the genre is usually noted for its light, breezy appeal. And at 6,000 square feet, there's no denying its presence.

Walsh was at the helm of a successful coal business that shipped vast quantities of heating coal to points west. When his house was new, it stood isolated on a hillside. Thunder Bay has since enveloped it, but the house remains a much-admired landmark in town.

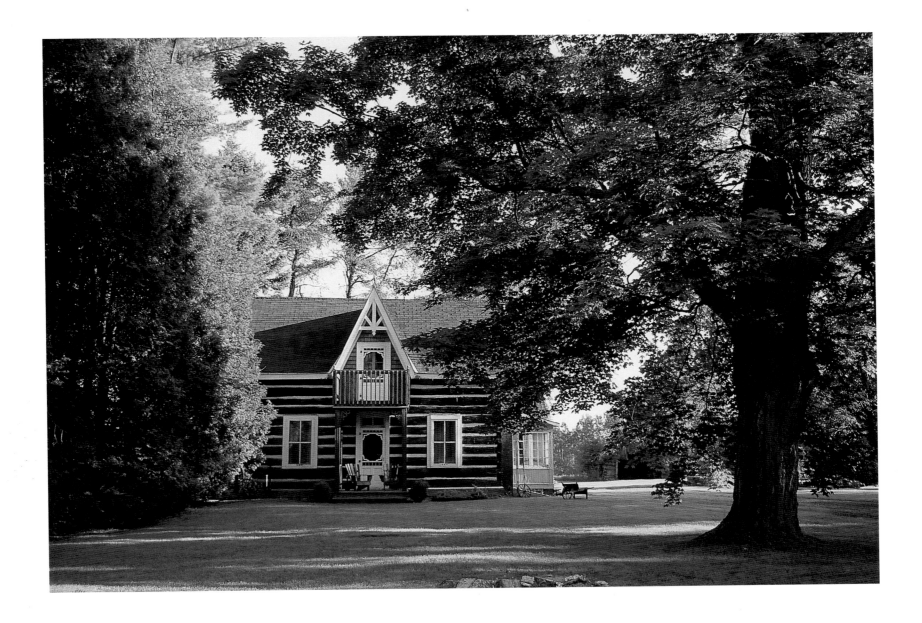

Log House

near Bracebridge

There are several reasons why, to this day, Muskoka boasts more than its share of log houses and barns. The same is true in Haliburton and the Ottawa Valley. These regions were settled later than the counties to the south, and parts of them never prospered enough to allow the settlers to graduate to anything better than homemade houses. As well, there was so much good timber about that the art of building with log persisted into the 20th century. Over the years, log houses in the near north remained remarkably consistent, showing little stylistic progression. It makes them hard to date with accuracy but certainly doesn't detract from their rustic appeal.

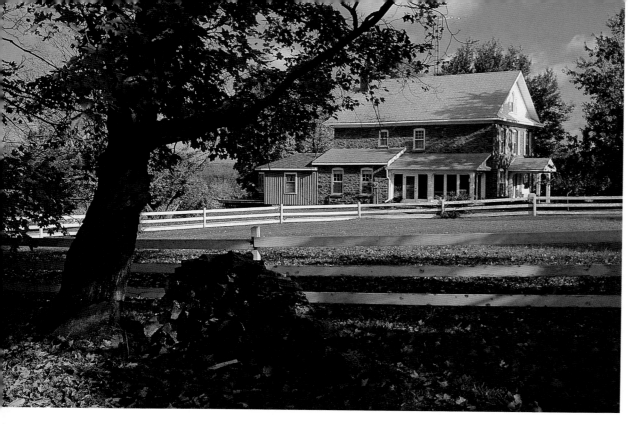

Meredith House

near Huntsville

Farming in Muskoka was always a challenge, but for those whose farms were blessed with adequate soil, it was by no means impossible. In fact, as this spacious house attests, some even prospered. The Meredith House, built about 1905 on a large acreage that touched Lake of Bays, is as large and up-to-date as anything of its era in the south. Its lack of ornament is more conscious than might be supposed. By the early 20th century, frivolous decoration was gone in favour of a plainer, more functional ethic. The oversize attic is a hallmark of the era and is seen on countless Edwardian houses in Toronto.

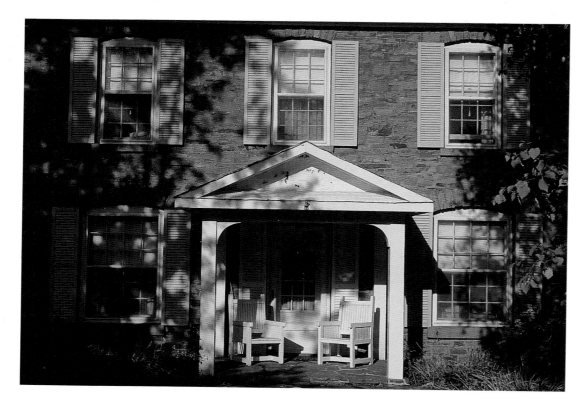

196

Hart House

Huntsville

Lumber towns have a certain frontier rusticity born, not surprisingly, of their proximity to the primeval forests that fuelled their early fortunes. Even the more fashionable houses were built of wood simply because timber was so readily available. Houses in Huntsville, younger sister to Bracebridge and Gravenhurst in the Muskoka triumvirate of lumber towns, were no exception. In the southern parts of the province, this house, whose fanciful turret defies its no-nonsense demeanour, would more than likely have been built of brick.

This handsome composition dates to the 1890s. It was home to Dr. Jacob Hart.

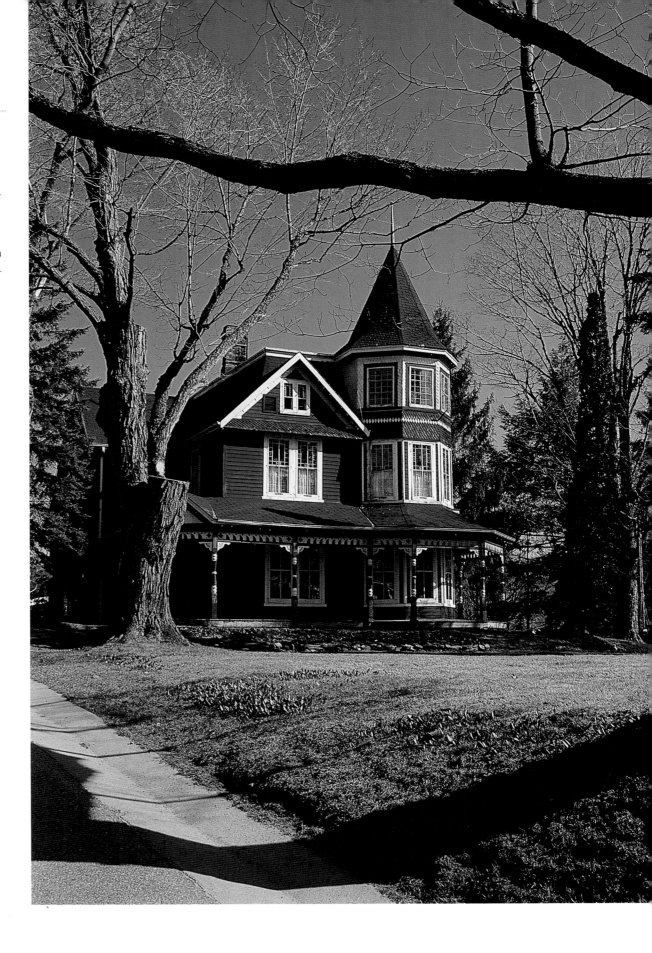

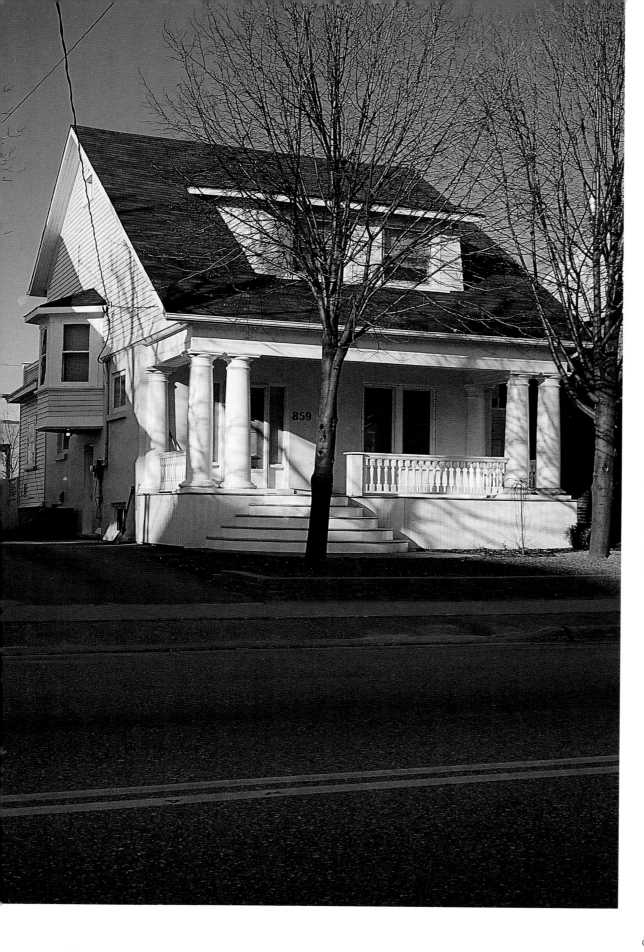

Angus House

North Bay

Resident architect Harry W. Angus was responsible for a row of bungalows at the west end of North Bay's Main Street. They differ slightly in detail but follow a pattern that became very familiar in urban locales around the time of World War I. In fact, you can see bungalows similar to this one in almost any Ontario city that experienced a construction boom between the two World Wars.

Far removed from the chill of an Ontario winter, the bungalow was actually born in the tropical reaches of the British Empire, specifically Sri Lanka, historically known as Ceylon. There, the *bangala* was a common housing form characterized by a low, sweeping roof and a recessed verandah, and it was rarely conceived as a permanent dwelling. By the time the bungalow arrived in Ontario, however, it had grown a basement and sometimes a second storey. Nevertheless, the low-to-the-ground silhouette and cavernous verandah remained its hallmarks. Thousands of variations on the theme were constructed across North America, but few were architect-designed. House-plan books and catalogues of the 1920s were sure to have several examples from which owners could choose. Some could be built for less than $1,000.

Below: Interior appointments compare favourably with those in houses of the same vintage in other parts of the province.

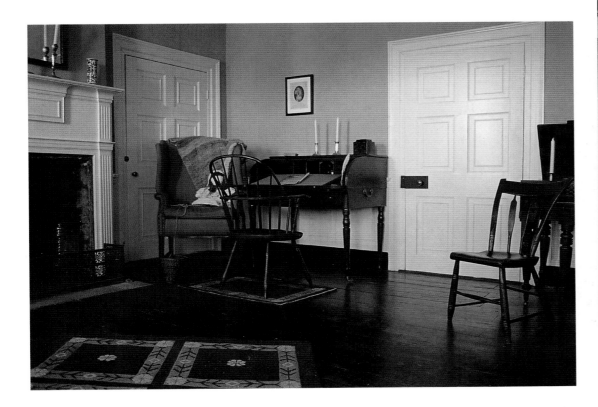

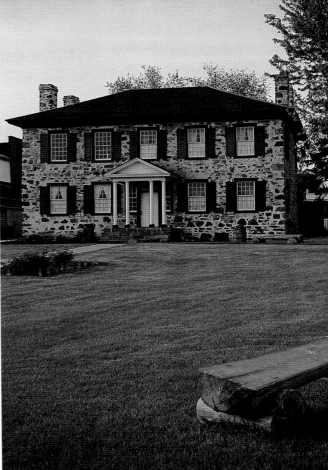

Ermatinger House

Sault Ste. Marie

How astonishing it is to first lay eyes on the Ermatinger House, for it is a rare find in northern Ontario, where any building past the century mark is considered exceptionally old. So what explains the presence of a house in the heart of the Soo that is approaching its 190th birthday? And not just an ordinary settler's cabin, but a stone house as sophisticated as any in the south.

The answer is beaver pelts. With profits earned from the fur trade, Charles Oakes Ermatinger was able to build a mansion in the wilderness and entertain in style. Like his wealthy contemporaries in York and Niagara,

he chose the austere order of the Georgian style and awarded the front door extra emphasis with a small columned portico (see John Brown House, page 118). The rubblestone walls are rough, but then, there weren't many masons to choose from, especially considering that the nearest real city was Montreal, several weeks away by canoe.

Today, the house stands in an urban milieu but remains a well-preserved landmark, restored as a museum home. It is furnished as if Ermatinger were still in residence, and it is quite a surprise to see how well he lived.

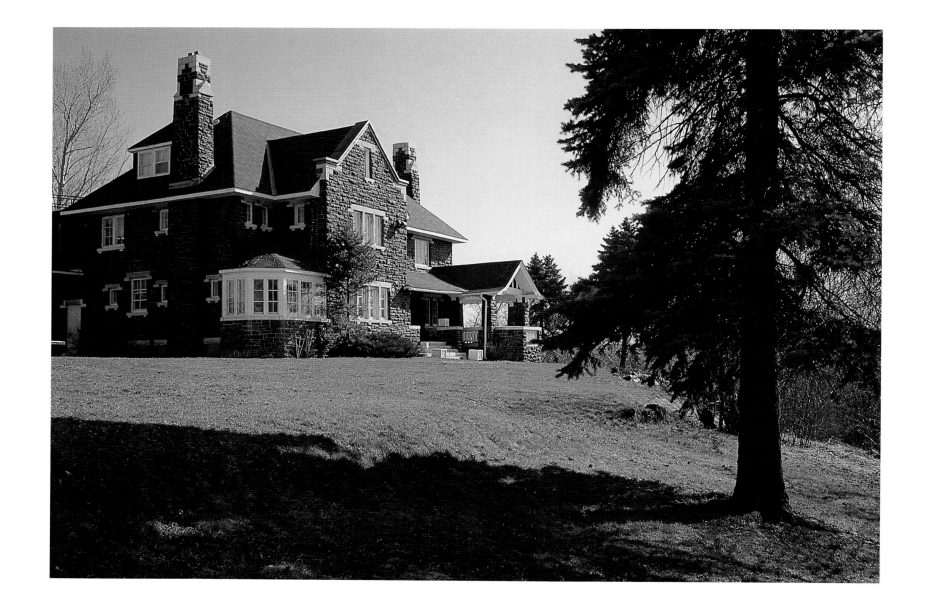

Bell House

Sudbury

While the rest of Sudbury was still emerging from the boreal forest, lumber baron William Bell built a stone house that was the envy of all his neighbours. When it was new in 1906, no local home could rival its splendour; indeed, it would have been an asset among the stock-brokers' houses in Rosedale or any other more established neighbourhood farther south. The scale is monumental, almost as though the building belongs on a university campus, and the detail echoes the collegiate theme. It is somehow fitting, then, that the house has been put to institutional use. Today, it is home to the Art Gallery of Sudbury. Because of a devastating fire in the mid-1950s, little remains of the building's original interior.

Senator Gordon House

North Bay

North Bay went through its first growth surge early in the 20th century, a decade or two later than its rivals to the south. Hence, homes of the Edwardian period rank as the oldest in the city. The Gordon House is probably the grandest of the breed, built for a senator in 1911 just one block north of Main Street. Its spiky, bald gables have a certain mediaeval air that could never be mistaken for Victorian Gothic, which was far more intricately handled. In its unadorned simplicity, Senator Gordon's house says much about Edwardian style. The wide windows are another period hallmark.

Not quite symmetrical (the bays don't exactly match), the house is another local landmark designed by Harry W. Angus.

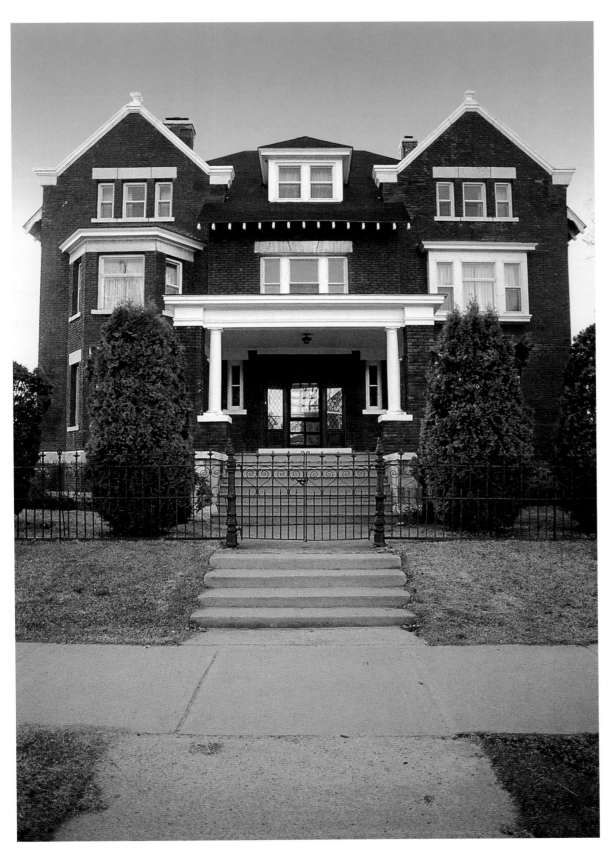

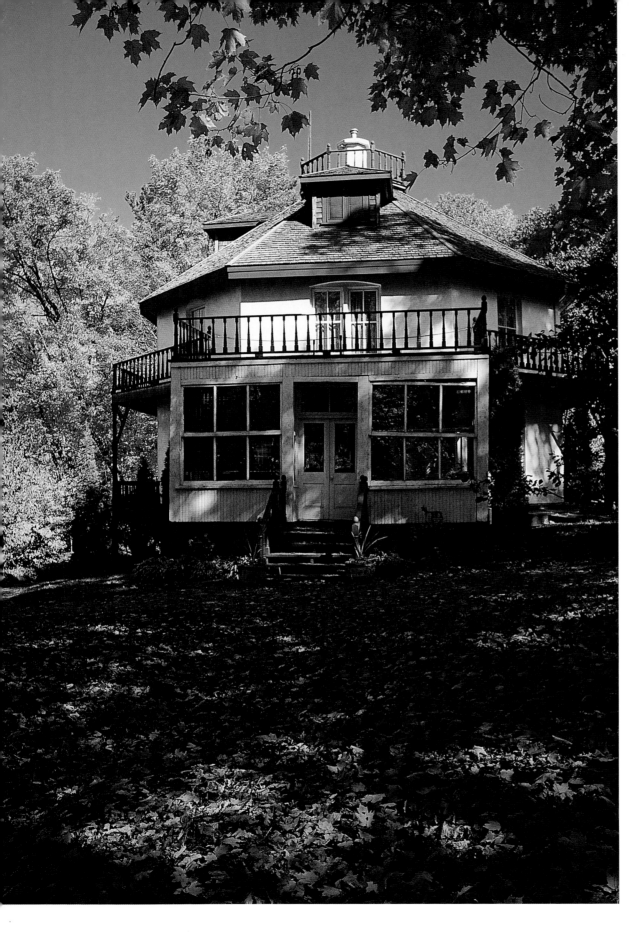

Woodchester Villa

Bracebridge

Woodchester, which stands on a hillside overlooking a bend in the Muskoka River, is more faithful to the prototype for octagonal houses than, say, Barrett's Octagon in Port Hope (page 64). Almost to the letter, it adopts the dimensions and plan advocated by Orson Squire Fowler, who championed the cause of eight-sided buildings in his book *A Home for All*.

Fowler argued passionately that a typical rectangular house was no place to raise a family. "How much fretfulness and ill temper, as well as exhaustion and sickness, an unhandy house occasions. It…sours the temperament of children, thus rendering the whole family bad-dispositioned, whereas a convenient one would have rendered them constitutionally amiable and good." According to him, the "convenient" house had not four sides but eight. An octagon would receive more sunlight, eliminate ugly internal corners and greatly ease the burden of housework by reducing the distance between any two points in the house. Although many of his claims were dubious, Fowler showed surprising foresight in his ideas for good ventilation, dumbwaiters, indoor plumbing, running water and other technological advances.

Woodchester embraces many of Fowler's concepts, both philosophical and practical. While the house can be criticized for an awkward arrangement of rooms, its mechanical systems were years ahead of their time. Ventilating shafts on either side of the chimney ensured a healthy exchange of air. Running water was supplied to sinks and washbasins from two rainwater tanks on the second floor. Meanwhile, the pulley-operated dumbwaiter was a triumph of domestic innovation, rising like an elevator from the basement kitchen all the way to the attic.

Woodchester came rather late in the history of octagonal buildings. It was not constructed until 1882, at least 20 years after the fad first crossed Lake Ontario from New York. The house was built by Henry James Bird and has always been a local curiosity. It is not surprising, therefore, that it is now a museum.

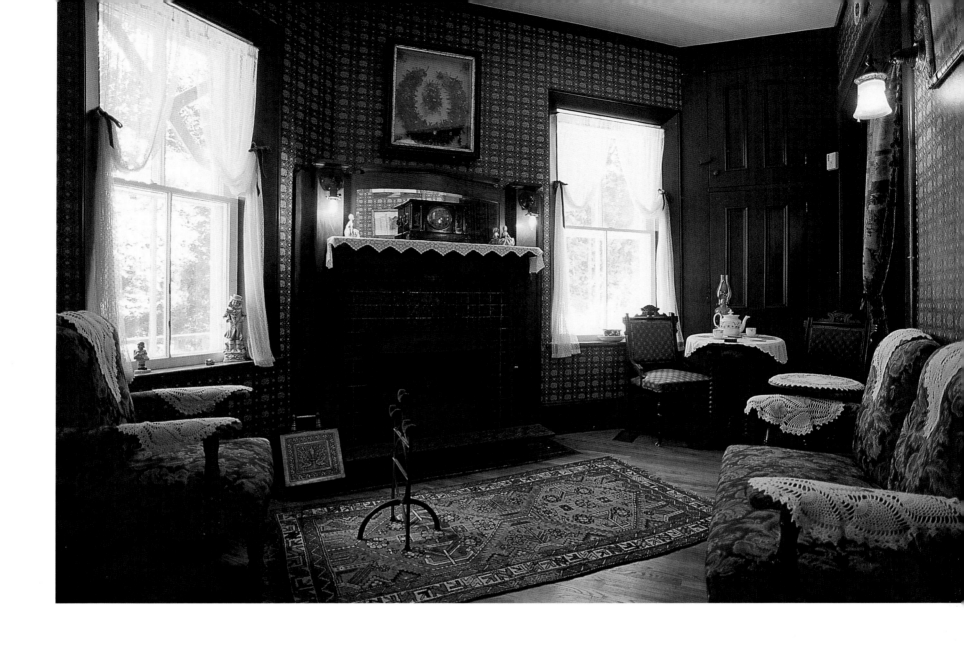

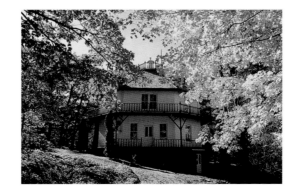

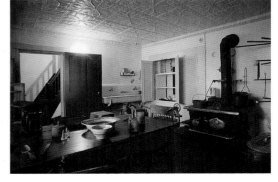

Above: Octagonal rooms were novel but a challenge to furnish.

Far right: The kitchen at Woodchester is a model of Victorian efficiency.

SELECTED BIBLIOGRAPHY

Angus, Margaret, *The Old Stones of Kingston*. University of Toronto Press, Toronto, 1966.

Ashenburg, Katherine, *Going to Town: Architectural Walking Tours in Southern Ontario*. Macfarlane Walter & Ross, Toronto, 1996.

Atkinson, Dan, ed., *A Decade of Sundays: Quinte Walking Tours*, volume 1. Architectural Conservancy of Ontario, Belleville, 1994.

Blake, Verschoyle, and Ralph Greenhill, *Rural Ontario*. University of Toronto Press, Toronto, 1969.

Cathcart, Ruth, *How Firm a Foundation: Historic Houses of Grey County*. Red House Press, Wiarton, 1996.

Clerk, Nathalie, *Palladian Style in Canadian Architecture*. Parks Canada, Ottawa, 1984.

Cruickshank, Tom, and John de Visser, *Port Hope: A Treasury of Early Homes*. Bluestone House, Port Hope, 1987.

Cruickshank, Tom, Peter John Stokes and John de Visser, *The Settler's Dream: A Pictorial History of the Older Buildings of Prince Edward County*. County of Prince Edward, Picton, 1984.

Fox, William Sherwood, *The Bruce Beckons: The Story of Lake Huron's Great Peninsula*. University of Toronto Press, Toronto, 1952.

Greenhill, Ralph, Ken Macpherson and Douglas Richardson, *Ontario Towns*. Oberon, Ottawa, 1972.

Ingolfsrud, Elizabeth, *Kingsway Park: Triumph in Design*. Toronto Region Architectural Conservancy, Toronto, 1994.

Leaning, John, and Lyette Fortin, *Our Architectural Ancestry*. Haig and Haig Publishing, Ottawa, 1981.

Lownsbrough, John, *The Privileged Few: The Grange and Its People in Nineteenth-Century Toronto*. Art Gallery of Ontario, Toronto, 1980.

MacRae, Marion, and Anthony Adamson, *The Ancestral Roof: Domestic Architecture of Upper Canada*. Clarke, Irwin, Toronto, 1963.

Maitland, Leslie, *Neoclassical Architecture in Canada*. Parks Canada, Ottawa, 1984.

McBurney, Margaret, and Mary Byers, *The Governor's Road: Early Buildings and Families from Mississauga to London*. University of Toronto Press, Toronto, 1982.

McBurney, Margaret, and Mary Byers, *Homesteads: Early Buildings and Families from Kingston to Toronto*. University of Toronto Press, Toronto, 1979.

McIlwraith, Thomas F., *Looking for Old Ontario*. University of Toronto Press, Toronto, 1997.

Neal, Carolyn, *Eden Smith, Architect 1858-1949*. Architectural Conservancy of Ontario, Toronto, 1976.

Otto, Stephen A., and Richard M. Dumbrille, *Maitland: A Very Neat Village Indeed*. Boston Mills Press, Erin, 1985.

Shiels, Judy, and Mary Appleby, *Sidelights of History: A Guide to Etobicoke's Century Buildings*. Etobicoke Historical Board, Etobicoke, 1975.

Stokes, Peter, *Old Niagara-on-the-Lake*. University of Toronto Press, Toronto, 1971.

Stokes, Peter, Tom Cruickshank and Robert Heaslip, *Rogues' Hollow: The Story of the Village of Newburgh, Ontario, Through Its Buildings*. Architectural Conservancy of Ontario, Toronto, 1983.

Wilson, L.W., and L.R. Pfaff, *Early St. Marys: A History in Old Photographs from Its Founding to 1914*. Boston Mills Press, Erin, 1981.

Wright, Janet, *Architecture of the Picturesque in Canada*. Parks Canada, Ottawa, 1984.

INDEX